Suzy Perette
NEW YORK

GA...

...onale

MW00699077

JEAN PATOU
PARIS
Tailored in London

Ginoli boutique

Mr. Blackwell
DESIGN

Miss Melinda OF CALIFORNIA

D 636F
Palace Costume Co.

YOUNG AMERICA
BY
Oleg Cassini ®

Elis Porter
FOR
Robinson's
CALIFORNIA

Robinson's
CALIFORNIA

Arpeja
CALIFORNIA
Young Innocent T.M.

Peggy Hunt

MISS *Elliette*
CALIFORNIA

LANVIN
PARIS · NEW YORK

Carol Craig

16

RUDI GERNREICH

Gucci

GRÈS
1, RUE DE LA PAIX PARIS

Lillie Rubin

MIU MIU
MADE IN ITALY

cacharel

DRY CLEANED
ARE A SECCO **EMILIO PUCCI**
FLORENCE - ITALY
12

CHANEL
BOUTIQUE

Lanz
FOR
BULLOCK'S WILSHIRE

Radiant
EXCLUSIVE

MADE IN FRANCE
Thierry Mugler PARIS
40

ISSEY
miyake ®

Nudie's
RODEO TAILORS
...
CALIFORNIA

Gucci
MADE IN ITALY

YVES SAINT LAURENT
menswear

Palace Costume

INSIDE HOLLYWOOD'S BEST-KEPT FASHION SECRET

Mimi Haddon

CHRONICLE CHROMA

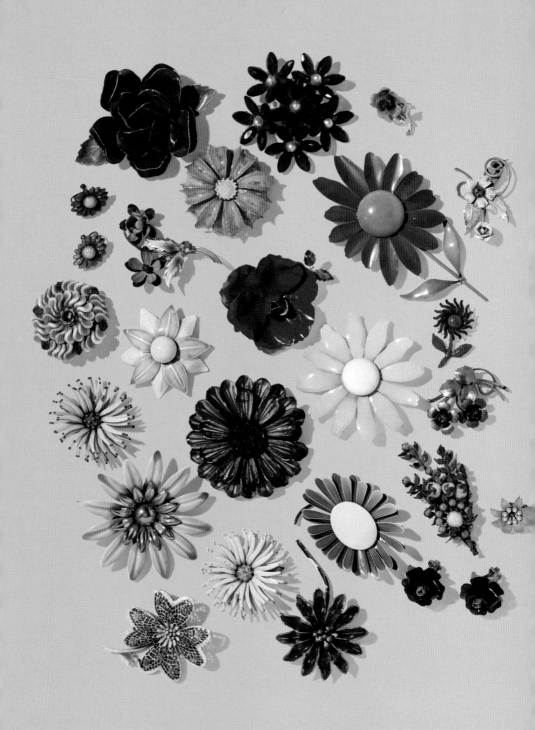

"I love that this collection is a part of creating worlds in Hollywood, Music, and Fashion. Without these industries, Palace Costume would not exist as the extensive collection it is today."

—*Melody Barnett*

Introduction

Nestled inconspicuously on a mural-lined street in West Hollywood, Palace Costume is a spectacle that eludes the casual passerby. The unassuming exterior belies the treasure trove within—four massive buildings interconnected, spanning 30,000 square feet and filled floor to ceiling with more than 500,000 items. It is a veritable working museum of sartorial artifacts—a kaleidoscope of cultures from centuries past and present.

This wondrous collection that has become the first stop for costume designers and stylists from around the world is the vision of one woman: Melody Barnett. What began with a box of Edwardian and Victorian Whites found at a Southern California swap meet nearly sixty years ago has turned into an immense fashion inventory featured in thousands of films, television shows, music videos, and fashion editorials.

The tale of my journey into the enchanting realm of Palace Costume began nearly two decades ago, when I accompanied a stylist as we prepared for a fairy-tale-inspired photo shoot in the mystical Topanga Canyon. As we entered this vintage wonderland, we were greeted by Lee Alexander Ramstead, who presided over the front room like a stylish sentinel, welcoming clients and overseeing the rhythmic flow of garments in and out.

Growing up, I was always somewhat vintage-curious and made a point of seeking out local thrift stores. When I traveled, I delighted in seeing how the merchandise would change according to the taste of the culture, and I always appreciated the collector's vibe and creative ways in which clothing and props can be displayed to tell a story. But Palace Costume is different. Where most thrift stores are akin to a personal art collection, Palace Costume is more like Le Louvre of vintage. It is an endless labyrinth housing the most colorful, detailed, quirky, elegant, bedraggled, flashy, handcrafted, futuristic, quiet, and loud clothing, jewelry, costumes, and props, representing cultures from around the world of the past one hundred years.

As I roamed through the collection on my first visit, my eyes were met by a riot of colors, textures, and tales. Amidst this bedazzled bounty I found my sanctuary—the vintage bathing suits. Perhaps this fascination was rooted in the pool-centric summers of my Palm Springs upbringing, but each swimsuit seemed to whisper its own narrative—a poetic expression frozen in time. They would later become the focal point of my first photographic series at Palace, with my makeup-artist friend, Laurel, and her artist-daughter, Cassia, our model. Together, we embarked upon a creative collaboration inspired by these vintage gems, spinning tales of a moment of fashion long past. From there, I have continued to create multiple series focusing on my love of textiles, prints, colors, patterns, and more.

Palace Costume is no ordinary clothing collection. It is a living, breathing entity, a pulsating ode to the art of storytelling through attire. My affinity for vintage had always leaned toward the eclectic, but Palace Costume elevated it to a cinematic scale. The space itself is a character, each room a chapter, and

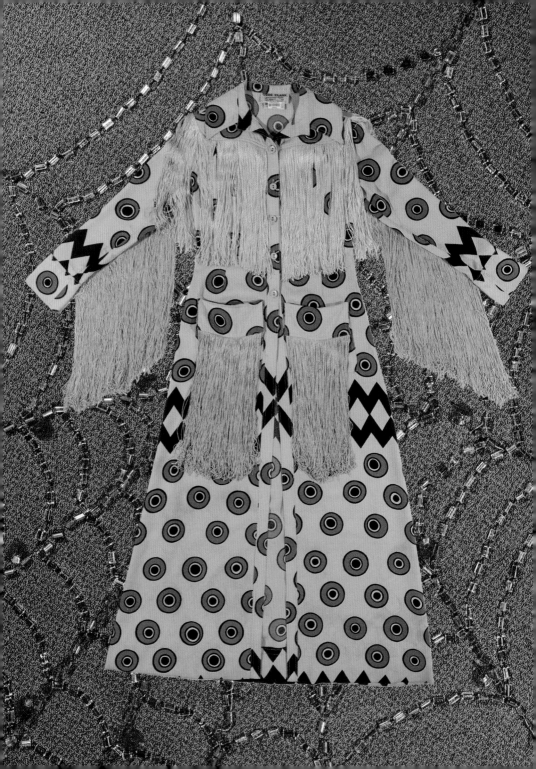

the racks a dialogue between eras, cultures, and aesthetics. If Melody's first love is vintage, a close second is redesigning environments and spaces to house her beauties. Walking through this maze of fashion and props, one senses the care and attention paid to every detail of display.

Throughout my time searching through, selecting, and photographing the timeless pieces that sit quietly on the rails, I have delighted in discovering the vastness and the range of the collection, always a reflection of Melody's quirky yet elegant curation. From the sports section to the vintage lingerie, each floor unfolds like a story waiting to be told. Gloves from a bygone era, illuminated by a makeshift lightbox, unveil intricate tales of craftsmanship. The lingerie room, dimly lit and steeped in history, becomes a seductive muse through delicate silks and laces.

Beyond the garments, I have been fortunate to witness the symbiotic dance between the masterful costume designers who give the collection its raison d'etre. Racks of clothing, labeled with production names, stand like auditioning actors awaiting their moment in the spotlight. The choices made by these designers speak volumes about the research and care that is taken in the selection of each piece—textures, colors, eras, and histories intricately woven into the fabric of character creation.

It is the costume designers and stylists who breathe life into Palace Costume, turning it into a vital force for the film, television, fashion, and music industries. It has been such an honor to interview so many of the most revered in the industry for this book. Hearing their stories and understanding how essential Palace Costume has been as a creative resource for decades underscores the enduring influence it continues to have. I am grateful to each and every one of them for their contributions, time, and insight for this well-deserved testament to Melody's vision and expansive collection. The fortuitous pivot from the original Crystal Palace retail store to the Palace Costume rental house in the 1970s was the catalyst for the endless stock, driven by the demands of the characters being shaped through the art of attire.

Although I have easily clocked my 10,000 hours photographically documenting the Palace Costume collection, I still have not begun to scratch the surface of its inventory. Every time I walk in I see something surprising at the end of the rail in the stylist room, evening gown room, or children's floor. Even as I am writing this, I have ideas of how to highlight certain gems that have recently caught my eye. Maybe another photographic series awaits? I can say that my love and admiration for Melody, her team, and the extraordinary collection continues to grow, and Palace Costume remains an inspiring muse.

With this book, I offer a glimpse into the enchanting world behind the modest facade of Palace Costume—a place where the hustle and bustle of West Hollywood streets melt away and one steps into a realm where threads weave tales and the ordinary transforms into the extraordinary.

—*Mimi Haddon*

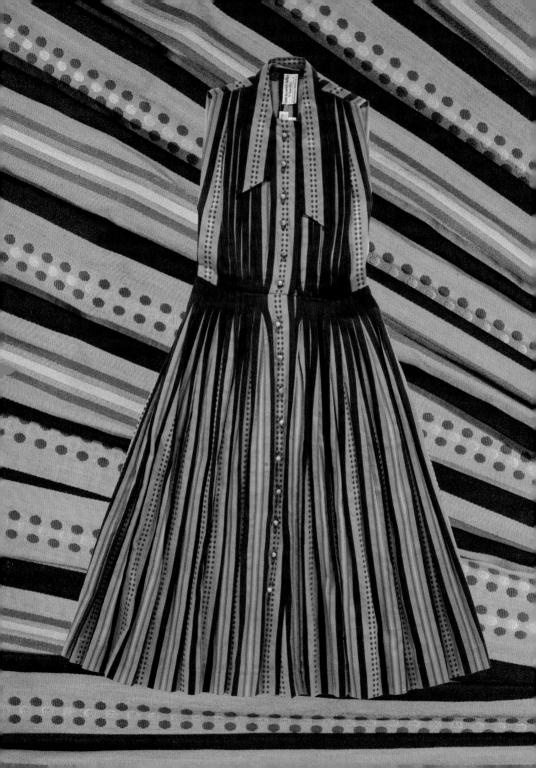

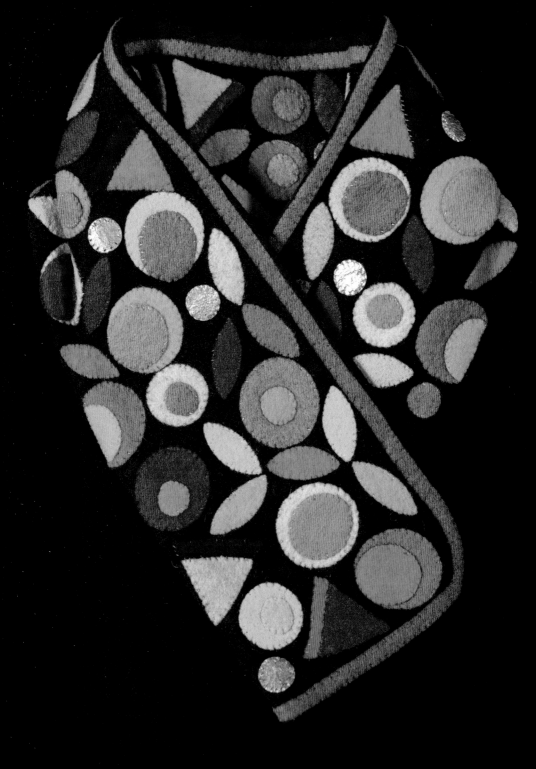

One word—WOW!

I was privileged enough to be shown around the mind-blowing Palace Costume space by its owner and founder, Melody Barnett. It is impossible to put into words the scale of Melody's clothing collection, which is one of the most important reference points and resources for Hollywood's leading costume designers. Palace Costume has to be the most enchanting place in the world to go if you're looking for vintage clothes, jewelry, costumes, or inspiration of any kind. It holds an amazing assortment of treasures and is so immaculately organized and maintained.

It's simply the best.

—*Paul Smith*

1967 BONNIE AND CLYDE 1972 LADY SINGS THE BLUES 1974 CHINATOWN 1977 ROOTS 1978
HEAVEN 1982 CHEERS 1983 FLASHDANCE 1984 MURDER SHE WROTE / TERMINATOR 1985 BAC
SUE GOT MARRIED 1987 DIRTY DANCING / THE LOST BOYS 1988 BEACHES / BEETLEJUICE / T
CHRISTMAS VACATION / DRIVING MISS DAISY / THE FABULOUS BAKER BOYS / GLORY / GREAT
MAGNOLIAS / WILD ORCHID / 1990 / BEVERLY HILLS, 90210 / DAYS OF THUNDER / DICK TRA
VOLCANO / MERMAIDS / MILLER'S CROSSING / POSTCARDS FROM THE EDGE / REVERSAL
JFK / THE JOSEPHINE BAKER STORY / SILENCE OF THE LAMBS 1992 A FEW GOOD MEN / A RIV
LORENZO'S OIL / MALCOM X / THE MAMBO KINGS / MARTIN / MELROSE PLACE / OF MICE AND
/ WHAT'S LOVE GOT TO DO WITH IT 1994 COBB / CORRINA, CORRINA / FORREST GUMP / THE
/ SHAWSHANK REDEMPTION / WYATT EARP 1995 A LITTLE PRINCESS / APOLLO 13 / THE BRID
EVERYTHING! JULIE NEWMAR 1996 THE BIRDCAGE / EVITA / MARS ATTACKS! / THE PEOPLE VS
BUFFY THE VAMPIRE SLAYER / DHARMA & GREG / EVE'S BAYOU / MEN IN BLACK / ROMY A
LEBOWSKI / BULWORTH / CITY OF ANGELS / FEAR AND LOATHING IN LAS VEGAS / FROM THE
SHOW / WHY DO FOOLS FALL IN LOVE 1999 THE CIDER HOUSE RULES / THE GREEN MILE / INS
BIG MOMMA'S HOUSE / CHARLIE'S ANGELS / CAST AWAY / CHOCOLAT / HOW THE GRINCH S
GLITTER / HANNIBAL / LEGALLY BLONDE / MULHOLLAND DRIVE / THE MEXICAN / SIX FEET UN
ME IF YOU CAN / FAR FROM HEAVEN / FRIDA / GEORGE LOPEZ / PANIC ROOM / THE RING 20
DOWN WITH LOVE / I HEART HUCKABEES / KINSEY / THE LAST SAMURAI / MEAN GIRLS / MYST
THE AVIATOR / CATWOMAN / CHARLOTTE'S WEB / CINDERELLA MAN / HOUSE / LEMONY SNI
BABY / THE NOTEBOOK / OCEAN'S TWELVE / PINK PANTHER / RAY / WALK THE LINE / WEDDIN
THE PRODUCERS / SHOPGIRL 2006 BIG LOVE / DREAMGIRLS / HIGH SCHOOL MUSICAL / NAC
GANGSTER / THE BIG BANG THEORY / BLADES OF GLORY / CALIFORNICATION / CHARLIE WIL
OCEAN'S THIRTEEN / THERE WILL BE BLOOD / ZODIAC 2008 AUSTRALIA / CADILLAC RECORDS
KINGDOM OF THE CRYSTAL SKULL / IRON MAN / MILK / REVOLUTIONARY ROAD / THE SECRET L
MAN / AMELIA / BLACK DYNAMITE / FUNNY PEOPLE / GET LOW / GLEE / HANNAH MONTANA:
/ X-MEN ORIGINS: WOLVERINE 2010 ALICE IN WONDERLAND / BOARDWALK / DIARY OF A WIM
RIGHT / THE RUNAWAYS / SECRETARIAT / SHANGHAI / THE SORCERER'S APPRENTICE / TRON: L
FRANKIE & ALICE / THE GIRL WITH THE DRAGON TATTOO / THE GREEN HORNET / GREEN LAN
TREE OF LIFE / WATER FOR ELEPHANTS 2012 ARGO / THE DARK KNIGHT RISES / DARK SHADO
THE PERKS OF BEING A WALLFLOWER / ROCK OF AGES / SHAMELESS / SILVER LININGS PLA
BROOKLYN NINE-NINE / THE BUTLER / GANGSTER SQUAD / THE GREAT GATSBY / INSIDE L
2014 ANNABELLE / BIG EYES / BIRDMAN / BLACKISH / FARGO / GET ON UP / GUARDIANS OF T
TRANSPARENT 2015 BALLERS / THE BIG SHORT / BLACK MASS / BRIDGE OF SPIES / CAROL / E
CASTLE / NARCOS / UNBREAKABLE KIMMY SCHMIDT 2016 20TH CENTURY WOMEN / ANIM
/ THE GOOD PLACE / GREASE LIVE! / HAIL, CAESAR! / HANDS OF STONE / HIDDEN FIGURES / L.
/ WESTWORLD 2017 BATTLE OF THE SEXES / BIG LITTLE LIES / FEUD / GIRLBOSS / GLOW / I, T
THE ORIENT EXPRESS / PHANTOM THREAD / THE SHAPE OF WATER / TWIN PEAKS / WHEN V
PANTHER / BUMBLEBEE / DIRTY JOHN / FIRST MAN / GREEN BOOK / GROWN-ISH / MARY POP
BOLDEN / CAPTAIN MARVEL / DOLEMITE IS MY NAME / EUPHORIA / FAMILY REUNION / FOR
IRISHMAN / JOKER / THE KITCHEN / THE LAUNDROMAT / THE MORNING SHOW / ONCE UPO
DOUBLE TAP 2020 BILL & TED FACE THE MUSIC / BOOKSMART / THE BOYS IN THE BAND / THE C
WORLD / PERRY MASON / THE PLOT AGAINST AMERICA / THE PROM / PROMISING YOUNG WO
BEING THE RICARDOS / C'MON C'MON / COMING 2 AMERICA / DON'T LOOK UP / DOPESICK /
POWER BOOK III: RAISING KANAN / RESPECT / SPACE JAM: A NEW LEGACY / THE STARLING / T
/ A LEAGUE OF THEIR OWN / AMERICAN GIGOLO / ANGELYNE / ARMAGEDDON TIME / BABYLO
LADY / THE FLIGHT ATTENDANT / GASLIT / INTERVIEW WITH THE VAMPIRE / MINX / THE OFFER
UNDER THE BANNER OF HEAVEN / THE VALET / WHITNEY HOUSTON: I WANNA DANCE WITH S
GOD? IT'S ME, MARGARET / BARBIE / BEEF / BIG GEORGE FOREMAN / THE BIKERIDERS / BOST
OF THE PINK LADIES / HIGH DESERT / OPPENHEIMER / RENFIELD / RUSTIN / WHITE HOUSE PLU

9 ALIEN / THE ROSE **1980** MAGNUM P.I. **1981** DYNASTY / HILL STREET BLUES / PENNIES FROM

UTURE / THE COLOR PURPLE / THE GOLDEN GIRLS / PEE-WEE'S BIG ADVENTURE **1986** PEGGY

G TRILOGY / WHO FRAMED ROGER RABBIT **1989** BATMAN / BORN ON THE FOURTH OF JULY /

RE! / HARLEM NIGHTS / PARENTHOOD / QUANTUM LEAP / SEINFELD / SAY ANYTHING / STEEL

RD SCISSORHANDS / GODFATHER III / THE GRIFTERS / IN LIVING COLOR / JOE VERSUS THE

NE / WINGS **1991** BUGSY / DAUGHTERS OF THE DUST / DOC HOLLYWOOD / THE DOORS /

HROUGH IT / THE BODYGUARD / DEATH BECOMES HER / DRACULA / ENCINO MAN / HOFFA /

SHOE DIARIES **1993** / ADDAMS FAMILY VALUES / LOST IN YONKERS / THE NANNY / THE X-FILES

R PROXY / LEGENDS OF THE FALL / LITTLE WOMEN / NATURAL BORN KILLERS / PULP FICTION

DISON COUNTY / CLUELESS / DEVIL IN A BLUE DRESS / NIXON / TO WONG FOO, THANKS FOR

NT **1997** AMISTAD / AUSTIN POWERS: INTERNATIONAL MAN OF MYSTERY / BOOGIE NIGHTS /

E'S HIGH SCHOOL REUNION / SELENA / TITANIC **1998** ARMAGEDDON / BELOVED / THE BIG

HE MOON / HOPE FLOATS / PARENT TRAP / PLEASANTVILLE / THAT '70S SHOW / THE TRUMAN

ADGET / LIBERTY HEIGHTS / MAN ON THE MOON / THE MOD SQUAD **2000** ALMOST FAMOUS /

STMAS / MISS CONGENIALITY / X-MEN **2001** ALI / A BEAUTÍFUL MIND / BLOW / BOJANGLES /

AME **2002** 8 MILE / ADAPTATION / CHICAGO / CONFESSIONS OF A DANGEROUS MIND / CATCH

MS / A MIGHTY WIND / ARRESTED DEVELOPMENT / BIG FISH / CARNIVÀLE / CAT IN THE HAT /

NIP/TUCK / PIRATES OF THE CARIBBEAN / SCARY MOVIE 3 / SEABISCUIT **2004** ANCHORMAN /

ERIES OF UNFORTUNATE EVENTS / THE LIFE AQUATIC WITH STEVE ZISSOU / MILLION DOLLAR

RS / WHITE CHICKS **2005** BEWITCHED / DANCING WITH THE STARS / MEMOIRS OF A GEISHA /

RUNNING WITH SCISSORS / YOU, ME AND DUPREE **2007** ACROSS THE UNIVERSE / AMERICAN

R / THE DARJEELING LIMITED / HAIRSPRAY / INTO THE WILD / MAD MEN / MUSIC AND LYRICS /

IOUS CASE OF BENJAMIN BUTTON / THE EXPRESS / FROST/NIXON / INDIANA JONES AND THE

S / SEX AND THE CITY / TRUE BLOOD / TWILIGHT / W. **2009** (500) DAYS OF SUMMER / A SERIOUS

/ MODERN FAMILY / PUBLIC ENEMIES / THE TIME TRAVELER'S WIFE / STAR TREK / WATCHMEN

OWNTON ABBEY / THE FIGHTER / HOT TUB TIME MACHINE / INCEPTION / THE KIDS ARE ALL

11 AMERICAN HORROR STORY / THE ARTIST / BAD TEACHER / BRIDESMAIDS / ENLIGHTENED /

NGOVER 2 / HUGO / J. EDGAR / MILDRED PIERCE / MONEYBALL / THE MUPPETS / NEW GIRL /

HCOCK / THE HUNGER GAMES / LIFE OF PI / MAGIC MIKE / THE MASTER / MEN IN BLACK 3 /

PARKLE **2013** AMERICAN HUSTLE / AUGUST: OSAGE COUNTY / BEHIND THE CANDELABRA /

AVIS / MASTERS OF SEX / SAVING MR. BANKS / THE WOLF OF WALL STREET / WOLVERINE

Y / HOUDINI / INHERENT VICE / MANHATTAN / PENNY DREADFUL / SELMA / SILICON VALLEY /

FTY SHADES OF GREY / FRESH OFF THE BOAT / GRACE AND FRANKIE / THE MAN IN THE HIGH

OM / ELVIS & NIXON / FANTASTIC BEASTS AND WHERE TO FIND THEM / FENCES / GOLIATH

/ THE LAST TYCOON / LOVING / NOCTURNAL ANIMALS / THIS IS US / UNDERGROUND / VINYL

E KENNEDYS: AFTER CAMELOT / THE MARVELOUS MRS. MAISEL / MINDHUNTER / MURDER ON

WONDERSTRUCK / YOUNG SHELDON **2018** A STAR IS BORN / THE ALIENIST / BARRY / BLACK

DINNER WITH HERVÉ / ON THE BASIS OF SEX / VICE / YELLOWSTONE **2019** BLACK MONDAY /

ARI / FOSSE/VERDON / GODFATHER OF HARLEM / THE HIGHWAYMEN / I AM WOMAN / THE

N HOLLYWOOD / PATSY & LORETTA / THE POLITICIAN / WHY WOMEN KILL / ZOMBIELAND:

HOLLYWOOD / LOVECRAFT COUNTRY / MA RAINEY'S BLACK BOTTOM / MANK / NEWS OF THE

QUEEN'S GAMBIT / THE TRIAL OF THE CHICAGO 7 **2021** ABBOTT ELEMENTARY / ACAPULCO /

OF TAMMY FAYE / HACKS / KING RICHARD / LICORICE PIZZA / MADE FOR LOVE / PHYSICAL /

STATES VS. BILLIE HOLIDAY / WEST SIDE STORY / YELLOWJACKETS / YOUNG ROCK **2022** 1923

ADAM / DARK WINDS / DON'T WORRY DARLING / THE DROPOUT / THE FABELMANS / THE FIRST

AG MEANS DEATH / PAM & TOMMY / TILL / THE TIME TRAVELER'S WIFE / TOP GUN: MAVERICK /

Y / WINNING TIME: THE RISE OF THE LAKERS DYNASTY **2023** 80 FOR BRADY / ARE YOU THERE

GLER / THE BOYS IN THE BOAT / THE COLOR PURPLE / DAISY JONES & THE SIX / GREASE: RISE

WONKA . . . TO NAME JUST A FEW.

Interviews

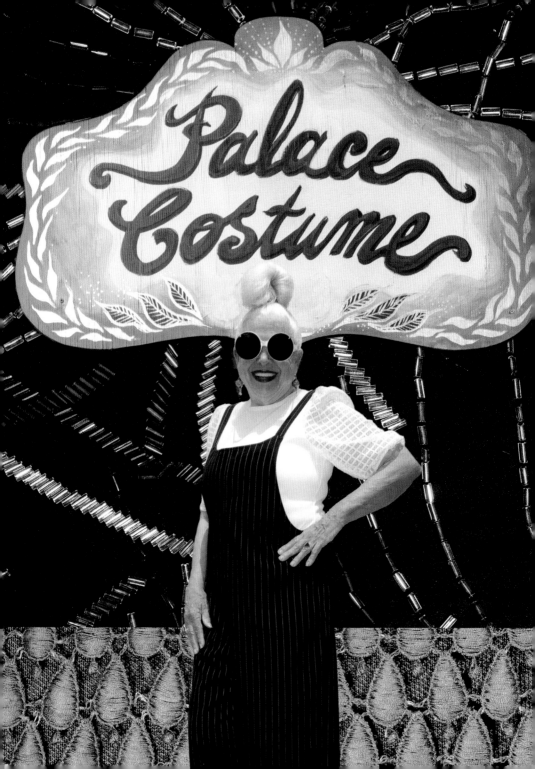

MELODY BARNETT

Melody Barnett has been collecting vintage clothing and props for the past sixty years. She has amassed one of the largest private clothing collections in the world and has turned Palace Costume into one of the most coveted stops for award-winning costume designers, stylists, and couture clothing houses.

MH: How did you develop an interest in collecting vintage clothing?

MB: I was definitely encouraged by my mom and my grandmother. My mom came from a prominent family in Yellow Springs, Ohio. When my mother was young they would go shopping in New York in the winter and Chicago in the summer. She just always had beautiful clothes. When my sister and I were young, my father returned from the Second World War and things seemed to fall apart in our lives. My mother always kept working. We didn't have much money, but we would go window shopping to see the latest fashions. Anything we liked, my mother was able to make for us. She was an incredible seamstress so I just always had good clothes. I was always creative with them, and in my high school yearbook it was predicted that I would become a fashion designer. That is not what happened. I was also a collector. One of the things that got me interested in vintage was thrift shopping, which, at that time, was not at all the fashionable thing to do. It wasn't until the '60s or '70s when that world really took off. I guess I was ahead of my time.

MH: How did you turn your passion for vintage clothing into a business?

I always bought things. I always went to garage sales. I've furnished my houses entirely with things I found at the swap meet. In the late '60s I moved with my husband and children to an old house in Laguna Beach. Once I completely renovated that, I started doing window decorating for several stores. One of them was an Indian import store.

When they went out of business, they gave me their entire stock. I loaded it up with my oldest kids and my stepsons, and we went to the Orange County Swap Meet in Santa Ana where we sold the clothes from my old red Volkswagen bus. One weekend, while shopping at the swap meet, I found a box of white Victorian and Edwardian dresses, chemises, petticoats, pantaloons, nightgowns, and textiles. These clothes were special. They were one hundred years old, but in good shape. I took them home to wash, starch, iron, and beribbon.

My husband, Donn, was a famous hair stylist in Los Angeles. He was a real character. When we moved to Laguna, all of his clients would come down from Los Angeles, including David Crosby and Timothy Leary. I had the vintage clothes hanging all over the great room that adjoined Donn's hair studio. These articles attracted a lot of attention from the celebrity-type clients, and I was told about the vintage stores popping up in Hollywood. One day someone said, "Why don't you take those to LA? There's a shop called the Liquid Butterfly." After a few months of selling with them, they moved without paying me. It was a big disappointment because the restoration of these garments was time consuming and laborious. When my neighbor, Bob Becker, heard what happened, he said, "I'd really like to have a store with you." Bob had trained at the Royal Academy in London, where he learned about antique jewelry, *objet d'art,* and furniture. A couple of months later he found a huge old antique crystal chandelier shop on the corner of San Vicente and Melrose. The beautiful building was in poor condition, but we moved in and cleaned about fifty gorgeous chandeliers, put in interesting flooring,

Melody Barnett, photograph and collage by Mimi Haddon.

dressing rooms, showcases, and window display platforms. The first room had massive windows, and the second room had a pipe organ in it. When it was played, the left-hand wall of the room had twenty-seven instruments behind moving mirrored panels, and they were rigged up so they would have horns, violins, even the human voice.

We called our shop the Crystal Palace. We sold vintage clothing, furs, hats, shoes, gloves, and jewelry. Everything was in perfect condition. Our repurposed articles were also really fun and trendy at this exciting time of generational change in fashion as well as lifestyle. Our customer base included the royalty of music, rock, film, and fashion. The clientele was amazing. Even before we opened we had people peeking in the windows and begging us to be let in day and night. Late one night, I was putting together one of the window platforms with a mannequin dressed in '30s/'40s attire—a great rayon dress with arms full of Bakelite bracelets. I had a very large wicker basket upturned on the floor with literally hundreds of Bakelite bangles spilling onto the platform. I heard a tapping at the window and saw that it was Diana Ross. I let her in and she shopped happily.

Not long after, I received a call from Robert Silberstein, Diana's husband at the time. He invited Bob and myself to an old mansion on King's Road. He was selling the property and was clearing it out. In the basement of the house was a treasure trove of vintage clothing, Broadway costumes, and enormous amounts of theater and film memorabilia. He gave us the entire lot. We still have bits and pieces of it today. The collection belonged to Ziegfeld Follies dancer Nellie Nichols. That was just the first of many fortunate treasure trove finds.

MH: What were some of your other secrets to buying?

Somehow, we got connected to a rag house in downtown Los Angeles. The floor sorters were mainly Latino women and men who did not speak English. Every week I would wear a different type of garment or look and indicate that I would like to collect them as well as those that I had purchased the previous times. For instance: Hawaiian, Victorian, 1920s embroidered and beaded dresses, Japanese tour jackets, Hungarian and Philippine dresses and blouses, men's formal vests, collar band and tux shirts, etc. The employees really liked my method, and it turned out to be a great purchasing technique.

MH: How did the Crystal Palace become Palace Costume?

We were extremely popular at the Crystal Palace, but within a year and a half, we found that the plans for building the Pacific Design Center had finally been approved after thirty years, so we had to shut down that location. We decided to take a year off, but I continued making and collecting things until we moved into our second and third stores on Melrose Avenue.

In 1976 we bought the center building of the complex where we are today, on Fairfax Avenue a few blocks up from Melrose. Around that time, Anthea Sylbert, who had purchased from me for *Chinatown*, suggested that we start renting instead of selling. For a while we did both but eventually stopped retail altogether because we became very busy as a rental house.

Whatever period of film was in production, I would go out and find vintage items for it. We always went to the Rose Bowl Flea Market, and we amassed a huge amount of inventory. We were also connected through Bob, who had an in on the best estate sales. It was crazy. And I was still fixing everything up with a small staff. My mother worked for us. She was amazingly good, and I had another girl who started working for me when my daughter was born. Those were the years. It was really hectic. A few years after we bought the center building, we bought the north then the south buildings. We had a giant courtyard in the center which used to house trash bins full of shoes. Eventually we turned

Bonnie and Clyde, from left: Faye Dunaway, Warren Beatty, 1967. Courtesy Everett Collection.

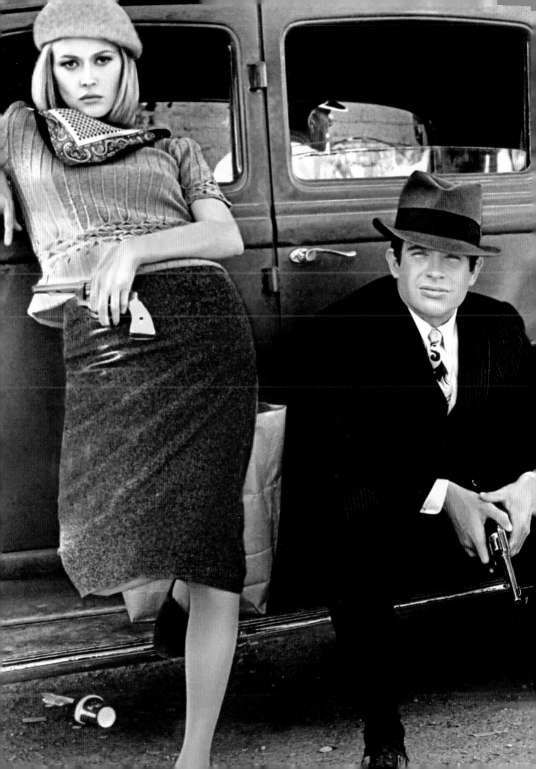

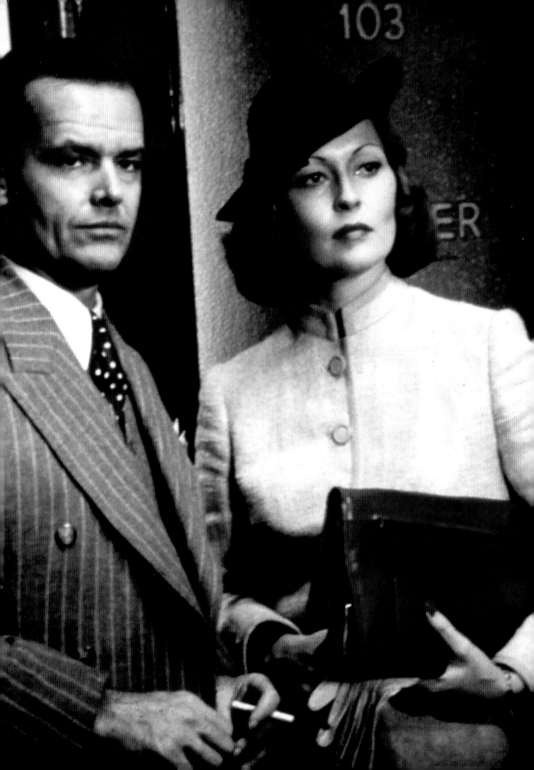

In 1976 we bought the center building of the complex where we are today, on Fairfax Avenue a few blocks up from Melrose. Around that time, Anthea Sylbert, who had purchased from me for *Chinatown*, suggested that we start renting instead of selling. For a while we did both but eventually stopped retail altogether because we became very busy as a rental house.

that space into a four-story building, adding fifteen thousand square feet. Now, in total, we have thirty thousand square feet and more than five hundred thousand bar-coded items. Every time we build and every time the stock of a certain era grows, we have to make changes. So, it's constant. Constant cleaning, maintenance, and repair.

MH: How would you describe your personal aesthetic?

MB: I think I always have had a unique sense of style. I was already wearing vintage when I was in high school. This was long before it was popular. But I would just do unusual things. I remember in sewing class, we were making fiesta dresses. Instead of making a dress I made a pair of pants, and I had little strips going all the way down the leg with separate trim. I did the same thing on an off-the-shoulder top. Everybody just loved it, but, you know, it was different. It wasn't what we were supposed to do. I just like to change things up. I don't know why I do what I do, but it's fun. I think I have always been creative, you know, and that's a gift, just to be able to have that. It's a really nice tool to have in the world, especially if you're working with objects, or furniture, or clothing. And my houses, certainly, when I redo them, they're pretty odd. But odd in a good way. I just do things differently.

I'm not strictly into vintage either. I just like unique things. I have quirky taste, and it's not just with clothes. I love old furniture. I love paintings. I love redoing houses. I love doing the whole thing. And I think we have created an interesting environment here at Palace Costume. It goes beyond having things perfect for my own personal use or building functional space. I like to do unique things with it. I think I have probably always had an eye for details. My mother had it until the day she died. But I'm more eccentric than anybody else in my family. I definitely have that. That makes things a little bit unconventional and intriguing.

I still find special things at the swap meet. What some of the artists are doing these days, cutting

old pieces up and redesigning them, is so clever. I was upcycling sixty years ago. I made some beautiful things, and I don't even have them anymore. I was doing it with damaged articles. I would never cut up anything that wasn't ruined. I don't believe in that at all. At one point we had a line called Hanky Panky, which were panties and bras made out of handkerchiefs. Another fun thing was something my mother worked on. I would have her take these vintage men's white pique vests, little tiny ones, and she would put embroidery on them. Oh, they were adorable. And they were perfect with those old Victorian and Edwardian nightgowns that were so voluminous. They had really beautiful lace on the bottom, but they were huge. So my customers would take those little tiny white vests and cinch them in, and it looked really good. I wish I still had them.

And the pantaloons from that era are so cute. In the wintertime, I want to wear long white sweaters with those old lacy things for pants. They're so adorable. I used to do that too, but I haven't done it in a while. I've lived in my coveralls for years. All the years we were building, rebuilding, adding this floor, that floor just . . . That's been my uniform forever. And I love my old paint-splattered coveralls. When I go to work on my old house in Laguna, that's what I have to put on, because we have done a lot of work on repairing the paper-mache, gilding, and decorative details on that place.

MH: So would you say you feel most comfortable in your coveralls?

MB: Oh, yeah. I feel like *me* when I'm in my coveralls.

MH: Do you ever get overwhelmed by the amount of work to do here?

MB: I think I have a handle on it because between myself and my employees we keep up with it. The employees here are wonderful, so we manage to get everything done.

MH: Have you gone out of your way to collect

certain designers like Rudi Gernrich, Issey Miyake, or Pucci?

MB: Not really. I love designers. If I see a designer piece I grab it, but not really. But we have acquired a lot of designer things, and we have also rented to designers as well. Norma Kamali was also one of my first customers. Stella McCarney, Tom Ford, and all the European designers have been here. I mean, people consider this a good library of fashion. Fashion designers will come here just to get inspiration from the way a garment is put together. The construction of a pocket or the way a button is designed. They can have a whole concept of what their look is going to be, but maybe they're searching for something to add to it. I don't think too many people reproduce identically from what we have. They get inspiration from the collection. All those details make a huge difference. They're great. I love detail. I have a huge button collection, and if I get another building, I'm going to do a wall of them. I don't know why I love them so much. Maybe it is because they are so necessary. If you lose one button on a period garment, you have to replace the entirety, however many there might be. Maybe just five or maybe fifteen to twenty. So I've always been after buttons.

MH: Can you talk about the power of costume and clothing to change a personality or character?

MB: I think it's so important to the performers to really look the part head to toe. Every aspect of their character should look authentic, including their hair, their makeup, and their wardrobe. I don't think complete authenticity in film was as important when it started out in the early years. Now it's really important. If it doesn't look like the correct period, it just doesn't seem to work. *Chinatown* is one of a few films that I think really influenced the desire for authenticity in costume. There were some films from the '50s and '60s, where women had beehives and these 1920s dresses with zippers up the back. It just wasn't that accurate, but now it is important. If they're making a movie about the 1940s today, all of the

designers of the film, production to wardrobe, have to really key in on that era to bring a genuine tone. I remember Anthea Sylbert and Milena Canonero would have historically accurate underwear, even though there was no disrobing. Everything would have to be just right. And they would pay a lot of money for it. The designers we work with need things to be period accurate. And so, from head to toe, you need it. We need the shoes, the stockings, the hats, the veils, the jewelry, the gloves, the handbags and evening bags, all that. We need it all.

MH: Do you think about the history of the clothes and what stories they might hold?

MB: Yes, I do. One of my great-grandchildren says, "I think there's ghosts in this place!" She's ten, she's really cute. She says, "Do these clothes talk to you?" and I said, "In a way they do." Some of the really early things, that are damaged for whatever reason, have found their way into our Depression section, and I love those. They can look as raggedy or as grungy as possible. I don't know, there's something about Depression Era clothing that is so utterly charming. I don't know how to express it other than I just want to walk into that room with those old, old used things. Maybe it's just because they have vibrations of history, being as old as they are, worn in people's lives until they're ragged. I like them because of how expressive they are. They have such stories.

MH: What is next for Palace Costume?

MB: Well, the next big move will probably be to buy another location or a different method of storage, but I definitely plan before I pass away to buy another building, because I am the one that's good at figuring them out. I mean, I'm really good at spaces, and I do want to do that, but my family intends to work at the shop and be really responsible for maintaining it and hiring the right people. It's not going to be just family. It's never been just family. My employees have been a vital part of this.

MH: We are sitting in your apartment upstairs, and we are surrounded by vintage women's shoes from one hundred years ago that are displayed in one long row all along the walls. The next few bedrooms are filled with lingerie dating back to the early 1900s to present day. What is it like to live among this collection of clothing?

MB: This whole top floor where we are was once one big, open, beautiful space. We used to have dinners and parties and socialize a little bit in those days. We had this entire floor as a living space. There was no lingerie up here. But it's been a necessity to expand, and it's basically my fault for buying so much. We live beneath the clothes, and that is comfortable for me. Sometimes I work at night. It's part of me. I'm usually downstairs by 4:00 a.m. I turn the television on when I wake up. I turn on the coffee, turn on the lights, do put-away, then I just go through everything, figure out what I'm going to do for the day. And there is never a time when there isn't something to do. Our racks are terribly crowded, but the jewelry is the hardest because it is just piled up in trays, and it gets so terribly messed up.

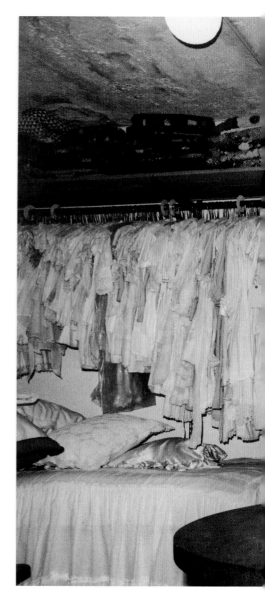

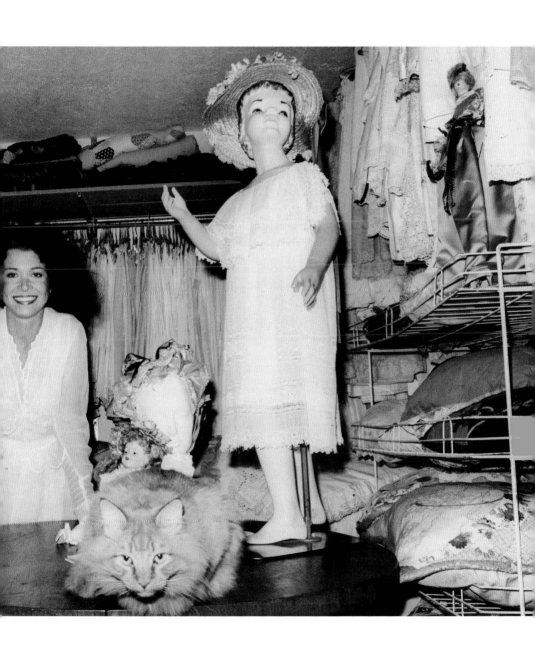

MB: Late '70s, The room was our Victorian storage and sewing room. The cat was Star Baby. My daughter gave him to me for my birthday, and he lived a long life. We no longer have that room. It was behind the center building and is now the four stories.

Collections like this should be in museums, but what we do with ours is different. We are a working museum, and we do try to really take care of the clothes. Other costume houses have great stuff, but I really *know* what I have. I *personally know* these clothes.

there's a little sun suit that my mother made for me out of fabric that my father brought from Hawaii. And I had one of my graduation dresses here. My granddaughters, Czara and Zoe, are really creative and are constantly looking and buying for the shop, and my grandson, Timmy, is also extremely interested in clothes. He keeps every pair of these high-end sneakers in the original boxes. He's really into it. He says that his collection is eventually going to be here too.

MH: What has Palace Costume meant to you over the past fifty years?

I love being a part of it. I love that this collection is a part of creating worlds in Hollywood, Music, and Fashion. Without these industries, Palace Costume would not exist as the extensive collection it is today. It is an interesting business. It's not for everyone. I was so lucky that I got into it when I did. I don't see how anyone could do it now because you cannot find enough quantity to do a film or films with hundreds of women, men, and children. The stock is just not out there. Collections like this should be in museums, but what we do with ours is different. We are a working museum, and we do try to really take care of the clothes. Other costume houses have great stuff, but I really *know* what I have. I *personally know* these clothes. And I've learned it from all these years of experience. I've had such great customers from all over the world. I feel customers have been inspired by Palace Costume, but, I in turn, have been inspired by the amazing and talented professionals who have supported us. This collection is really such a great place for clothes to end up because they have a whole new life by being a part of something. These things can be seen in thousands of films, television shows, and videos, so their stories continue on.

MH: So is your dream for your family to continue with your life's work at Palace?

MB: Well, I get along so well with the kids. And now that they're older, they're able to really help. They don't run the store, but they understand what I do. And when they find something I might like, they don't have to ask me, they just know. So they are doing their contribution to the shop now. My whole family, everybody just kind of works together. I've been training them since they were really young for that. They have always been with me buying from estate sales, garage sales, and thrift shops. It will continue. My youngest great-grandchildren have been here helping to sort children's shoes into the correct size range baskets, because we really try to keep it organized. And they're just learning by doing. They all have really cute fashion sense, or their parents do, so I have all their clothes. That's one of the ways I've grown my children's department, just with my own clothes, my sisters, my children's, my grandchildren and great-grandchildren. I mean, I've got it all. I have very good examples of each period. I think

Photo was taken in the Men's section of Palace Costume in 1978. Photographer: Peter Tevis.

MB: Oh, he's absolutely enormous, and he runs this space. He is so knowledgeable and practical. He is also picky about the stock and is very strict, which is something I appreciate. You have to take care of clothing, period. You have to take care of any clothing properly, but vintage is really difficult. It has to be hung upright. It has to be laundered or soaked. Or pressed right. It has to be dry cleaned with a good dry cleaner. I mean, everything is so particular about it. And he is very strict with the customers. They have to bring things back in the bags that they go out in. Thank God I have him. I think he is a huge part of my success. Just his knowledge of period clothing. Absolutely. And the meticulous way he tries to teach people how to handle it. And he may seem kind of grouchy, but I'm glad he's picky. I am really glad because there are a lot of people who are rough with clothes. And they can't be treated that way. Oh yeah. Vitally important. Absolutely. And, I mean, he's not as old as I am, but neither one of us intends to quit the business. I mean, I'm going to die here, probably. But he also has no plans of retiring. He likes it. We like it.

MH: Tell me about first meeting Lee in the late '70s. What was it about him that made you want him to work with you as you were building your collection?

MB: Well, Lee had become our friend. Originally we bought from him. It was the beginning of this vintage clothing explosion, and he had sold in Canada, Europe, and New York before coming here. He's really great at finding interesting pieces from estate sales and swap meets and probably went more than I did after a while. After we closed the Crystal Palace, I was so busy here, I really didn't go out as much, but I could trust Lee to go and find great stuff. Also, Lee is a talker and the customers love him. I'm just not a people person. I like people, but I'm always *doing* something. And I'm always busy. Just like today. I wish I didn't have to clean up the jewelry, but I thought, "I've got to do it. It's a mess."

MH: What would you say is Lee's imprint on Palace Costume?

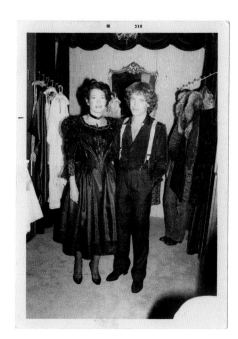

Top left: Taken at The Crystal Palace on Melrose—late '60s early '70s, photographer unknown. Bottom right: An opening of Palace Costume, front room, 1978/79. Photographer: Jim Shay.

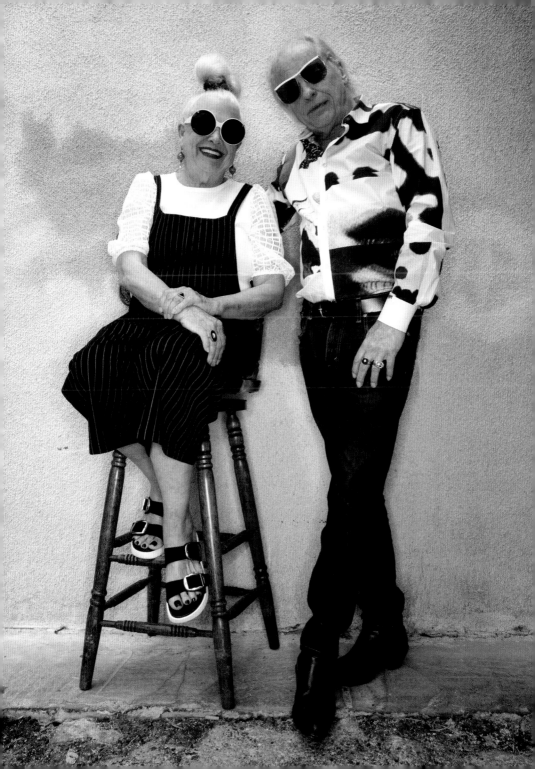

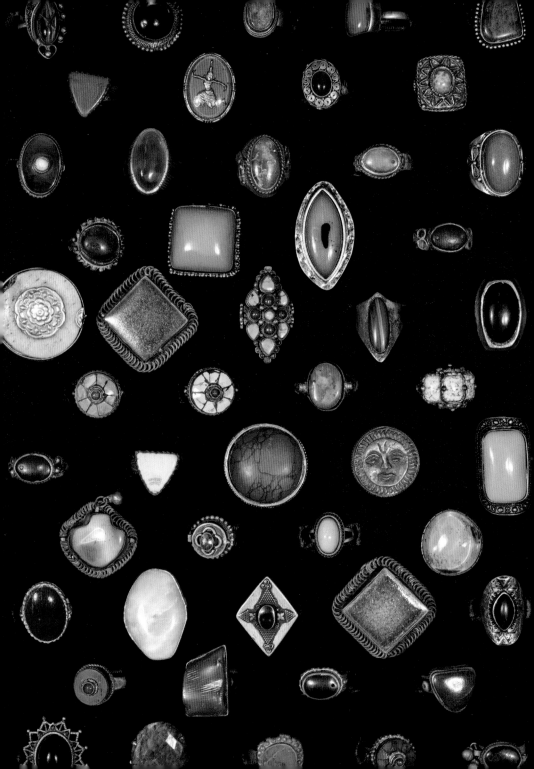

LEE RAMSTEAD

Lee Ramstead has been collecting and selling couture vintage since the early 1970s. He has worked with Melody Barnett at Palace Costume, helping to build the collection and run the shop, since 1978.

MH: What was your early connection to vintage clothing?

LR: That's what everybody wore in the '70s. That's when it all started. I had a vintage clothing store in Toronto. I opened it in '73 with two friends. It has had many owners, but it is still going. In '76 I left and moved to England where we lived off King's Road. I'd go to the flea markets in the morning and then walk down the street and sell to Antiquarius. I was buying Victorian Whites and Chenille curtains. You could buy them really cheap. It's an easy way to make money if you know what you're doing. You can go to any country, if you don't have working papers, it's a cash business.

MH: How and when did you meet Melody?

LR: I met her probably the first month I came to California in June of 1977. She still had the store on Melrose, and this was kind of the workroom for the shop and the beginning of the rental business. I came here when I was a PA for this director who had a small theater production. It was a '30s play, and they had purchased the dress from Melody. I had to take it to her to be repaired, so I went into the store and I thought, "I can sell to this woman." And I sold to her for a long time, and she kept asking me to come to work for her. Which I did.

LR: This was the workroom for the store on Melrose. We would get the clothes ready here, then Melody and I would go over to the shop at night when it was closed. We would do the window displays and put new clothes on the racks.

MH: What were the early days in the rental business like?

LR: The first year I came to work here, she had three movies. We rented for *Pennies from Heaven*, *Frances*, and *Coal Miner's Daughter*. But you know what, we weren't well known for the rentals in the beginning. People knew Melody from the Crystal Palace on Melrose. The costume designers would come here really just for their principal clothes. At that time, all the studios had sold off everything in the wardrobe departments, and the only other rental house was Western Costume.

We had limited stuff, but it was all principal quality. And in those days, if it wasn't perfect, we just threw it in the garbage and bought new stuff. It was that easy to replace. What we had in here, I mean, it was just that one room, but it was packed, and it was packed with treasures. And if a designer was doing a movie, we would run out and buy inventory for it. You could do it that easily. It's not like now.

MH: You have gone to countless estate sales over the years. What is it like looking at the life of a stranger through the clothing and objects that they have collected?

LR: That's the fun part of it. I think, if somebody has good taste, it usually transcends in all facets of their life. From clothing to jewelry to home furnishings, just like bad taste transcends stuff.

MH: How did you expand your knowledge about vintage clothing?

LR: It's not something you can teach somebody. You learn it from watching old movies and touching old clothes. You have to touch them and feel them to know them, I think.

MH: Given that it is such a tactile experience, has the internet changed the way you buy things?

LR: I just don't purchase as much. The internet has ruined all buying, I think. I don't even really go shopping anymore. It's just, there's nothing out there. In thrift shops or anything. I still buy from the estate sales enough, but . . .

MH: It makes you realize that the Palace Costume collection would be impossible to duplicate today.

LR: Yes, you could never get it together to this extent. Or it would cost millions and millions of dollars. And that's another thing. You can still buy this stuff. It's just very expensive. Basically, people sell it for what we rent it for. It's just not worth it for us to buy something for that much money. If you pay a lot for something, it could sit there for years before you even have one rental to get your money back.

MH: And then there is also the risk of it getting ruined from wear.

LR: But you're going to buy something that can be strong enough to hold up to dry cleaning and several wearings. That just comes from experience of knowing what's going to hold up and what is going to fall apart.

MH: I have heard from many designers that one of the things that sets Palace Costume apart from other costume houses is the fact that you care so much about the clothing. Do you find that you have an emotional connection to the collection?

LR: You can't get emotional. You'd be upset all day long. You have to emotionally detach yourself from the collection, or you'd be a wreck. You just can't let that get a hold of you. It's just merchandise. It's just very beautiful merchandise. But I think

what sets Palace apart is that we're more fashion oriented than the other costume companies. Some people specialize in uniforms, but we're more fashion focused. I mean, anybody can buy old clothes.

MH: Would you say that you are protective of the garments?

LR: I think it's just, it's a very labor-intensive business, and that's really what the problem is. Every time a piece gets worn or used, usually there's a seam to sew or a button to sew back on. It's a high-maintenance business. It's very labor intensive. And I think that's what we do. We are very organized. It's clean. I mean, it's just how we do it.

MH: Do you and Melody buy pieces for the collection together?

LR: Yes, Melody and I, we're very similar. I know what she likes. And I know what she doesn't like too.

MH: Do you ever have to convince her to buy things that she doesn't care for?

LR: Sometimes. Yes, she doesn't like the gaudy '80s clothes at all, which I do. She doesn't like the large, oversized things. It was not her thing. She actually doesn't really care that much for a lot of '80s clothes.

MH: When you enter Palace Costume, one has to be let in. You are usually the person who admits them. Who is allowed to come into Palace Costume?

LR: Well, costume designers and their team. We have fashion designers come in. We have stylists come in who do music videos. They do commercials, photoshoots. I guess that's about it.

MH: And are there people who have been asked not to return?

LR: Yes, the ones who bounced a check and didn't pay. They don't get to come back. No, our customers are pretty respectful.

MH: If you had to pick an era, room, or rack, do you have a favorite?

LR: No, the only eras that I don't like are the last thirty years of fashion. That's the only time period I don't like. I find the last thirty years have been very boring in fashion, in my opinion. I don't like buying contemporary clothes. I don't really like buying anything that was made in the last thirty years.

MH: So, as a collector, you don't buy anything contemporary.

LR: Yes. I mean, there are designers we collect. Of course you collect Paul Smith, and of course you'd want something from Gucci, or you'd want something from YSL or LV. But what I think we should collect for our 2000 clothes is just strictly designer items. I don't think we should be collecting all this fast-fashion crap. But that's not my decision.

MH: So that's where you and Melody might differ?

LR: Yes, there's stuff that's cheaply made. If it sits on the hanger for twenty years, it'll go in the garbage. They have no hanger life. Usually, after you dry clean them once, they're dead. They're meant to be disposable clothes. And after they sit on the hanger for twenty years, I think they'll probably end up in the garbage. They're not quality fabrics, and they're not well made either.

MH: Do you have any favorite film, TV, or music videos that have pulled heavily from Palace?

LR: My favorite films are older. Probably *The Women* is my favorite film, and *Imitation of Life*. Those are probably my two favorite films.

MH: And did you ever think about being a costume designer?

LR: Maybe at one time I did, but that was a long time. I mean, when you're in your twenties . . . Yes, maybe at one time I did, but that was a long time ago. I like working here.

MH: Can you tell a lot about a designer from their pulls?

LR: They're all different. Everybody has their own MO. It's interesting to watch them, the really good ones. Like I see Mark Bridges. He'll pull one shirt, one pair of pants, and it works. Other people have to look at a shirt for thirty minutes to decide. Somebody like Mark will make that decision in two seconds. It's just that quick. They all have their own styles, which is interesting as you get to know them. They all have a different way of pulling. Some designers never come in here, which I find surprising. They just send their team here. And then other designers want to put their hands on every single costume.

MH: You have talked about costume designers using historically inaccurate elements in the clothing.

LR: Well, the good ones don't make mistakes. But you see mistakes being made, and then I say, "It hurts your eyes." It's like in *Gunsmoke* you'll see Miss Kitty with a zipper at the back of her dress, but it was a different time. Sometimes you don't have the budget to do it perfectly. And then sometimes, if you're on location, you really have to work with what you have. You don't always have the luxury of running into a costume shop to pick another garment. It's always better when the production shoots in town. It's harder on location.

MH: Is there one home or one collection that particularly struck you?

LR: There was one estate in Prescott, Ontario, in Canada. It belonged to three sisters, and they never wore the same thing twice, and they never wore black. They weren't allowed to wear jewelry either, for some reason, so they had very ornate clothes. Don't ask me why. And then during the Depression, this family, they started buying up department stores, and they just had this huge house, and they just filled it up. There were mounds and mounds of clothes. By the time I saw the house, it had been pretty much cleaned out, but there was one room where you couldn't see the furniture. It was filled with clothes. The window had broken, so some vines had grown in the house, and all these beautiful garments were rotting. I'm telling you, there were stacks of dresses so high that you couldn't even see the furniture. Most of it had never been used.

LR: I would go up there about a couple of times a year. This went on for a few years. I would go up there, and then we would box the stuff up, and we would drive over the St. Lawrence Seaway to New York and then UPS it back. Pretty much the whole '30s room was all from there. It was a great collection. Plus, because it was not worn, it was all unused. That was the big secret of it there.

They had great taste. And they all had tiny little feet. All those shoes in Melody's apartment upstairs, those were all from them.

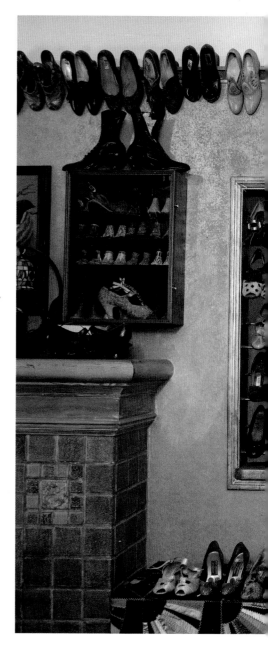

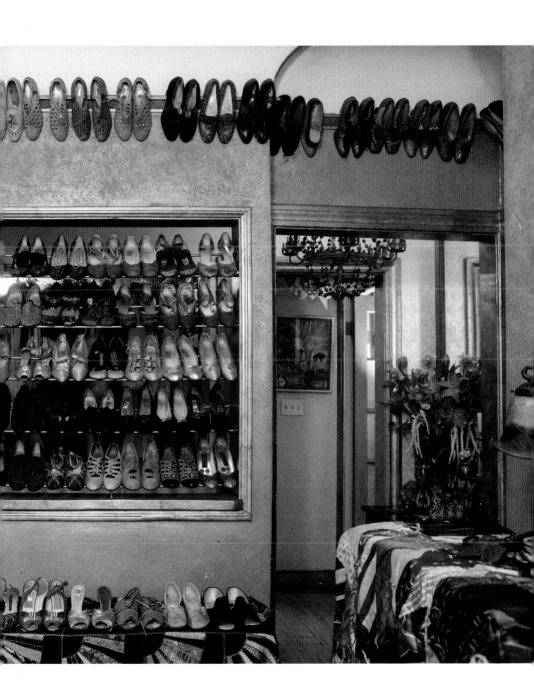

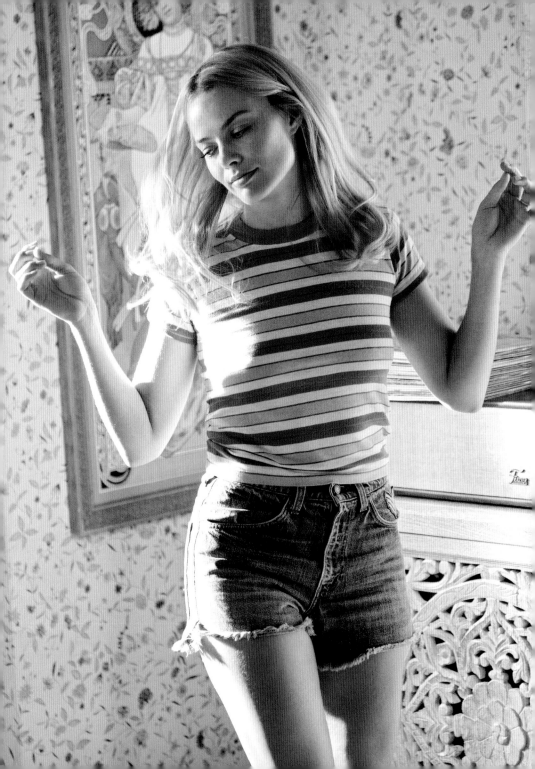

ARIANNE PHILLIPS

Arianne Phillips is a three-time Academy Award–nominated costume designer for her work on Walk the Line (2005), W.E. (2011),and Once Upon a Time in Hollywood (2019). She also received a BAFTA nomination for A Single Man (2009) and Once Upon a Time in Hollywood (2019), as well as a Tony nomination for Hedwig and the Angry Inch (2001). She has worked with Madonna for the past two decades on photo shoots, music videos, and on costumes for six world tours. She has also collaborated on fashion films with Prada and Gucci.

MH: What is so unique about Palace Costume?

AP: There are all kinds of costume houses, and some have closed, and some have opened. So, what Palace does is unique. Melody is unique. Palace is a reflection of Melody's aesthetic. Melody has a very elevated eye and a discerning eye, so if you think of Palace as a time capsule, twentieth century, I think that it would represent, aesthetically, the best versions of most archetypes. It is like cultural anthropology because it's such a cross section.

I think what is unique about Palace is specifically Melody and Lee's eyes and Melody's passion for collecting. I mean, you can see it because there are living quarters mixed in with the lingerie room, there's an apartment up there, and there's kind of no clear dividing line between Melody's aesthetic, her work, and her private life. There's that passion, that dedication. What you're getting is so unique. You're getting Melody's curation and what she finds to be valuable. I appreciate her aesthetic and her discerning eye and just her. What she's chosen to keep and to have in the costume house is her curation. It's her point of view.

MH: Can you recall the first time you visited Palace Costume?

AP: So, I think I first came to Palace in the late '80s, at the beginning of my career, when I was living in New York. Most costume houses are physically overwhelming. They're big warehouses

out in the suburbs, or at film studios. The thing that I liked about Palace then, and I still like today, is the accessibility and the way that it's this kind of ramble of buildings and garages and pockets. As she's expanded along the way, it does feel like a delicious treasure trove, and you can kind of burrow in there like I do if I'm looking for something.

It's a massive experience, as opposed to a lot of these costume houses, which are like warehouses. They are great too, but I can put my headphones on and go to Palace and really kind of be immersed in it in a different way. I just enjoy the physical experience of being there. And I just love the

Once Upon a Time in Hollywood, 2019, Margot Robbie, following pages: Brad Pitt. Andrew Cooper/© Columbia Pictures/Courtesy Everett Collection.

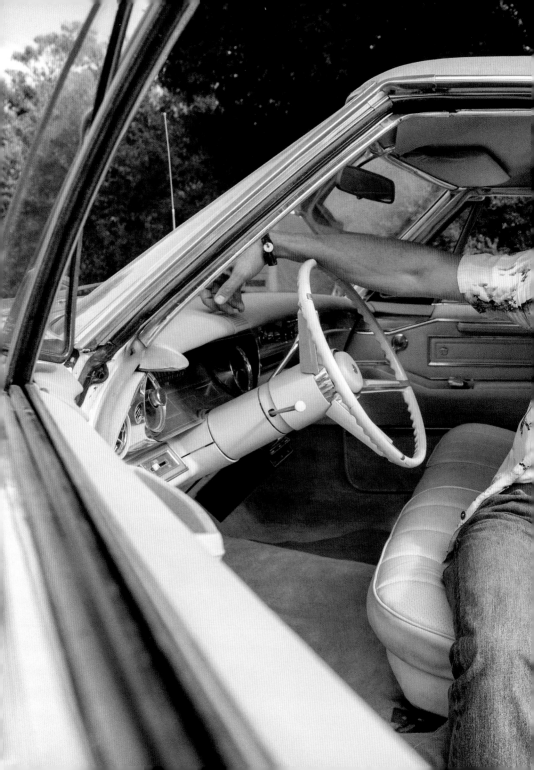

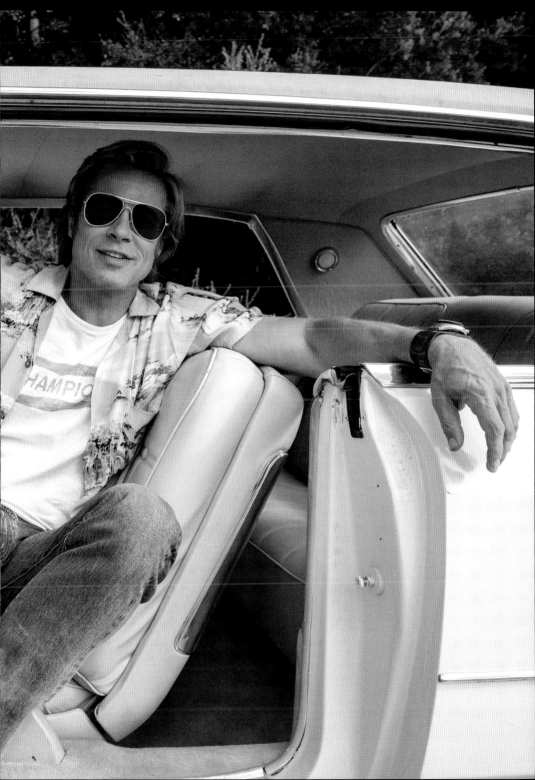

There are so many pieces at Palace that have a resonance in pop culture, things that people would recognize out of context from great films. I did *Once Upon a Time in Holly*wood, and Brad Pitt's yellow Hawaiian shirt was something I ended up making, but it was inspired by a piece that I found at Palace. So, the original, that original shirt, for instance, was my starting point.

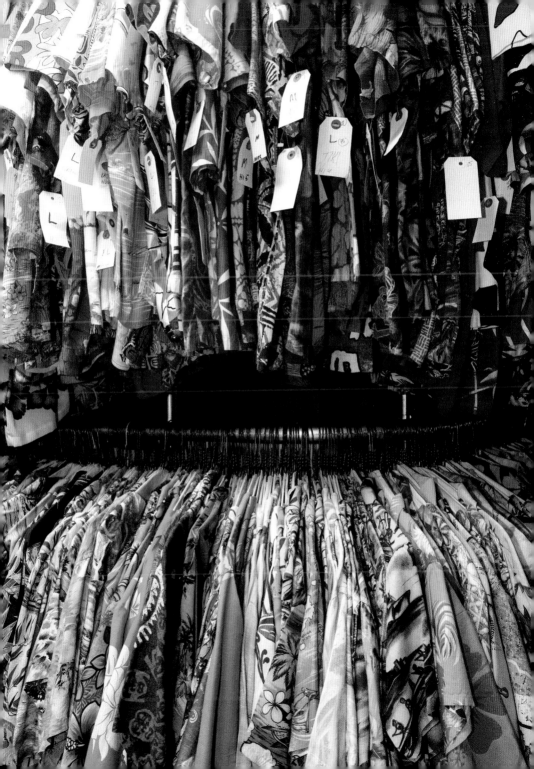

meanderings of Melody's personal expression and passion. I feel like I'm in her home, and I feel like I'm going to find something, discover something.

Melody also has an unexpected eye. Her accessories are stellar, as are her regional pieces. She doesn't have a lot of any one thing compared to the big, huge costume houses, but what she does have is notable. I have always kind of gone to her to focus on my up-front principal characters, whether it's for inspiration or literally to put them in a film. I kind of always start there because it gives me direction and really helps me to kind of understand the period. And over the years I've revisited certain periods in my work. I've done quite a bit of mid-century films, films set in the '60s and the '70s, so I've gotten to know Melody's collection of that period very well.

There are always gems that you may have overlooked or may not be appropriate for a previous project you did in that period or . . . I'll remember, "Oh yeah, that piece I couldn't use in that film will be perfect for this one." I think also, I grew up as a costume designer leaning into Melody's collection.

My goal was to work in character-driven films, so my first kind of grown-up, character-driven film, which was a huge coup for me, and I was definitely in a state of fear about it, because it seemed like such a big intimidating challenge, was in 1995, *The People vs. Larry Flynt*. The film spanned quite a broad spectrum, from the beginning of the film set in the '30s and then a flashback period visiting Larry Flynt's early life. And then the bulk of the movie is set in the '70s and the '80s. There were so many costume changes with the characters, and I didn't have the time nor the resources to build everything.

Even if I am going to build most of my costumes, I will always start at the costume house for inspiration. I actually hold a lot of value in hunting and gathering pieces, original pieces, because it's impossible to recreate those fabrics or the nuances of clothes that are made at a certain time. So, regardless, I'll go to a costume house.

But, for *The People vs. Larry Flynt*, my lead characters had forty to fifty changes. So, it was daunting, to say the least. I hadn't done a movie of that scale at that time. I had started as a fashion stylist working on music videos and fashion shoots and stuff like that. I think I first went to Palace Costume in the late '80s when I started out, and I was working with Lenny Kravitz. And his whole vibe that we were doing when his record came out was this kind of retro '70s thing. And you could actually find those clothes easier in vintage stores, and not even curated, you could even sometimes at the Goodwill, but there weren't always great pieces.

So, I started my "self-education" at Palace Costume, going through the '60s and '70s clothes in the late '80s. As someone who was born in the '60s and raised in the '70s, there are times when I've come across a piece at Palace that I remember, that looked like something my mom wore, or I'll find something that inspires these kinds of visceral reactions in me. I've had that a few times at costume houses or at a thrift store, which is wonderful. My interest was in the '60s and '70s, specifically for Lenny, and then I worked with a French artist named Vanessa Paradis in the early '90s. She was going for a very kind of retro '60s, like Mary Quant meets Françoise Hardy kind of thing. So, that always led me to Palace.

So, Palace is kind of like one-stop inspiration. And then, just back to *Larry Flynt*. There are pieces that I used on that film that are still there today that I see hanging. Like notable pieces that made camera on principles. And I love that the pieces can live on and live for other designers in other ways. I mean, at first, I remember thinking it was an awkward thing, like, "Oh, I used that dress on Courtney Love in *The People vs. Larry Flynt*," and now someone else can wear it. But then, it's like a warm and fuzzy old friend that you can see there.

I am also really grateful to Melody and Lee for how

supportive they've been of me. I've brought big projects to them and a lot of small projects too. And they've always found a way to make it work for me and be really supportive. And they've come to screenings of my films, and they are intrinsically a part of the community. And they have been a non-union costume house, which made them a little more, in a way, egalitarian, because people really use them for everything, from photoshoots to commercials to print work. So, they have been used as a resource beyond film.

And they have a very diverse and expansive clientele. I know a lot of fashion designers send their teams there, and it is an institution at this point. And yet, Melody is constantly expanding and bringing new pieces, so I'm always surprised. There was a time when Melody's mom worked at Palace, and I loved seeing her there. She made dresses and did a lot of alterations. She was a very, very sweet woman.

And I've made a lot of friends who've worked there over the years. There's a certain kind of person that Melody has working there. They just have a lot of loyalty. I feel very comfortable and at home there, and Melody has always been so accessible and interested in the work that I've done or that I'm doing at the time. It's always been clear to me that ultimately my relationship with Palace Costume far outlives any director or artist or anyone that I may have had an ongoing or long-term relationship with. My longest-term relationship is actually with Palace. There's a consistency there that I can depend on. And it's a resource.

At this point, it's like a precious museum that we get to be a part of. It's a living, growing place. I think my concern is that . . . I don't know if it's a concern, I just . . . I hope she doesn't outgrow . . . I'm sure she's outgrown this space already.

MH: Can you talk about Melody's personal style?

AP: She's folksy. I love that about Melody, and she's in her overalls, and she's personally got

great style herself. She's of a generation that is very familial to me. I grew up in a family of women who, aesthetically, were very much like Melody. This kind of going to the Rose Bowl Flea Market, thrifting as an aesthetic. It's an appreciation just for the quality of the way things are made.

It's different with collectors in general, who usually are very uptight about, like, if you ever go to one of those shows like the Pickwick or the different vintage shows, and sometimes collectors, it's like they don't wanna part with their pieces. I mean everything feels like she handpicked it herself, and it must be a wonderful feeling to see. She really has supported such a vast community globally. They ship stuff all over the world. They have a huge part of who I am as a designer and who I've become. It's like being able to lean into the collection that is Palace as, always, a starting point for me when I might not even know where I'm starting on a movie. And I have friends who come from Europe, costume designer friends, to pull up to Palace just to get immersed in a period and see the collection.

The truth is that most clothing from the early twentieth century is starting to rot. And when I started out, and I've done a lot of films set in the '50s, it was pretty easy to find them at costume houses. And now it's more challenging. You find more reproductions, because clothing rots, and these are not particularly temperature-controlled environments. You have people touching things. There is part of our mid-century history that is slowly decaying. While it's like a living, breathing museum, it's a resource and an archive that we are not precious about. I mean, we are, we take care of everything, but people are working with this type of archive in actual museums.

It's going on bodies, on actors, and they're sweating, and they have perfumes on their body or whatever. So, like a film I did last year, *Don't Worry Darling*, which [was] set in the late '50s, early '60s, across the board at all costume houses, those clothes, the condition is deteriorating everywhere.

And I mean, I've talked about it with Lee and with everyone. It's just harder to find, just like it was when I started out with '30s and '20s dresses that just deteriorate after a while. The fabrics and the textiles are deteriorating. So, things are changing with time. And it just shows how fragile textiles are over time, for sure. For *Don't Worry Darling*, I did pull most of my base costumes. I made a lot, but I pulled a really big stock from Palace.

Palace is a reflection of Melody. So, it's reliable. I know that there are certain things that are there that I can rely on and depend on and discover. I mean, I constantly find things. I go back to pieces. I know the collection, I think, *pretty* well. I mean, I'm always surprised because nothing's there 100 percent of the time because so many people are renting, so you always find things that you didn't see before.

There are certain things that I know she has that other people don't have. She also has a lot of fashionable clothes from the twentieth century [that] were in fashion but not necessarily designer. She has some of that too. She has a really good mix socioeconomically of what someone would wear. I definitely go to Palace for inspiration and to kind of immerse myself in a period, and then I go out and figure out where else I'm going to work.

To me, the thing that makes Palace notable is Melody and her curation. I've always thought that. The first time I stepped foot in there, I was just blown away by the pieces, by the organization, by Melody herself, and Lee. It's clearly Melody's collection, Melody's curation, Melody's story. You can see what her passion is based on the things she has chosen.

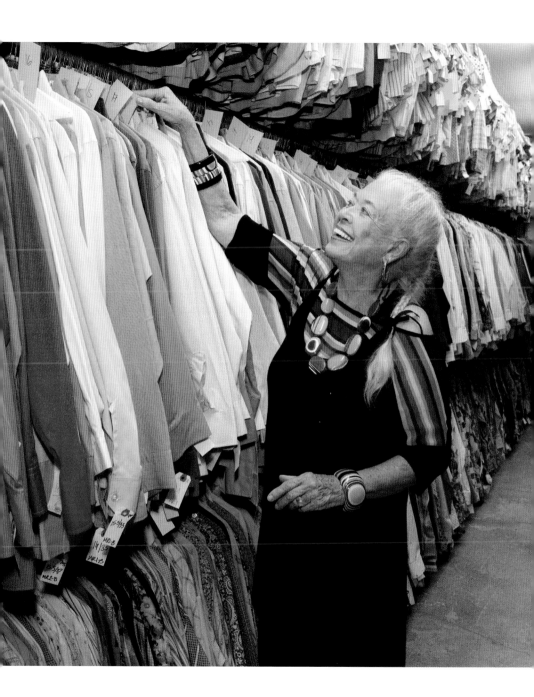

51

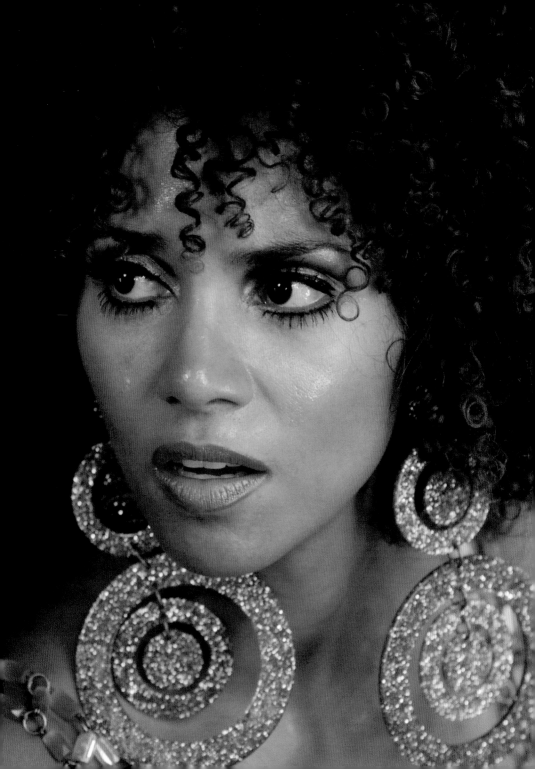

RUTH E. CARTER

Ruth E. Carter is a four-time Academy Award–nominated costume designer for film and television. She has won the Oscar two times for her work on Black Panther *(2018) and* Black Panther: Wakanda Forever *(2022), making her the first Black person to win an Oscar in costume design and the first Black woman to win two Oscars in any category. Her additional film credits include* Do The Right Thing *(1989),* Mo' Better Blues *(1990),* Malcolm X *(1992),* Amistad *(1997),* Frankie and Alice *(2010), and* Selma *(2014).*

MH: Do you recall the first time you walked into Palace Costume, and what were your impressions?

RC: I don't remember the exact project that I was on the first time I walked into Palace Costume, but I do remember some of the first projects that I came in here to work on. One was, *What's Love Got to Do with It*, Tina Turner's life story. I just remember this being a place, like a big crayon box. I mean that it was intriguing. It was exciting to walk in because you saw all the vintage clothes that were just surrounding you. It's different here than it is in other costume collections, like Western or American, where they have tall ceilings and wide aisles. Walking into Palace has always felt like you were walking into Melody's home. Even though her apartment is located in a different area, it all cycles around her aesthetic. And she curated this collection, and it shows like her, Melody, through this collection. And so, when you meet her, you feel like you know her. And that's how I felt, pulling the costumes in here.

It's an experience. So, I remember just being in here, taking my time. There's research and asking questions on where things were. This was before she expanded, so it was really small, and I didn't feel like I was in a corporate business. I felt like I was in someone's home, and that's what kept me coming back here. Not only was the collection so outstanding, there was so much motivation in how she put these, like, picture boxes together all around. She curated these looks from different eras, or sometimes it was just a combination of colors or textures, and everything was beautifully

organized, and it was easy to pull out what you were looking for. And it's curated again and again and again. There's a little bit of everything. So, I really felt that I was someplace that I could work, that I could be creative in.

MH: Do you have any pieces that have made you stop in your tracks, or any of your favorite pieces here?

RC: I remember I did Halle Berry, *Frankie and Alice*. I found these incredible earrings that were like giant loops that were Lucite and gold flex all through the clear Lucite. And they were big, round discs. They're incredible. And Halle Berry wears them in the film, and I remember just really loving it. It opens the film, you see her face, and you see these big, giant earrings, and that really wasn't a period film, but you could come in here and use elements of period pieces in a modern film, and it really does give the character much more interest.

MH: You talk a lot about the research of art and costume that goes into your process. How does Palace Costume help with the research that you do for your films?

RC: Well, there's a wonderful collection here, and it's nice that she gives you access to some rare books, fashion books, art books, and you're surrounded by that. The clothes are explained in the research. And so, it's a place where you can actually build your film and actually go nowhere else because, once you finish at the women's side or the men's side, you can switch off and go to the opposite side and find all of your characters, find the details. It just runs

Frankie & Alice, Halle Berry, 2010. Sergei Bachlakov/©Freestyle Releasing/Courtesy Everett Collection.

the gamut. So, I felt like I was a kid in a candy store here at Palace, and Melody was always very nice and pleasant when you saw her. She's interested in what you're doing and encouraging. I feel like this was the place that I found not only the research to be accessible but the advice from the staff that was very much aware of their collection. So, if you were looking for something specific, you could ask them a question, and they would direct you to where there was something that you were talking about. So, I really did love that about this; pulling here, you're amongst friends.

MH: Can you talk about the difference between looking at a book versus being able to touch the garments and having the tactile element accessible to you? Do you turn things inside out, looking at stitching and details?

RC: Well, yes. I do an anthropological view of the costumes sometimes just to see, basically, how they're made. That's interesting to me as well. But for the most part you find that there are some original pieces that you can look at. You can look at the fabric and the color and the texture and understand the period. There are also remakes that you can find that actually will fit modern bodies. And you know that Melody has taken her time in selecting what types of remakes she would have in her collection. And so, you trust that it's going to work. And from a scholastic point of view, it's interesting to look at where the seams fall in a 1920s garment or how the shoulder is constructed in a men's suit from the '40s to the '50s. But mostly, when you come through here and you're on a film, you're really trying to collect volume and you're trying to put a collection together.

So, I wish this process was a lot slower. But I think a lot of the things that you discover about the items that you have once you get them back to your studio is that Palace Costume will have some pretty incredible pieces that will stand out. Most of the time you don't want them to be incredibly delicate or handsewn to the point where they're easily damaged. And when we find something like

that, something that's really precious, we alert them and send it back. We'll use it as a prototype, make one from it, so that it stays here to be available for students or whomever wants to really study a good period garment. It's sometimes not worth putting it on a body that sweats. Perfumes and oils from the skin will ruin it. So, some things like that we do bite the bullet and say, give it back. But first we'll rub a pattern off of it and study the fabric and try to replicate it.

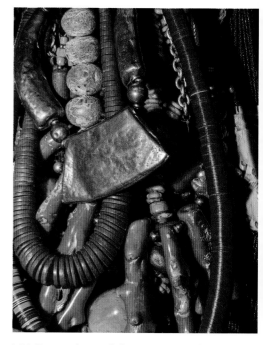

MH: I'm wondering if there is a particular room that resonates more with you?

RC: Oh, it depends on the project. I remember from *What's Love Got to Do with It*, I was in the '60s rooms, and all the colors felt like the '60s. I've done every era in here, and I've been fascinated by just how each room is so lovingly put together, and I just can't imagine doing it because every inch of this building has something to inspire you. So, you go into the lingerie room, and you're just overwhelmed with lingerie of different eras. And once you do your

research and you start really seeing it in person, it's wonderful to see that she has collected such great pieces. There's the '20s room. I remember going in there for things. I have been in every aspect. I've been in the cultural room where her jewelry collection and her cultural collection lives. I feel like she was on a safari somewhere and just collected a bunch of stuff and came home with it. I mean, it's incredible what she has collected over these years.

MH: So, you become immersed in whatever the era is of the film that you are working on?

RC: Yeah, and it's wonderful to go into a room where she's curated the '40s or she's curated all the children's stuff. It's all playful up there. It's a fantastic playhouse for costume designers.

MH: Color and color palettes come into play so much in your work. Can you talk about the way that color comes into play in the organization of the Palace inventory?

RC: Oh, yeah. It's like you're immersed in a paint box here, and it's very evident from the moment you walk in that you'll be able to pull a collection together that not only is authentic to the period you're looking for but also has the hues and the tone that you're looking for. Or even if you don't know what you're trying to achieve with the color palette, it starts to reveal itself to you here. And that's the other thing that's super helpful here at Palace because Melody understands texture and color, and she has several examples throughout the building of ways to combine beautiful fabrics with items and accessories. And so, it's not unlike a person to come here and just really discover their film. You go up to the very top floor where there's the 1830s, and you start understanding the weight of the wool and the deepness of the navies. And then you're down in the '60s and you start seeing all the vibrancy of the '60s. And you find the Mondrian-type of '60s and the hippie side. There's several versions of the '60s that can be discovered here. And as you pull, you just start to see what you're looking for, and it makes it really easy.

MH: And can you talk about what makes Palace Costume unique among the many costume shops?

RC: I've been in many collections and many outstanding collections, from New York to here in Los Angeles, to London, to Italy and Africa. Everybody collects differently. There are the great, big costume houses that have a huge staff and rails, and there is a style to that. Some of them are pretty massive. But the collections that I've been to around the world that are like Melody's . . . some of them you walk into, and you think, "Oh, God, like, let me put my hair net on and my gloves because this is going to be a dig!" And you know that they have gorgeous things. They just don't have the organizational style that is here at Palace. So, when you come into Palace, you know that you're going to have a lovely experience because everything is just well manicured here.

RC: And they know their stock. It's not like they just have a bunch of boxes around and they want you to dig through the bottom of the box. I mean,

there are collectors. There's one in Massachusetts, and it's amazing, but it's dusty. It's piles on top of piles. They don't have the staff to keep it up. And so here, it's not like any other place I've been. You can even just be in here studying how things were made or how embroidery was done, or how the workmanship of the different shapes and silhouettes came together for that period. And it's lovely because you haven't spent an hour and a half discovering it, finding it. It's right there for you to see, and there are many to choose from. So that's what I think makes Palace really special. This is Melody's home. You're in her house, and because you're in her house, you kind of respect it in a different way. You always respect the place you're working at, but here, you really do feel like you're in her home. Yeah. When you say, we're sitting in her living room, I'm like, yeah, there's the TV. This is her living room.

MH: Can you talk about the act or art of collecting?

RC: It does define you. Like I said, when I come in here, I feel like I know Melody even before I meet her. And I think if you were to walk through my house, you might say the same thing. You see what my interests are. I think the pieces that you collect, they are under your care. They were under someone else's care if they are vintage, and it's passed to you, for you to love and care for. And I think that's what makes collectors important to the regeneration of our art and our legacies and our ability to recreate, because collectors have valued the past and have valued these things and have pulled together and honored them so that other people can also enjoy them and collect them and share them. So, it's definitely a process of sharing the past and recreating art.

MH: I know you are such a storyteller, and objects can be such storytellers as well.

RC: Yeah. And you look at objects in that way, what story they are telling. And vintage clothing is especially notable for that because they were conceived by someone you've never met, and then you reconceive them to fit within the story that you are telling. So, it's really kind of like a spiritual journey.

MH: Are you a collector of clothing as well?

RC: I do have a collection of costumes from my films. Early on, I did the movie *Summer of Sam*, and the producers said, "Hey, do you want the clothes? We don't have anything to do with them." And I said, "Yeah." I took them all. And then I started to realize that I had pieces from other films that I'd done, and I continued to collect every time I did a film, and I looked up and I had a collection, and then I had an exhibition. So, we curated an exhibition, and we remade some things, and now it's a traveling exhibition, and it has seventy costumes from different films. It's five thousand square feet. It was after *Black Panther* when I started thinking that the costumes from that film shouldn't die in a closet somewhere or be in a collection hidden by muslin. I wanted people to continue to enjoy that film because it had made such an impact.

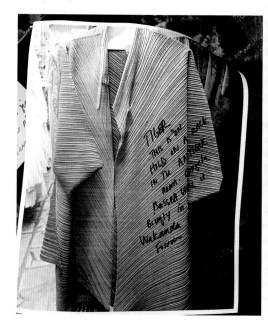

MH: There are the vignettes set up around Palace Costume that help to set a tone, and if you could [discuss], just kind of as a costume designer, how those can inspire or set a tone for you walking through.

RC: Usually, at the front where you check in, there are displays there where the stuff is beautifully curated and, as they are writing up your order, you can actually look and really learn from a period. It's amazing. And I've always just stared. Just stared at those window displays. And you know, what you think you might know about a period you learn even more because you see it in repetition, or you see variations that you didn't realize. You see everything from the more serious to the fanciful to the playful, and you actually see the range of . . . this one style of garment. You see the trend of it; you see how it's played out in the same type of fabric in other iterations of it.

So, it's amazing how she has this collection, and probably she's pulling things out that she thinks that people may have not seen or not appreciated. So, she's actually helping you to appreciate what's here, by doing that. And the fact that she's here with them, I'm sure she goes, "This shoe is going to live here," or, "This item is going to have a new life when I do this display." You know, and she's able to sort of take her time and find all of those little bits and pieces. Yeah, it's a great life.

MH: You've talked about being given a key to the costume shop at your university in your theater department. Can you talk about the act of being transported and transformed through a clothing collection?

RC: Being a costume designer doesn't necessarily mean that you are creating a garment. It really does speak to humanity and how you see it and how it plays out for you in the confines of a story. You know, it answers all the questions of why a person wears what they wear. What effect what they're wearing has on other people—how and what they represent. The clothing and the transformative

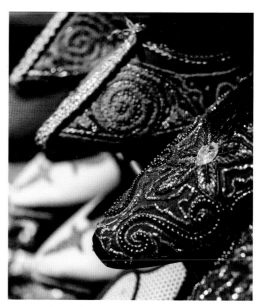

nature of a collection of costumes on individuals makes up a world or a society. And that's in the hands of a costume designer, which I think comes with a lot of thought, a lot of research, a lot of collaboration, and is the magic of what we do.

I think you have a lot to communicate, and being in a fitting with an actor or looking at background on set as a whole, after you've made your choices about color and all of that, you're still defining it because you know it best, and you've made this commitment to it. So, yeah. I think that there is that magic that happens when you turn the key or you come into a place like Palace that lets you know that you are the orchestrator and that the music is about to start. And sometimes it's a long road to discovering how to make each thing work with the others involved in that collaboration, and you do need the actors. You do need the texture of the people. You do need the atmosphere. You do need the background. So, all of that has to play in your mind as you select the pieces that you want to be a part of it. So, yeah, that's the transformation for me.

SANDY POWELL

Sandy Powell is a fifteen-time Academy Award–nominated British costume designer, making her the most nominated costume designer in Oscar history next to the legendary Edith Head. She has won the Oscar three times for her work on Shakespeare in Love (1998), The Aviator (2004), and The Young Victoria (2009). She has also won three BAFTA Awards and two Costume Designers Guild Awards. Her film credits include Orlando (1992), Far from Heaven (2002), Gangs of New York (2002), The Favourite (2018), Mary Poppins Returns (2018), Carol (2015), and The Glorias (2020).

MIMI HADDON: Do you remember what production first brought you to Palace Costume?

SANDY POWELL: I thought you'd ask that. I thought that would be the first question. The one that I can remember is *Far from Heaven*. In 2001, wasn't it? Well, and it was very strange because *Far from Heaven* was based in New York, and I had flown out on the 10th of September, the day before 9/11, from New York.

I'd flown to LA for a few days to pull costumes for *Far from Heaven*. I woke up the next morning, having arrived, put the TV on, and 9/11 was happening.

I ended up staying here for three weeks. I mean, I think I ended up being stuck because they grounded all the flights. The airports were all shut down. And I was here for three weeks, and I spent most of that time in Palace. So, really, that's my burning memory. That's certainly the longest amount of time I spent sort of consecutively. And we just had to get on and carry on working. There was nothing else for me to do. I was stuck here. We didn't know whether the film was going to go ahead or not. But I thought, well, we might as well be doing something. So, we spent a lot of that time at Palace.

MH: So, was it nice to be able to immerse yourself in that space during that time of uncertainty?

SP: Yes, it was. Well, it was so bizarre, especially for me. I hadn't really been in the country very long, and of course nobody knew what was going on. I mean, *no one* knew what was going on. I was thinking, "Am I ever going to get out of LA? Am I ever going to be able to leave the country again?" We really didn't know what was happening at all. So it was, "Okay, I'm going to do what I know how to do." Which is to carry on working. And looking at clothes, looking at costumes. So that's what I was doing in Palace, and that's my earliest memory.

MH: You've been to costume houses all over the world. What makes Palace Costume so different from other costume shops?

SP: When I think about Palace, what I like is the scale, because it's not massive. It's not like a warehouse filled with stuff. It's contained, it's small, and it's packed full of stuff. There is a lot of stuff in it, but I sort of quite like the way that it's a manageable size. And actually, when I think of Palace, I think of color. I actually think of it as being very colorful. But maybe that's because of the sections I've been in or spent a lot of my time in. I mean, going back to *Far from Heaven*, when we were looking at '50s, it was sort of set in the fall. I did *The Glorias* there recently, which was set in the '60s and '70s, so I've used it a lot for that sort of '50s, '60s, '70s period.

And then *The Irishman* as well. But I like the fact that it's small, and you don't feel overwhelmed. And it's not one of those costume houses where the minute I'm in it I feel like I want to get out. Sometimes you just feel overwhelmed and you just need to leave the building.

Following pages: *Carol*, from left: Rooney Mara, Cate Blanchett, 2015. Wilson Webb/©Weinstein Company/ Courtesy Everett Collection.

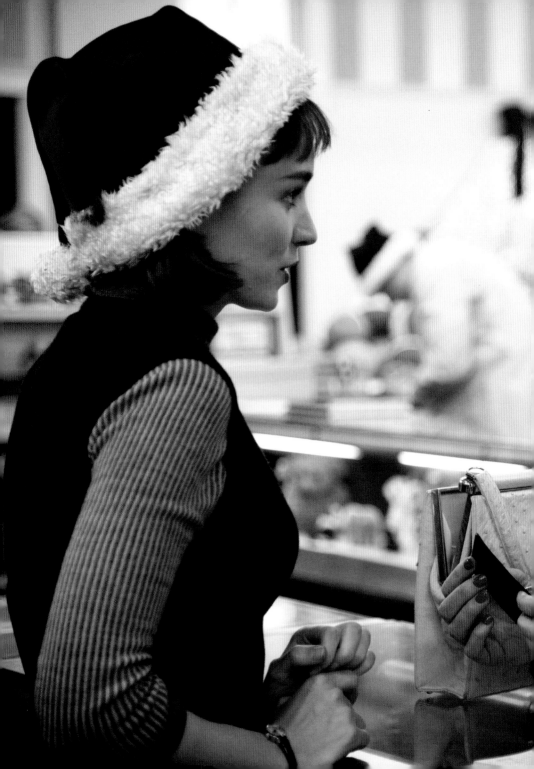

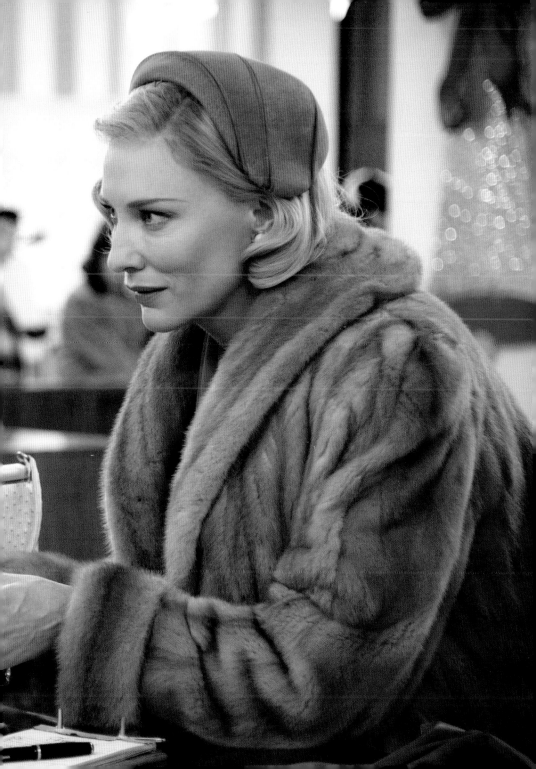

MH: You created lush textile landscapes in the film *Carol*. Did you pull from Palace for that production?

SP: Oh, yeah. Yeah, *Carol* was definitely a Palace job. *Carol* was, of course, one of those incredibly very low-budget films for the scale of it. For what we had to achieve. We actually had a fairly small core group of extras, and it was the same people that we kept redressing to be different people in different scenes. And I do remember that we couldn't have done that without Palace actually giving us an extraordinarily good deal. I do remember striking a very good deal with them. And so, yeah, we did pull a huge amount of stock. I mean, most of it was from Palace. There were things from New York as well for principals, but we couldn't afford New York prices for crowd. So, Palace would've been used for crowd. For sure. And I remember pulling that myself with Christopher Peterson. We worked on that together.

MH: As a storyteller who uses clothing as a medium, can you talk about finding that perfect piece for an actor?

SP: Yeah. I mean, that's the bit about the job I like, and that's what I like about costume houses. And I mean, for example, now this isn't Palace, but for example, I was in Angels, and there was a pile of knitwear just on the floor in a corner, fallen out of a box, and you know how a lot of these places are: there's stuff everywhere. It's quite hard to maintain and keep everything perfect all the time. And I just found a piece of a ratty old knitwear little sweater that ended up being the primary costume for *Hugo*'s main character. And when you find that star piece that sets the tone for everything, it's your eureka moment. Like, this is it, I know how it's going to be now.

MH: Is that part of the magic that happens in costuming a film?

SP: Who knows? Yeah, exactly. Who knows? I mean when I meet an actor for the first time, I will have gone to a costume house and pulled a lot of

things within the world that we are thinking about, things that would sort of hopefully fit them, colors that I think will suit them. But I'll have a variety of different things to throw on them. It is mostly to eliminate, to say, "No, that doesn't work, that doesn't work, this works." It might be there's one piece or one element of a piece that works, and you think, "Okay, that's the direction we're going in." And you can't do that without a costume house. You couldn't go out and buy all of those things thinking I might not need it. It's just like a random selection of stuff. And it's actually a process of elimination.

MH: And to that, can you talk a little bit about doing your research in a costume house versus in a book or online or through paintings?

SP: Well, the research comes from everywhere. I mean you start with the books and the online and the paintings and the sort of academic side of it. Reading about it, looking at it. But the bit that I like, the bit that I really want to do, is get my hands on something real. I actually want to see items of clothing. That's when it happens for me. I mean, it's all very well looking at it on paper, but you want to see how it actually really works in 3D, and I want to feel it and touch it. So, in that sense, it's as important, but it's the bit that's the next stage; it's one step closer to actually coming up with the design.

MH: And do you yourself still have time to go in and get your hands on clothing and look through things?

SP: I always do. I always start the main pull myself with my assistants, but I always do. It's what I do at the very beginning. I wouldn't wait for people to bring me things at all, because they might be missing something. Somebody isn't going to notice something that I would notice, or somebody would think that something's irrelevant. Whereas, or maybe it is irrelevant, maybe it's not what I've asked someone to look for. But if I'm working on a period piece, I'm not satisfied until I've gone and

looked at every single item on the rails for that period. Yeah, I do. I actually do, because if I haven't done it, I'll always think that thing, that prize item might be there, and I've missed it. And someone else isn't going to know. I'm not saying I don't trust people or to have the same taste or to know what they're looking for. I mean, no one knows what's really in my head, or no one knows what might trigger off an idea.

MH: Like the sweater for *Hugo*.

SP: Yeah. I need to know that I've seen everything that there is. And then the first time, I mean, the very first time you look, you're very fussy. It's like, no, no, no, don't like that. And then you find, over the weeks, you go back, and there you see something that you didn't see the first time round, but then maybe that's because you've moved on. You've moved on, you've developed, you've understood the period a bit better, or you've understood the character a bit better, and you might come back to something you rejected earlier.

Or, whereas you thought they might not work at the beginning, now they might. Or it wasn't as bad as you first thought, or you have to start getting less fussy because you've got to get some clothes and you're running out of time.

MH: In my experience at Palace, I've overlooked certain rooms, and then later I'll go back and fall in love with that part of the collection.

SP: Yeah, exactly. You change, you fall in and out of love with things, don't you? You really do.

MH: Are you a collector yourself?

SP: A bit, yes, I am. I've had to sort of curb it a bit, because of space. No one has the space to store things. I mean, I love clothes, I've got lots of my own. Let's say you're in vintage markets or stores, or whatever it is. Or vintage fairs, which I love, which in this country are much better than in the UK. And I'm looking, let's say I'm looking for 1930s,

then I just see some fantastic 1950s thing and I think, "I'm going to have to buy that now because I'll need it one day." I mean, there are things that I just look at, and I think I'm going to have to get that because I'll use it somewhere one day. You do. But I try to keep it down because it's just . . . It's a bit of a burden having racks and racks and racks of clothes.

I'll tell you what I do have. I have lots of trim and fabrics that aren't easy to find. I do have boxes and boxes of things like that.

MH: How do you incorporate those into your work?

SP: Well, what happens is I usually, if I'm on a production where I am setting up a workroom and building a lot of the costumes, it takes a long time for the buyer to go out and start accumulating things. And it's great to have a stock of things that I like that we start with, and it's just something to play around with. Or sometimes it's, "Oh, I need a bit of blue ribbon. Well, let's get the blue trim box out," and it'll always be in there. But I know that everything in all of the crates I've got are things that I've chosen. So, I know that I like them.

MH: If you were to ever open a costume house yourself, what would your signature voice be?

SP: I can say it's too hard work. I don't think I'd actually open a costume house. I'd hope that somebody else would do it.

But if I was to *support* somebody else opening a costume house, what would it be? I mean, one of the things I really quite like doing is finding things that are literally falling apart. It's sad when you see things that are like hanging on a wire hanger, and they're just in shreds, some sort of gorgeous 1920s something that's in shreds. I would keep those to one side. You'd have a sort of section that is just not wearable but there for research, or for turning into other things, or for sort of recycling and using elements of it. I think that's very useful. Quite often

in these big places, they're all mixed in with the good things. But I don't know what my signature would be. I mean, maybe it would stick to a certain era or stick to a certain number of decades as opposed to everything.

MH: You've mentioned a distinction between vintage and antique clothing. Do you ever come across pieces at Palace or other rental houses that you think should be in a museum?

SP: Yeah, definitely. That goes back to what I was saying about when you find something hanging off a wire hanger. It shouldn't be there at all. It shouldn't be out for rental. It should be kept well in order for people to look at, or it should be in a museum. Definitely. I am always thrilled to find them. And I'm glad they're there because I want it. But I don't want anyone else to have it. And it shouldn't be rented out over and over again. All the time, you find things. I could easily go through and pull out all these things saying this really shouldn't be. Well, on one hand it's nice that it is, because I can use it. On the other hand, it really shouldn't be. But then that's going to happen more and more.

MH: It's a conundrum of sorts.

SP: I mean, you can think, "Oh, it should be in a museum," but museums don't have the space to display everything. So, if it's in a museum, it's going to be in a box somewhere. It's going to be wrapped in tissue paper and hidden away, and no one's going to know it's there. Whereas in a costume house, it's getting used, and it's getting a life, and it's getting enjoyed.

MH: That is the gift of these costume houses; they are offering these prized pieces to people who appreciate them in a very specific way.

SP: But what's going to happen is the real thing is going to disappear. If you were doing Edwardian or Victorian period, you can find original pieces, but no one fits them anymore because everybody's bodies have changed so much. Occasionally you

can find things, but they're becoming more and more obsolete. It will become as difficult to find '20s, '30s, '40s as it would be to find an eighteenth-century something in a costume house. They will all have worn away and disappeared. But they should be used. They should be re-worn and reused.

I suppose if they're couture pieces, they should be in a museum. But anything that's been mass-produced is different. There's plenty of 1940s clothes that have been mass-produced. It's not quite the same as when you suddenly find something with a label; then you think, my god, this should not be hanging up here. Occasionally you find those real treasures.

MH: Are there any other things you'd like to add about Palace Costume?

SP: Just that everybody's always so welcoming and friendly, and I quite like the way you're just left to get on with it. I like that. I like that you don't have to have a costumer with you who is watching over you the whole time or doing it for you. I like that freedom. I like to just come in and be left alone, and that's what you feel there.

Because there are other costume houses around the world where you have to have somebody with you. There's one of the Italian ones with racks that are like five high. And they say, "What are you looking for?" And then they send a man in overalls up a ladder to pull things out, and you have to go, "No. Yeah." And I just think, "Let me get up there. Let me do it. Let me look! Do you really know what I'm looking for?" Again, "I might see something that you don't." And that's so frustrating. And you're not allowed to actually touch things yourself. They have to do it for you. That's really frustrating. I just want to be left alone overnight. On my own!

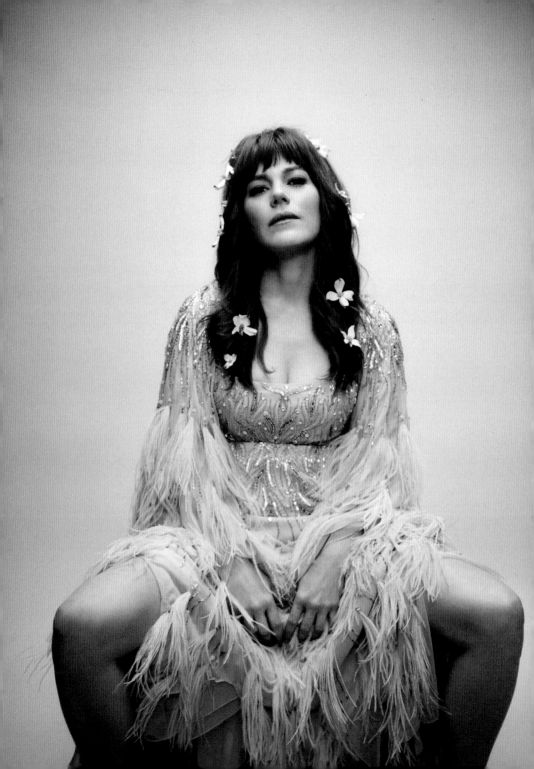

SHIRLEY KURATA

Shirley Kurata is a Los Angeles-based stylist and Academy Award-nominated costume designer for Everything Everywhere All at Once (2022). Her work has appeared in television, film, advertising campaigns, fashion editorials, on the runway, and on stage. She has worked with Autumn de Wilde, Rodarte, Kenzo, and Gucci, and on music videos for Beck, Pharrell, and A$AP Rocky. She is also the co-owner of lifestyle boutique Virgil Normal.

MH: How has Palace Costume influenced your work?

SK: Palace has influenced my work in so many ways, just seeing the different patterns, fabrics, the colors, treatments. A lot of it is stuff that you can't find anymore. Even if you're not doing a period piece, you can still find something that could be very modern and current. Or it can even be a little detail that you might want to use on something for a piece that you're designing for today.

MH: Do you have a different approach to your pulls depending on if you are styling for a music video or editorial versus costume designing for a film or TV?

SK: Yes. I think they're definitely connected, but with film and TV, it's so much more character driven. And in other aspects where it's maybe more fashion related, it's about the clothing, right, that's the main star. It's really about how the clothes drape. So, within each world, it sort of varies as to how I put together the looks and everything. With actors, you have to make sure that that's what the character would wear. Additionally, you want something that the actor would be comfortable wearing. And then there's action within it too, so like, for example, I don't think that that computer chip vest piece that I pulled for Ke would have been used if he were doing a lot of stunts. There's no way I could have used it because I would have to have multiples made of that, right? But I knew that this was going to be a one-off scene, so that was fine. But yeah, there are a lot more variables involved in film and less so in terms of doing a fashion editorial or commercial music video because it's a much shorter time frame.

MH: You've worked a lot with Autumn de Wilde and other talented photographers/filmmakers who work with musicians. What role does Palace play in the art of music and painting those images?

SK: Yeah. Well, for example, I've dressed Jenny Lewis in so many costumes from here, and I think, especially with musicians, they can be sort of a chameleon too. In the music videos or on stage, they sometimes play other characters. So, Jenny

Jenny Lewis, photograph by Autumn de Wilde, styled by Shirley Kurata.

would be like, "Well, I'm doing a music telethon, so I just need some looks for that." And so, I could kind of maybe skew some of it to be a little bit more '70s, '80s. Then, other times, she's like, "I wanna be more like a Loretta Lynn from the late '60s or something." And so, for her, I was able to pull from here to fit the character that she wanted to portray. And so, it's been really fun doing that with her. But I've done that with other musicians and with Autumn. I think that musicians tend to be a little bit more adventurous and for the most part tend to love vintage a lot more too. So, I think that there's definitely appreciation for the amazing collection here. There are just pieces here that you would never find in the real world, modern day. So, it's definitely still an important resource for styling musicians.

MH: Do you see Palace differently as your career has evolved?

SK: No, I think that I still always consider Palace for every project I do. Not every project will have me coming here; sometimes it's present day. But, even for present-day things, I still come here to pull. It just depends on the job. But, for sure, Palace is always one of the first places I think about when I work on a project. Even if it's not a matter of using all the pieces but just as a source of inspiration in the initial period of getting ideas. Then, maybe I'll come back here to actually pull, based off of characters and stuff like that. So, yeah, I think for, like, *Everything Everywhere All at Once*, I didn't use a ton of costumes from here, but I did come here to see what there was that could work, and from there I got to use a couple pieces. One of them is in the costume section upstairs. It was worn for one of the Alphaverse scenes, which was supposed to be dystopian futuristic. I found a vest made out of computer chips. I had seen that, and I was like, "I wanna use this." So, Ke wore it. The sad thing is just there's so much quick editing, so there's a quick flash of it, but I think we have a pretty good photo of it. He's in the van. So, things like that, where I'll come here to see what I can use or be inspired by. That's sort of the initial design

process for me. It's just kind of observing what could possibly work and then creating the designs, and then doing fittings and everything.

MH: You obviously have a strong connection to film and narrative in your work. I was wondering if you've ever imagined the mannequins around Palace Costume as characters telling a story?

SK: Oh, yeah. I mean, you know, there's that *Twilight Zone* where the mannequins come to life? And sometimes, you know, I think that, like, when Palace is closed, they come to life and just start doing their own fashion shows.

MH: Tell me more about that because that is one of my favorite *Twilight Zone* episodes.

SK: It's so good. Because, yeah, the story was, like, a mannequin that doesn't realize that . . . well she comes to life but forgets that she was a mannequin, and she's walking around the department store, right, and she gets visited by some of the former mannequins, and she's wondering what's going on. And then she remembers that, oh yeah, they all had a chance to go out into the world and become human. But, like, I think the mannequins here would have amazing fashion shows. They would have a lot of fun trying on different things.

I do get spooked here. You know, especially going up to the children's room. I sometimes think, "Are there ghosts here?" But I never felt like—it's more like spooked in not a harmful or negative way. It's more like, you know, there are spirits here having fun maybe? You know, so spooked in that way, but not in an evil way.

MH: That's the way I see it. They're present but not menacing. But still, there's like . . .

SK: Something . . .

MH: You've said that you watched a lot of films and read a lot of books as a child. What were some of your favorite films growing up?

SK: Well, I'm a product of the '80s, so of course there were the John Hughes films, you know. So, like, Molly Ringwald and *Pretty in Pink* was a huge influence because she wasn't rich, so she thrifted a lot and still had a sense of fashion by wearing vintage and thrifting. So, that was super inspiring. Also, vintage clothing wasn't as big then as it is now. There were a few vintage stores, but hardly as much as what we see now. So, that was my first introduction into starting to go out to thrift stores and stuff and starting to wear vintage clothes. And I also had friends who had that style too, so we went to Orange because they had a bunch of vintage stores in that area, in Orange County. And just out of high school I worked at American Rag, and that had a lot of amazing vintage. I got into watching a lot of art films. My local library was actually really good, and they had a great selection of movies that you could rent. And so, I would rent those. I thought *A Room with a View* was so beautiful. I kind of went through a phase, like, "I kinda want to dress old-fashioned like that," you know, like I wore longer skirts and stuff and more buttoned up.

MH: Were you thinking of yourself as a character?

SK: Yeah, kind of. You know it was also very romantic too, so I think that spoke to me. Like those Merchant and Ivory films were always so beautiful. And then, of course, the French new wave was a huge influence. *Anna Karenina*, Godard films, and Jean Seberg in *Breathless*. So that was a huge influence, especially with that '60s new wave style.

MH: Do you ever wish they were in color?

SK: Yes. I mean the ones that were in color are amazing, so, yeah, those were influential. I really loved Wim Wenders films, David Lynch, and Jim Jarmusch.

MH: When was the last time you found a surprise at Palace? Do you remember what it was?

SK: It was just downstairs. There was a white sequin

jacket and matching skirt and had different color artwork on it, and I'd never seen that before. And it was just hanging on the end. I think sometimes they just pull out stuff and feature it, or maybe a stylist comes and is just about to pull it, and they just leave it there on the end. I've kind of gone through a lot of sequin stuff because those are fun to pull, especially for music videos, but I'd never seen that one before.

MH: Do you have your favorite room at Palace?

SK: It depends on the day. I really like downstairs, like the kind of more showgirl and theatrical room. I love the evening gowns and, of course, the '60s. And just because you see less of it, I kind of prefer the '20s and '30s era stuff, because it was just so beautiful. The prints and the embroidery are just exquisite.

MH: Do you have a collection yourself?

SK: I have a mini collection. If I say, "I'm collecting this," things can start to get out of hand. There are pieces that I like to buy for myself, like vintage Comme des Garçons or Courrèges, but I don't want to get the whole "collection" thing started because that could just be enormous. I would rather it be at a place like Palace, where it has more of an opportunity to be used and seen in an interesting way. Sometimes when you start a collection, you begin to shelter it from the world, unless you decide to donate it to a museum. But I'd rather not use too much of my personal time with a large collection.

MH: Do you think about the fact that you're allowed to touch all of these garments, which would be pristinely stored if they were in a museum?

SK: Yes, fashion is very tactile, and so it's nice to be able to actually feel the fabrics. I understand that some things are fragile, and so they need to be protected. But it's also nice to just have this as a library that you can be inspired from. I know a lot of fashion designers come here too, to pull for

inspiration, so it's kind of an important place for people to access.

MH: Do you usually look for standout pieces here to have on principal actors?

SK: Yes, but I do actually like pulling for extras too. It still is very exciting to dress someone who's just walking down the street and looks like he's straight out of a photo from the '50s. It doesn't always have to be something dazzling and sparkly. There are definitely statement pieces that are something I look out for. Especially for musicians or performers in a more contemporary setting. They can throw on a dress with feathers, tulle, and beaded embroidery and look amazing in it.

MH: Can you describe the point of view of the Palace collection?

SK: Well, the point of view is definitely a love and appreciation of vintage and the importance of preserving that, I think. And so, you can definitely see that, and you definitely see that in the way that they handle the clothes and try to keep the integrity of it. I think that's why it's closed to the public, right? I think you definitely see—I mean, you have to love vintage and clothing to rent from a place like this, and so that's definitely apparent. And I think that they also have a very refined eye because there are so many amazing, beautiful pieces. There's a lot of vintage out there, but there are some vintage garments that just deserve to be kept and cherished more than others. And I think that they understand what those pieces are.

MH: And they are still buying!

SK: Yeah. Well, we were just talking about the fact that it's pretty full in here, and space might be a little bit limiting. But the fact that they're still continually buying just shows their dedication and love to clothing and vintage clothing. So, I really respect them for that and am very grateful.

MH: Do you think about the personal histories of the garments?

SK: Yes, all the time. More like in the men's suits because they'll have the actor's name inside the suit. You don't see that so much with the women's wear, but when they have it, it's always exciting, because sometimes it's an actor that you recognize, and you're like, "Wow!"

I know they acquired a bunch of stuff from EC2, which was run by Bill Hargate, and he had designs from a lot of the variety show stuff from the '60s and '70s. When I did a music video for Jenny Lewis, the video was *Hee Haw* inspired, so I wanted to find something with a '70s western feel to it. I found a dress here and, apparently, do you know Tony Orlando and Dawn? Dawn were two of the backup singers. So, they would usually be matching. I think it was Lee who told me that these dresses were from that show, because they have doubles. So, there are some things where I know the history, but not a lot. I know there's stuff from *Austin Powers*, but it would be great to know the history of *all* of these pieces. Who wore it and what was going on. I'm sure most of these were non-showbiz pieces. They may have belonged to some wealthy lady before Melody and Lee picked them up from an estate sale. But it's always great to hear stories about the person who wore them.

MH: Anything else you want to add?

SK: I just hope Palace stays around for many, many years. We are really lucky, in LA, to have this place. I feel like LA really has some of the best costume houses. I think Palace is the best one. It's sort of this historical archive. You can see how the film industry is tied into fashion in LA too. I just hope it continues for many years.

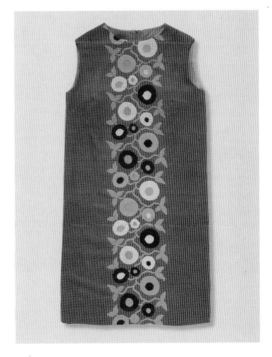

Following pages: *Austin Powers In Goldmember*,
Mike Myers, 2002. Costume Designer: Deena Appel.
New Line Cinema. Courtesy Everett Collection.

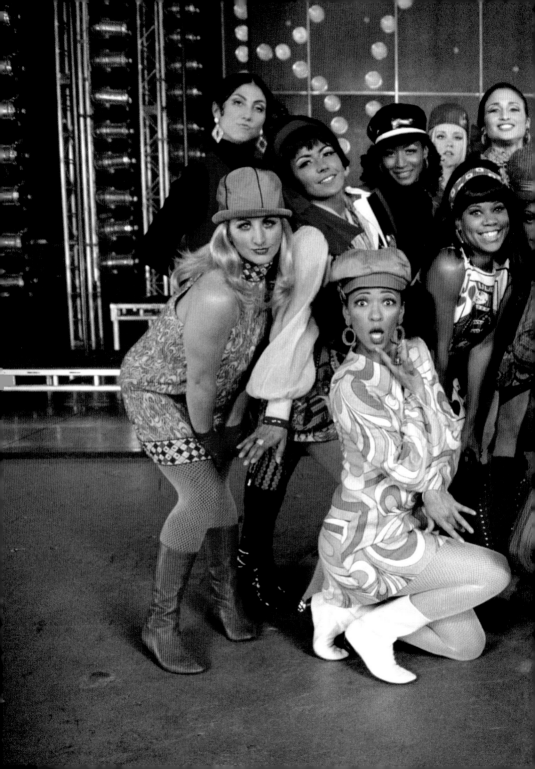

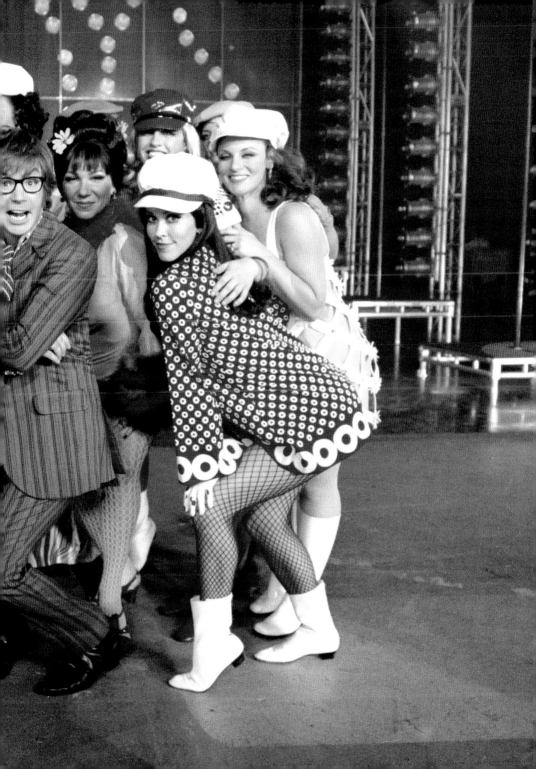

MARY ZOPHRES

Mary Zophres is a four-time Academy Award–nominated costume designer for her work on True Grit *(2011),* La La Land *(2017),* The Ballad of Buster Scruggs *(2019), and* Bablyon *(2022). She has worked with the Coen brothers on all of their films for the last thirty years, including* Fargo *(1996),* The Big Lebowski *(1998),* No Country for Old Men *(2007),* Burn After Reading *(2008),* Inside Llewyn Davis *(2013),* Hail, Caesar! *(2016), and* The Tragedy of Macbeth *(2021).*

MH: Can you remember the first time you visited Palace Costume?

MZ: My first time at Palace was on the reshoot for *Born on the Fourth of July*, and the designer hired me as the assistant, and we came here to pull. And that was the first time I met Melody. It was smaller; she hadn't taken over all of the buildings yet, so it was just contained. In my memory, we pulled the whole reshoot here.

She had a very close relationship with Richard Hornung. I worked with him as an assistant costume designer, and we did *This Boy's Life* out of here and *The Hudsucker Proxy*. I loved Melody. She was as kind to me as she was to Richard. In hindsight, I think about that. At the time there was a wonderful democracy here where Melody just had an open-door policy with really great stock. We found so many great pieces on both of those films. Then a couple of years after that, I started designing on my own, and it's always a treat to get a movie where you can utilize Palace. Sometimes there's no need to, but many times, even on contemporary films, I find myself here because of the great pieces.

MH: Do you have a strategy, when you work here, on the most efficient way to do your pulls?

MZ: You always block out a good chunk of time to pull here, but what's beautiful about Palace is that it's really well organized. And it's well organized because it's, I think, because it's owned and operated by Melody and the people she hires

to work here; she gives them her knowledge. So, everything is organized in the right way. There are costume houses in town where you'll be pulling, and you're in the '50s era, and there's things that are not '50s in that section. But that doesn't really happen here, so you can plot where you want to go based on what you're looking for. Most of the time I'll start with my principal fittings, and so sometimes I'll come and I'll just pull for the principles. And then other times I'll be pulling for principles and the rest of the movie at the same time. It kind of depends on the schedule. But I know when I'm looking for something specific I'll know where to go because it's so organized, and that's a beautiful thing. Things are in the right place. It's pretty rare that you'll find something in the wrong place. And that is so helpful; it saves an enormous amount of time. You can just look for what you need, and if you need to backdate something, you go to another room where a different decade is housed, and it's extremely helpful.

MH: The scale of actors that you costumed for *Babylon* was epic. Did you find yourself pulling from Palace for that production?

MZ: Palace Costume has a substantial collection of beautiful vintage tuxedos from the 1920s and 1930s that we were able to rent for *Babylon*. We had several large party scenes in *Babylon*, many of which were formal, so we were able to utilize the vintage tuxedos from Palace and other costume houses. In the Wallach party scene, the idea was that the men and women were invited to dress

Following page: *Babylon*, Margot Robbie (center), 2022. Scott Garfield/©Paramount Pictures/Courtesy Everett Collection.

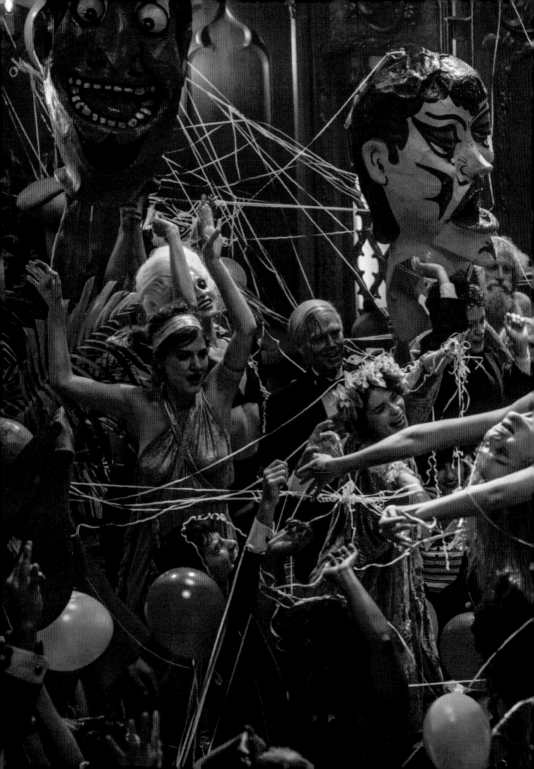

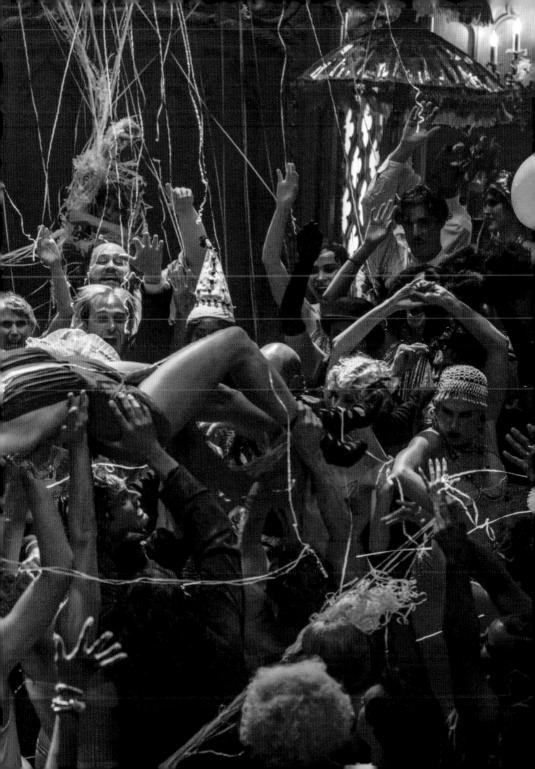

in either formal attire or a costume. There was a point in time at the party when the guests were intoxicated, ecstatic, and enraptured by the energy and by Nellie. Some costumes are still on, some are taken off or apart or passed around. It was all about inviting the audience to be immersed in the story that Damian was telling.

MH: I know that color plays a very important role in your designs. Do the colors and color organization here at Palace inspire you?

MZ: My favorite part of Palace are the displays. Again, the organizational quality of how she displays the clothes makes your job easier. And, yes, in the end, it makes you a better designer because . . . I usually have my color palette in my mind before I come in here, but the fact that it is in a palette-minded order makes it so much easier and pleasant and inspiring to pull.

MH: Do you take into consideration the backstory of clothes? Do you think that there are ghosts at Palace?

MZ: I definitely take into consideration the backstory of clothes. Like when I see a garment hanging, I often wonder, "Who wore this? And what was its journey here?" Particularly if you find a piece that might have all of its components, like from a certain era. It might have the hat and the shoes, and they all work together. I definitely think about the woman or the man who might have worn that. I think that's because I love period films so much. Part of it is delving into history, and not only the history of the story but the history of the people who wore those clothes. It sort of pays homage to lives lived.

I don't recall feeling a ghost presence at Palace ever. I think that the clothing carries with it a person's story: "Why did they buy that?" and, "What was it for?" And some things never sold, some things were just dead stock. How did that happen? Did a store get shut down? Or this is another thing, for me. Oftentimes there are

things from dead stock and the reason why they were dead stock is because they didn't sell them, nobody wore them then. They shouldn't be wearing them, necessarily, in the movie that you're doing. There is that too, but that's another topic.

MH: I also think about the people who made them.

MZ: Absolutely, and the workmanship. And that's one of the reasons why I love period movies is because I have a huge appreciation for vintage clothing and the hand that goes into them and the fabrics. They just don't make them like that anymore, and as each year progresses, it sort of gets worse and worse. There are virtually no mills in the United States anymore, and printing has become way too overused. It's so rare to find a woven print anymore, and you look around here . . . every rack is well represented. I love period clothes, and yes, a lot of it has to do with, "Who made those?" and the workmanship. I am a great appreciator of vintage clothing, and that's one of the reasons why I love coming here.

MH: Can you describe how Palace has evolved over the last twenty years?

MZ: Well, I think in the past twenty years, Melody has expanded the collection, which is another great aspect of Palace Costume. It's not like she has her collection and is content to stay that way. And I've watched it get bigger and bigger. At first it was like . . . getting into rooms where she lived, and then she bought another building, and it's just expanded and grown throughout the years. It's grown along with her collection. It's like coming home every time I walk into this place. I love pulling here. The people who work here are very nice, and it's clean, and it's not dust filled, and the clothes are kept in really good condition, and the lighting is correct, and the climate is correct for the clothing. That's been consistent over the past twenty years.

And it's fun coming here because she's got such great pieces and, depending on what you're looking for, you'll open something up and it's like this joyous occasion because you're not bombarded by dust or being toppled over by boxes. In general, I don't mind doing that. I don't mind digging through some pretty cruddy places, which I've also done. But Palace is not that; you don't have to do that. It's like uncovering treasures. It's really nice. So, over the past twenty years, the personnel and the personality of the place haven't really changed; it's just gotten bigger. But it still has an eye. It's still Melody's eye and her eye that's collecting these pieces. That's something that's ingrained in her. It's not something that you just happen to have.

MH: Does it feel different pulling from Palace because it is in Melody's home?

MZ: No, I remember being here the first couple of times going up, and you're actually in a bedroom. And there's like the women's lingerie and the period lingerie and the slips and the nightgowns, and a lot of that is up there, and I thought, "Oh, it's just like she's expanded into this part." It didn't occur to me that it was also her home. I wasn't

assuming. And then I realized it was, and so, it does give it a homey quality. Again, of course, everything is well taken care of because it's inside a home, and that sort of makes more sense. But, that's just the way it is. When you go to a place for twenty years, it's the reality of it. It just is what it is.

I like it when you start to smell dinner, and you're like, "OK! What are they having?" That's always a funny thing to have happen. I've been up there when she and her grandchildren are there and they're watching TV. They don't care. This is their life, and it's kind of cool, right? That it's not an intrusion. It's just the costume designers pulling for a show. It's no big deal. They're accessible. I've come here on weekends. When I was working on *First Man*, I was doing another project, and I had to come here. Lee met me here, and I just spent all day on a Sunday. I had the whole place to myself. That's pretty rare. He lives close by, and it wasn't a big deal. At other costume houses, they'll do that, but it's a pretty penny to have them open up. And I get it, staff has to come from their house, but it's just different. It's more like family here.

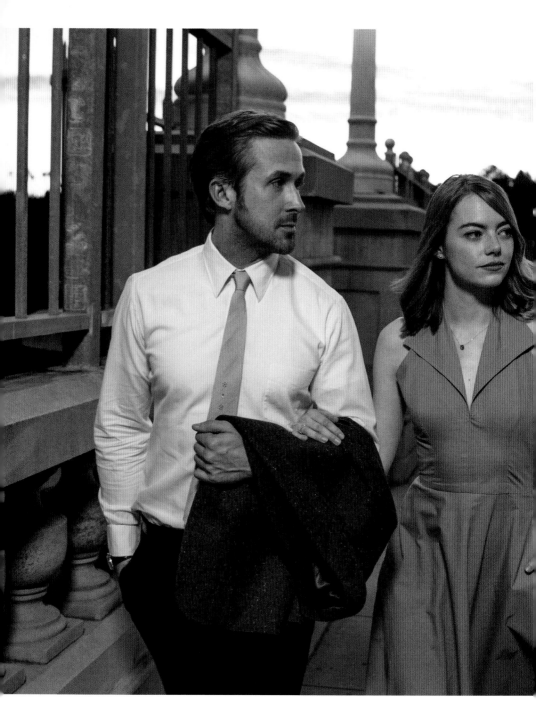

La La Land, from left, Ryan Gosling, Emma Stone, 2016. Dale
Robinette/©Summit Releasing/Courtesy Everett Collection.

MH: You had mentioned getting Mia's salmon halter dress for *La La Land* from Palace.

MZ: Well, that's a good example. I come here most often for period films, and that's when I spend the most amount of time here. When I was working on *La La Land*, I wanted it to have a vintage-inspired feeling to it. Early in the movie, there are a few pieces that she wore where I didn't mind that it was obvious that they were vintage because I think someone who—I did it myself—when you don't have a lot of money, I used to go to vintage clothing stores and thrift stores and style myself. I did that for a long time. It was just more economical than buying something from a department store or a more expensive ready-to-wear store. And I think she would have done the same thing.

So, I came here looking for very specific silhouettes because I had already done my sketching and I wanted something that had a silhouette from the 1950s but without a gathered waist. I remember I had one afternoon to look at Palace because it was a fast and furious prep, but I looked through the dresses. I think I rented three or four pieces from here, and I used them all. There was a salmon pink halter dress, halter cotton—no stretch, zipper in the back—I think I had to replace the zipper, but no gather at the waist. The skirt was cut on a bias. And I tried it on Emma, and it was *adorable*. Other than replacing the zipper, it needed no alterations. It fit her like a glove, and she loved it!

And we used it in a couple of scenes. The one where they're walking across the bridge, and it ended up in still photographs that were in a lot of press. A lot of press. When it wasn't the yellow dress or the green dress or the blue dress, it was the salmon-colored dress. Which came, it's from that back aisle when you first walk in. It's with the halter dresses.

I found the white blouse that she wears to work when she's in the coffee shop. It's not the long-sleeved one, but it's the white one, and it had little notches at the waist. She wore it tucked in

sometimes, and she wore it out and as the shirt was originally intended. They wouldn't have put those notches in it if it weren't okay to wear outside. It was a 1950s blouse; it was just adorable. She wore that. And it inspired another shirt that I had made, and then she wears that shirt in her one-woman show at the end. Then there was a pink A-line skirt that she wears in the montage when they're on the Angels Flight train, and she gets out and she has a little top that's tied at the waist, and there's a pink skirt. The pink skirt came from here too.

Every inch makes a difference. One of the reasons why I love vintage clothing so much is that so often you see the warp and the weft of the fabric. The manufacturing of the cloth was different then than it is now, and you see the texture. Even on that white shirt, on a close-up on the big screen, you see texture.

But sometimes a vintage piece just disintegrates. The other thing we got from Palace for *La La Land* was when we did a dance number at the end. I came back and they added some dancers to the finale. They added some dancers, and I wanted them to be in chiffon. When they would spin, I wanted them to float and stay up there. And in my head, I knew that I wanted those chiffon dresses from the 1950s, and I wanted them in these vibrant colors. We rented quite a number of them here. You don't want to use a vintage dress in a dance number, and one of them was falling apart while we were filming. So we took it to a restorer, and they brought it back to life and put it back together. It's one thing to have it disintegrate during a fitting. It's a whole other story to have it fall apart while you're filming. Usually you discover it before. In a fitting, you can tell. But in a dance number, people start sweating and then it's . . . It was only a half-day shoot, thank goodness. If it had to last a couple of days or more than a week, we would have had to build those dresses.

MH: You mentioned that sometimes you have pieces that you donate to Palace after production.

When we finished *The Big Lebowski*, the producer came up to me and said, "We don't want to store this." It's a Wrap is on Ventura Boulevard, and they'll keep the stuff in boxes until the picture's been released, and then they'll put the clothing out in the store. They paid one or two thousand dollars, and that was it. They bought everything, including stock and principle clothing. All of it. And I remember going along with it because I didn't want to rock the boat.

But I remember somewhere in the back of my head thinking about the costumes from the dancers in the dream sequence. It was pretty major for me as a young designer, coming up with that concept and doing the headpieces. Everything had to work. They had to work with the choreography, and they couldn't come falling off. I remember that it was a very stressful build for me, just because I had never done something like that before. So I guess that must have been the most important thing from that film. Even though, in hindsight, probably John Turturro's jumpsuit was more important to people. But in the end, I said, "Well, we can't fit these big bowling pin things in the boxes." So I put all of the Chorines' outfits: the skirt, the top, the headpieces and the shoes [in the car], and we drove them over to Palace.

I told Melody that after the movie was done, she could rent them. I don't know if she's ever rented them. They're here somewhere; I think up in that specialty room. So I gave them all to her. And then over the years, every time you do purchases on period films, a lot of times they're quite good. Like on *First Man*, we had unbelievable purchases because we tapped into every vintage source around the country and around the world really. But you have trades, and so, you know, you give your good trades to Palace because you know it will be taken care of.

The Big Lebowski, from left: Jeff Bridges, Julianne Moore,
1998. © Gramercy Pictures/Courtesy Everett Collection.

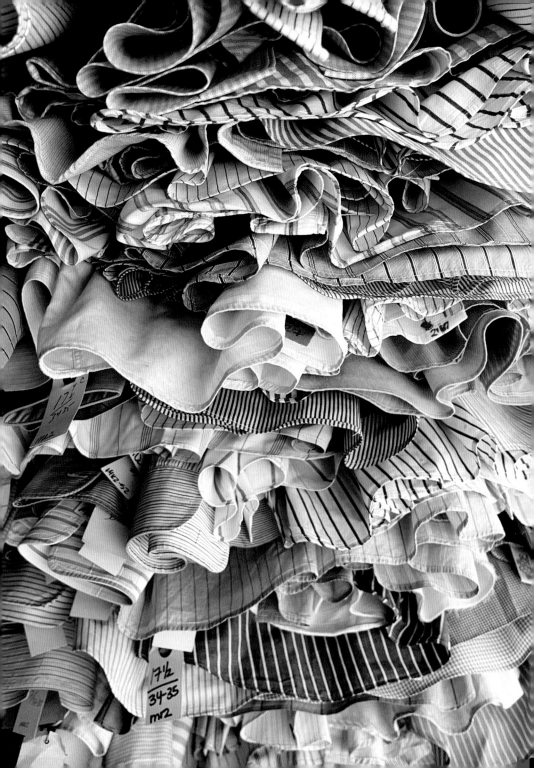

MARK BRIDGES

Mark Bridges is a four-time Academy Award–nominated costume designer, winning twice for his work on The Artist *(2011) and* Phantom Thread *(2017). He is also the recipient of two BAFTA Awards for Best Costume Design. He has frequently collaborated with Paul Thomas Anderson for each of his films, including* Boogie Nights *(1997),* Magnolia *(1999),* Punch-Drunk Love *(2002),* There Will Be Blood *(2007),* The Master *(2012),* Inherent Vice *(2014), and* Licorice Pizza *(2021). Other film credits include* The Fabelmans *(2022) and* Maestro *(2023).*

MH: How long have you been coming to Palace Costume?

MB: My first show in LA was in the fall 1989. I was assisting Richard Hornung on *The Grifters*, and we came to pull at Palace. So, I've been going there for over thirty years.

MH: Can you talk about the evolution of Palace?

MB: Yeah, it's just over the years, and you just sort of roll with it, because you're always sort of single mindedly, just . . . "I need some shoes. Where are they now?" I think that's kind of settled down actually, but there was a time where it was constantly changing, and you'd be like, "Where are those things now?" "Where is?" Because it was always just the main place, and then she constantly built on or bought a building next door. So, those garbage cans full of shoes have been in *a lot* of places. They used to be outside in the courtyard. They were outside! But, you know, safely covered and everything, and it just amazes me how much it continues to grow and expand.

I think Palace is one of the first places that I go to because it's quite organized, and if I was to think of all of my films, there's gotta be at least one or two things in every one of my films from Melody's, if not many, many more things in each of my films. Even if it's just for prototypes or something. I'm not sure that I used much for *News of the World*, that was 1870s, but I might have. I might have even gotten some women's wraps there or something.

There's always something to be found there, big or small, whether it's a commercial or a camera test for something. They make it so easy to work with them that you just love going there. And after thirty years, I still wanna be really respectful of their stuff. They just make it easy to blow in and get what you need and leave. And they just continue to grow and add things to the collection, which is great.

MH: You've talked about the concept of "extraordinary ordinary clothes." Can you describe what you mean by that in relation to the Palace collection?

MB: Palace has such a wide range of items, from the most fabulous evening coat, which I used on *The Artist*, or samples of men's A-shirts, the tank undershirts from that period. So, of course, I just went there because I figured they have some early samples in different shapes. Whenever I want a prototype shape, I would probably go there first. An A-shirt would be an example of "extraordinary ordinary clothes" because it's really just a simple piece of underwear, but the width of the strap or the texture of the knit tells a story.

It's an A-shirt, but it's extraordinary in the fact that you can't buy it today, and it looks so dead-on the period. It's just an ordinary piece of underwear, so that's kind of what I mean by the extraordinary ordinary, and they usually do have it. Just because of the volume of stuff that they have, it's gotta be there, or at least there's a really good chance that it's there, and that's why I go there first.

MH: I wonder about how the immersive spaces and vignettes might help your process as well?

MB. It's like a little museum; it's a collection of artifacts. I have a lot of shots on my phone of things that I take pictures of when I'm not even looking for them. They just happen to be on a restock rack or the end of a rail or something. I'm thinking of this incredible pair of kids' overalls, like a play clothes thing, and it's all hand-embroidered with *Snow White and [the] Seven Dwarfs* on it. I took a picture of that. I didn't need it or anything; it is just so incredible. And like a granny square sweater that I took a picture of recently, and I'm going to copy that, I think. This incredible men's '60s golf sweater, and it's really kind of Vegas because it's black with these incredible neon stripes up the front. My eye gets caught and distracted by these incredible things, but we all have our own taste and what inspires us. My phone has a lot of pictures of what I found while scouring the Palace.

MH: Do you ever get too distracted?

MB: Not me, no. Luckily, I'm kind of single-minded about these things. The way that I work, which is really interesting, and this is another reason why Palace is so important to me, is I like to put my hands on garments, get ideas, get a texture up in that Depression room. There are a lot of ghosts up there of what the clothing was that have seen better days. And that's inspiring, that's cool, the way things are distressed. Recently, I needed something that had to be really distressed, but from an earlier time, and I went. The Depression room was the first place I went up there.

And it's always a bit of a treasure hunt, which is kind of fun, the treasure hunt aspect of it. And sometimes you find things that you didn't even know you wanted, like I'm looking for one thing, but then you find something so incredibly cool that you're like, well, maybe I'll do that, because it's so darn cool, or at least have it play as a possibility. It might never work, but I thought it was cool, so I grabbed it. A lot of my work is like that. Like I'm a

designer and I plan, but then you gotta be open to these oddities that sort of present themselves to you, and maybe it even works better than what I was thinking. So, I love that.

MH: It is like a tactile encyclopedia.

MB: Absolutely, absolutely. Inspiring, educating, informing, I guess, is the same way of saying that it's like a living museum. And what's great about them is they're one of the best places to have things separated by period too. Sometimes, the costume houses, it gets a little blurry. You find '50s in the '70s or whatever. They're pretty clean on that; they really are. So, between their detailed work, and then us knowing what we're looking for, it also makes for a quick in and out too. Here's the beautiful section. Either they got it, or they don't.

MH: I'm sure you've been inside Melody's apartment in their lingerie area. I would love to hear your take on the fact that she actually lives there.

MB: I remember when she . . . she really lived there, she had a housekeeper there, and that was when there was an outside patio in the back. I think that was before the four-story building came. And she'd be cooking in there. But still there were rooms, and then I think some of her family members stay in some of those rooms that have the slips and the pajamas and things.

So, I'm always, to this day, I've been going there for thirty years, and it has changed because she spends less time there. But I'm very self-conscious about going through her apartment up there. I'm very, "Is it okay if I go in there?" and Lee says, "Oh yeah, she doesn't care." I was like, "Oh, okay, helloooooo!?" Because she'll be watching CNN or something in her bedroom, so you're just like, "Oh, hi," and then go on through and look for the room beyond, which has one thousand nightgowns and some bras and slips and everything. And her collection even becomes part of her decor in her apartment living room. There are all those shoes that are kind of a divider, but

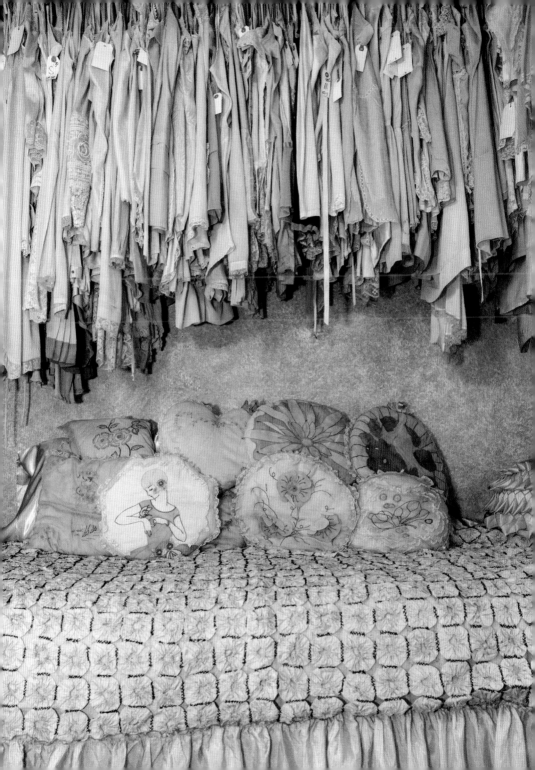

they're incredible specimens. They would never be rented because I understand that they're like a size four or something.

They're very incredible. It's just like, "Oh, this is fascinating," just right at this moment, but then you get to work, and you go in there. I remember, in some of the rooms, you have to stand on the bed to get to the bed jackets or something. I was like, "Here it goes; I need it." They said I could come up here; I gotta do what I gotta do. I'm gonna take off my shoes, of course, but I'm gonna stand on the bed, *sorry*! And you just do it, and I think it lends itself to feeling like "community" and that you belong there. It's still trippy to me to this day, thirty years afterwards, going there for things like that. And the sheer volume of clothes and jewelry and earrings and ephemera. I know that for one show how daunting it is to try to put it all away. Imagine having one hundred shows worth of clothes in there, and it continues to be organized and barcoded and put where it's supposed to be where you can find it. It's crazy.

I love when I find things that I either gave her at some point at a wrap of a show or used on another show. I rarely use things twice. I just . . . I don't like it because it's a different show. But I have found things that I remember we donated to her at the end of *Natural Born Killers*. I was the assistant designer, and I came across this belt buckle. "Oh, there it is!" I remember us buying this in Arizona or something. So, I have a little bit of a history there.

I think she started it as a retail space, actually, if I recall. In the '70s, when everybody was digging vintage clothes, she had some real high-profile clientele in Hollywood, and it just continued to grow. I will tell you one thing: it becomes so difficult to maintain everything. We're kind of saddened by just the natural march of time on a lot of these clothes. Because clothes are only going to last so long. We just did a scene which was a prom in the '60s, and a lot of the dresses . . . It is just natural, I guess. I actually think it was for *Inherent Vice*, where the weight of the garment on a hanger or

something makes it deteriorate. Or we're seeing a lot of faded shoulders. We're seeing silk organza that you could just put your finger through. A lot of these pieces were never meant to last sixty years. So, that's kind of sad. And they do their best to keep up, but just by sheer volume of stuff, it's hard.

So, we're happy. I think Melody likes to send stuff out "to take a walk," so to speak, and we do what we can to restore it as we have it, so that maybe it could do one more show or a couple of more shows. It's just such a huge operation over there. We'll point out things to them, but you can't go through every piece, like, "Well, this inner lining is shattering." But it just happens, and we try to do our part to keep that stuff alive, because we need it, and other people need it, and it's sad to let go.

MH: You mentioned the Depression era room. Do you have other favorite areas that speak to you?

MB: I like it all! I love the evening gown room. It's incredible. I love them all, each room, when I'm looking for something. The men's pajama room: there's always an incredible example of a period or something where you're just like, "Wow, this fabric is so cool," so, I love that room.

I have done so much '70s! I'm all for the ease of everything. I love it all when I need things . . . the hallway displays, I love that. It's just . . . the western room, the jewelry room. Gosh, I love it all. I really do. I was looking at a shirt the other day, and thought, "That looks familiar." In the still photo from *Boogie Nights* in 1996, John C. Reilly is wearing a shirt with stripes on the sleeves, and then when I saw *Licorice Pizza* that we also did with Paul [Thomas Anderson] in 2021, I noticed an extra outside the pinball place, and he's wearing that same shirt. I was like, "Oh, okay! I knew I'd used that before." So acrylic lasts, and it's still going. My second and my ninth film with Paul, twenty-five years apart.

I took a beaded dress to England for *Phantom Thread*. It was like a '20s dress, and I added some iridescent chiffon to the shoulders. Very easily

removed, but they kept it like that. They just left it like that, and they really liked the fabric that I chose, so I was like, "Oh, well, thank you." And it was just used briefly in the film, but I was flattered that they would think my addition was "an addition," and not, like, "Could you restore that to how you got it, please?" I appreciate that.

MH: Is there a treasure hunt aspect to pulling at Palace?

MB: It's all real nuts and bolts for me. I'm super practical that way, and is it cool, and is it really specific of what I'm looking for, and then, of course, that pesky detail of the size, the dimension, and has this been badly altered? Is it really my size but someone measured it, altered, or something? That's part of the treasure hunt. And in a way, I think . . . I hate to say this 'cause it seems really obvious, but maybe people haven't thought of it this way: those garments are the paint that I paint with and make a scene or make a person. So, I'm kind of looking for a person in there, of the right dimensions.

Usually, I get a half a dozen options because things fit differently, or if you've got a foundation garment or something, or maybe it's even because we were talking about fading or how things are breaking down. Or maybe, and God bless her for still being here for this, I'll get it because we're going to copy it into fabric that will survive five-, twelve-hour days and physical activity and whatever. But at least we're looking at construction techniques. We're looking at how the inside was built. So, there is a Met Museum quality to that, except you can touch it and feel it and look at it and see which part was handsewn and which part was not and how wide the hems were. It's just something to be cherished and found and discovered. Every time we get something, I think in my last show that I just did, we had to make a lot, we had to make multiples for period clothes, so it was really great to work off of a prototype.

And so, Melody's place became a very valuable source for prototypes. It may not be the right size for that character or whatever, but the garment's there, and we can learn from the techniques and how they cut, like, "Oh, this is funny. The body is on a bias, but then the skirt is on straight, but then the pockets are on the bias." All that fun stuff when you get into the nitty gritty of it. So, I love that too. That's how I use that place. Really.

She gets some cool collections too. She has that designer room with a little section of Zandra Rhodes and a little section of Geoffrey Beene, or whatever. That's a year's course at FIT right there! For the fabrications in each period. I used a Zandra Rhodes thing in *Boogie Nights*, which just looked cool to me. This girl in the Valley probably would not have had this unless she went to Beverly Hills and spent her paycheck on a little Zandra Rhodes silk screen chiffon number. But why not?

MH: Or maybe she would have thrifted it?

MB: Yeah, exactly. And we used it in *Boogie Nights*, and it's still there. I can go in and look. I'll walk by and I'll see something I used on the *Vinyl* pilot for Scorsese. I was like, "Oh, this is still here." It's an invaluable source to me for all the reasons I mentioned. I just love it. I just love it. I'll be taking this stuff out for a walk as long as I can.

MH: Do you always start off each new project with a visit to Palace?

Yeah, I always go there first. I go there for inspo. And they're so friendly and kind, and they know me, and it's like family. I just rue the day that it ever stops being. I will take it as a sign that it's time to get out. It's time for me to quit. There used to be eight fabric stores, and now there's one. There used to be ten tailors; now there are two. And then that would be . . . I would just be like, "Okay, I gotta go."

I was looking at a shirt the other day and thought, "That looks familiar." In the still photo from *Boogie Nights* in 1996, John C. Reilly is wearing a shirt with stripes on the sleeves, and then when I saw *Licorice Pizza* that we also did with Paul [Thomas Anderson] in 2021, I noticed an extra outside the pinball place, and he's wearing that same shirt. I was like, "Oh, okay! I knew I'd used that before."

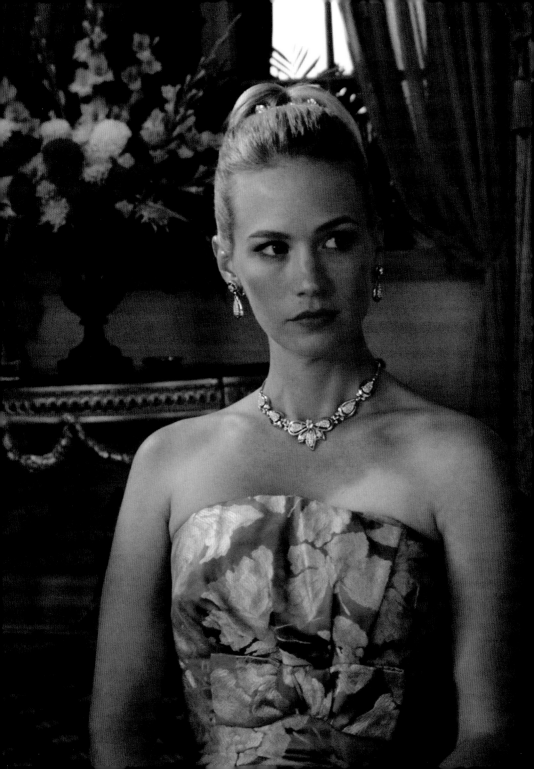

TIGER CURRAN

Tiger Curran is an Emmy Award–nominated assistant costume designer for her work on Netflix's Hollywood *(2020). While still a student at UCLA, she began working in the costume department of* Mad Men *(2008–2010). She has worked as an assistant costume designer on* Pretty Little Liars *(2016–2017),* Bullet Train *(2022), and* Horizon: An American Saga *(2024). She is currently creating a documentary film on Palace Costume.*

MH: You are currently creating a documentary on Palace. Tell us about how your passion for this place has evolved. Do you remember the first time you came to Palace and what your impression was?

TC: I started my career in the industry as an intern and PA on *Mad Men*, the now iconic 1960s era TV show costume designed by Janie Bryant. We were constantly coming to Palace to rent clothes. So many iconic looks from *Mad Men* came from here. And so, as an intern and PA, I was mostly just dropping off and doing returns and seeing the front room and being sort of intimidated by Lee as like "a twenty-one-year-old dropping off stuff." But even just seeing the murals outside, walking in the doors and going into this insane place felt very special and magical from the first moment I came. And you know, maybe now Hollywood is a little more corporate, but I think in years past, there really is a truth to the magic and weirdness of Hollywood. I'm not from California, so to come here as a young person and come into this unique and special place, I felt like I was really a part of this Hollywood, Babylon part of the industry. And then one day I had to meet the assistant costume designer to give her something. She was actually in the depths of Palace, and instead of just going in the front of the house, I had to make my way through the maze of Palace to find her. I remember just being completely blown away and mesmerized and fascinated by everything here.

MH: What was going on in your head the first time you walked through?

TC: It's been a long time since I first walked through Palace Costume for the first time. I remember thinking that it was like being in one of those interactive museums, or a fun house, or like some *Grey Gardens* mansion. And you're thinking that the wall of shoes may fall on you if you push it too hard. And it is just so easy to get lost. It's like going through these magical closet doors into Narnia.

I was just amazed by this place and knew how special it was from the very first time. And from being an intern back then, I have continued my career in costumes and come to Palace as a shopper and assistant designer and designer many times over the years now and know it very well. And I don't get lost anymore, although sometimes I have to remind myself where I'm going, even after fifteen years, getting tours from Melody and making a documentary about Palace. There are still some times I'm like, "Wait, where am I?"

Mad Men, Season 03, Episode 10, "The Color Blue,"
January Jones, 2009. Costume design by Janie Bryant.
Mad Men Courtesy of Lions Gate Films Inc.

93

But yeah, I've continued my career in costumes coming here again and again. And I always knew how this place needed to be documented somehow because it feels almost fragile. In this big, scary world, where Hollywood is more regulated and corporate compared to the fringe and weirdo associations from times past, this feels like a flower that, like, a dandelion that could blow away in the wind in a way. In as much as I know that Melody is such a force and has no signs of stopping and is eighty years old and is still talking about getting new buildings and expanding into different ideas and starting custom-making things and . . . there's still an ephemeral quality to it.

Hearing Melody's story is so inspiring, especially as a female business owner in the '60s and '70s, when it was so rare for a woman to start an empire. She is so humble, but she is definitely the force behind what you see. And everyone who works here respects her and loves her so much, and then interviewing other costume designers that also have such a deep and almost spiritual feeling about this place. Shirley Kurata talks about really knowing every single piece in here, like a friend, and being so delighted to find something new that she hasn't seen before. And Arianne [Phillips], who says that she's used Palace in every project that she's ever done since she first came here in the '80s, from Madonna shoots to Oscar-winning movies. So, it definitely has a strong impact on everyone that comes in here.

MH: What is your take on the fact that Melody lives here in the middle of all this collection?

TC: It's definitely strange in a great way that Melody lives in the middle of the collection. She's basically someone who has a vintage collection obsession, and she's turned it into a business and is really sharing it with the world. She shares it with people who need it and appreciate it. Melody says herself, "Oh, yeah. It started out as a big, beautiful apartment, and now we're literally living underneath the clothes that have taken over every inch of this place." She'll never stop buying. So, it's like, in another ten years, will there be even more? think that's kind of cool!

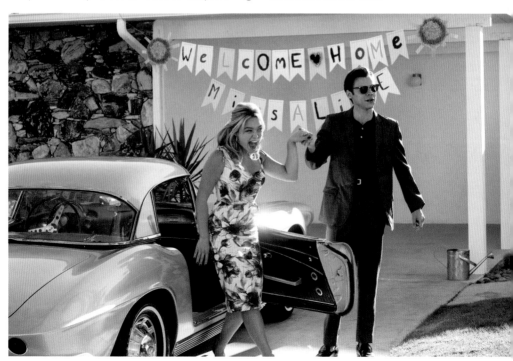

There's something cozy about it. There is such a trend for minimalism and taupe right now in interior design and clothing as well. You see these trending spaces and *Architectural Digests* that are just a stone floor and cream drapes and emptiness and the Marie Kondo of it all. This is definitely anti-Marie Kondo. It's the maximalist's delight. I think it reminds you of the past in a way, where you think of these old homes where you have your knickknacks and books and rugs and doilies. That's all sort of disappeared from modern interior design. So, it has a nostalgic feel of this coziness. And yet, it feels super organized, and everything has its place.

MH: Do you feel the presence of . . . not necessarily ghosts but just the energetic presence of the people who wore the clothes?

TC: I obviously have a love and passion for clothes and think that they have a soul. It's almost like your teddy bear when you're a kid, and you're like, "Maybe it's really alive and it's just acting like it's not alive because it's gotta keep the ruse going, but it's probably really alive." I don't know if you thought about that about your teddy bear, but I did!

I feel like clothes are like that too. They are alive maybe, or they have a soul that carries on wherever they go. I sort of inherited some clothes from someone who recently passed, and you feel like, "Oh, what part of them lives on, or why did they keep this item until the day they died? What about this clothing meant so much to this person? And is there a part of them imbued in it?" And at Palace, it comes back, and it's dry cleaned, and it's back on a rail with a hundred other dresses.

Like, Arianne recently told me that one of Florence Pugh's dresses from *Don't Worry Darling* was here, and she was like, "Yeah, yeah, it's here. You can go find it." And I was looking for it to photograph for the documentary, and there's a long aisle of probably five hundred 1960s printed cotton day dresses. And you page through hanger by hanger looking, and there are all sorts of different great prints, each one completely unique. Designs that textile artists drew

to have printed back in the '60s. And then, finally, squeezed tightly between neighboring dresses, there's the Florence Pugh dress that's on all the posters for *Don't Worry Darling*. It's just squished there amongst the other 1960s day dresses. But, for some reason, it stood out.

In reality, the answer is no; it probably doesn't keep the spirit or essence of who wore it before. I wouldn't have known that Florence Pugh wore that, just as I wouldn't have known that it came from some estate sale where somebody died, you know? But I wonder how many other of those dresses have an even more fascinating tale that you just skip right by.

It's up to the stylist or the designer to really see the potential, because a dress on a hanger is very different from a dress on someone who's moving, acting, dancing, or having an emotional breakdown in a scene.

MH: Do you think Melody's style of collecting and curating sets it apart from other costume houses?

TC: I think so. When you page through the racks at Palace, you find a lot more quirky things or special things or museum-type things where you're like, "I'd want to take a picture of this, or look at this insane little embroidery here of a playing card, or look how whimsical this item is." I mean, of course there are also the ordinary things too. There are rails of solid-colored pants and shirts here too.

I think Melody and Lee have an eye for more special things. I think other costume houses do just sort of take whatever is left over from the film for trade. Things that are the most rentable items that are sure to go out again and again on films. Whereas Melody and Lee may also have that in their mind, like, "Will this actually be rented?" But at least from what I can see, it's not only from a monetary business-minded standpoint of, "Oh, this solid gray suit will get rented again and again." But more like, "Oh, this tiara made of guitar picks is fabulous!"

Don't Worry Darling, from left: Florence Pugh, Harry Styles, 2022. Costume design by Arianne Phillips. Merrick Morton/© Warner Bros./Courtesy Everett Collection.

Melody says, "I'll buy anything I like if it's beautiful." She doesn't say, "I'm seeking out clothes that will be rented on jobs."

MH: Can you talk about the physical location of Palace and the interesting buildings in which the collection is housed?

TC: Driving down Fairfax and seeing the murals and the crazy building with the gargoyles surrounded by crystals . . . even if you haven't been to Palace Costume, it's noticeable. But I think once you come inside, you're sort of transported where you could be on a different planet in a way. I know Melody loves being here and doesn't want to go to the Valley, but at the same time, she talks about wanting more and more warehouses and space, so we'll see. But I can't really imagine it. She's also built this herself. She's built multiple buildings and floors and connected things, which is why it's such a maze. That's just the way it's grown over the years. It sort of doesn't have one overarching game plan, but it has expanded as Melody's collection has expanded. And it's changing all the time. Every time you come, there are new things or rooms that have been reorganized.

It feels like Palace is a part of Hollywood, *in* the heart of Hollywood. Melody goes to the Melrose and Fairfax flea market every Sunday, so that's very convenient for her. Maybe that's part of the ephemeral nature of it too. Is it one day going to be pushed out to the Valley to expand? I don't know.

MH: How is Palace Costume Hollywood's best-kept fashion secret?

TC: Well, I mean, you walk by, and you see a sign on the door that says, Not Open to the Public. It's really a collection that's for the use of costume designers and stylists. If you are just looking for a Halloween costume or something, and you happen to find it on Google, you will be sorely disappointed. Not everyone can rent from here, and it's for a good reason. Like I said, this really is a museum. They really need to keep account of every single

item in here because it does come back. It's not a store where things are for sale. The collection is something that they want to hold onto for decades and generations. So, it is like a vetted source for films, and Melody's collection at Palace has been used in films since 1967. Theadora Van Runkle, who designed costumes for *Bonnie and Clyde*, was the first person to use Melody's pieces in film. Since then, all the way through to today, the collection has probably been used in every period film or TV show that was shot in Los Angeles.

And if you work in historical films in LA as a costume designer, you absolutely know and love Palace. But if you are outside of this industry, even if you're a passionate collector of vintage clothing, you may never come here. It feels like a privilege to be able to come to Palace and see the collection here and take special pieces back to the studio for actors to try on. We create characters and looks with pieces from this collection, and I'm grateful that I have had the opportunity to spend so much time here and pull hundreds of garments for all the various vintage period shows that I've worked on over the years.

Murals by Miss Van, Victor Castillo, Dan Quintana and Esao Andrews.

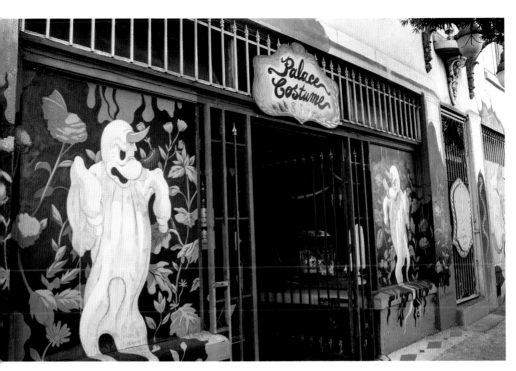

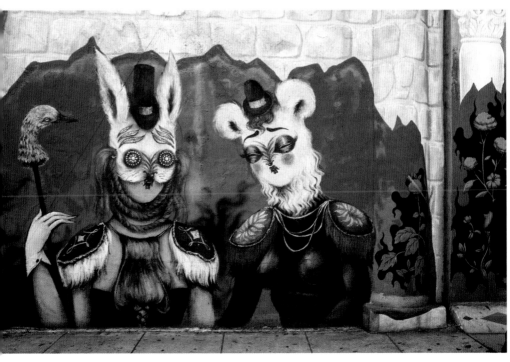

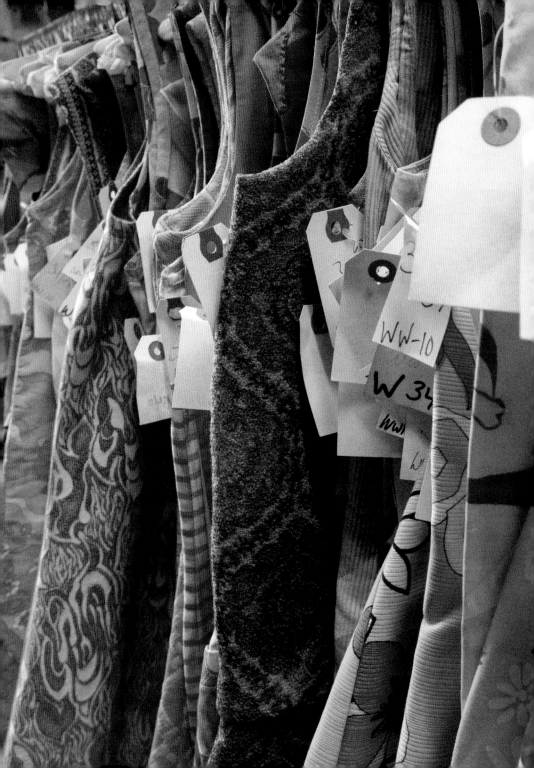

CHRISTINE WADA

Christine Wada is an Emmy Award-nominated costume designer for her work on Loki (2021–2024). She has also been nominated for a Costume Designers Guild Award for Excellence in Sci-Fi/Fantasy Television. Her film and television credits include Beloved *(1998),* O Brother, Where Art Thou? *(2000),* Bridesmaids *(2011), and* Our Flag Means Death *(2022).*

MH: How would you describe Palace Costume to someone who's never been there?

CW: I would describe it as going to a circus event of clothing where you get to time travel, but you also get to explore different cultures and worlds. It's like the world's fair. It's the world's fair in a costume house. It's an incredible journey through time and culture.

MH: Can you remember your first visit there and what production you were working on?

CW: I think it was '92 or '93 for a movie called *Foreign Student* that took place in the '40s and '50s. I was the assistant designer, and it was just those days where the designer and I could spend months just pulling ourselves. I got to spend, I think, a full month and a half in there.

MH: Wow!

CW: Yeah. I really got to just dig. Of course, I was probably going to other places, but we would spend three days out of a week at Palace Costume. It was incredible. It was such a luxury at that time to be able to go through each piece of clothing.

MH: It sounds like you have a forager's instinct with the patience to go through and dig around all of the bins or racks?

CW: Yes, I did. In high school I used to skip class to go to St. Vincent de Paul's and Goodwill, and I would just dig around. I was really obsessed with the '60s

back then. For some reason I had this thing for Edie Sedgwick and Warhol. But I would just dig around. I think the forager's instinct in terms of a costume house is a little bit different than going to a vintage store. The reason I examine each piece and I kind of work through a rack like this is because it's feedback. It gives me feedback.

MH: It's more curated in a costume house than a flea market or a vintage store.

CW: Yeah. When I'm at a flea market, I'm just thinking about a great piece.

Whereas when I'm really looking for a character, I'm also thinking what can inspire a character. So, that's a little bit of a different process than just looking for a fantastic design.

I'm hoping that everybody preserves and treats what is in Palace like gold because I think that's what has made it so special and at this level for so long. On *Beloved*, we had a lot of stuff from Palace. You would make sure that each individual item was tissue papered. You would tissue paper the hangers if you were shipping it back that way, and you just returned it in pristine condition. You would take really good care of the stuff from Palace because you treasure it. You knew you'd want it ten years, twenty years later.

MH: Would you say that is just what they expect?

CW: They do. Well, definitely I think Lee shows an incredible care and love of everything in that

Following page: *Beloved*, Danny Glover, Oprah Winfrey, Kimberly Elise, 1998. Colleen Atwood costume designer, and Christine Wada costumer. © Buena Vista Pictures/ Courtesy Everett Collection.

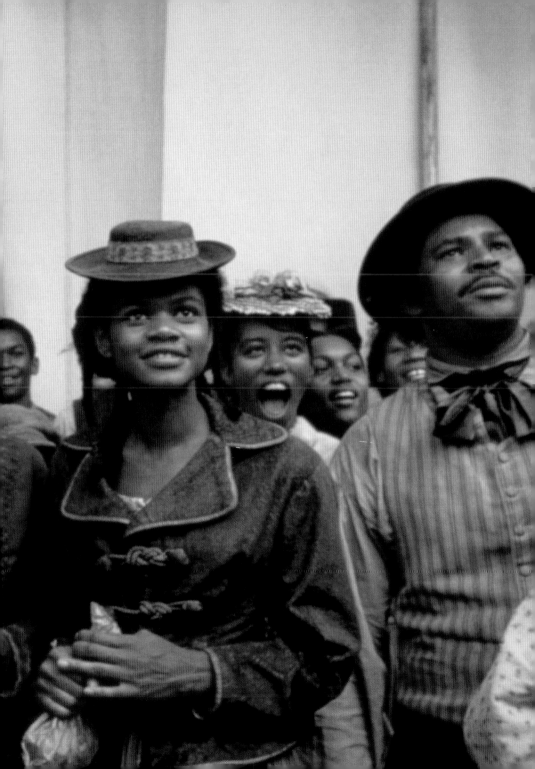

building, and, yes, I think he definitely wants to put the fear of God in people in terms of taking care of it. Thank goodness he does.

MH: Do you remember when all the big bins of shoes were outside in that courtyard area?

CW: Yeah, I totally remember that.

MH: What was that like?

CW: Yes, I remember and, granted, they still have those sheds and everything in the back, but it really was just those rooms upstairs and downstairs. And, yes, the courtyard. That's right. I mean you just took me back. I will not lie; we used to curse those bins.

MH: Your work has taken you to a variety of genres. And so now you're working on *Loki*. Are you still pulling from Palace often?

CW: Well, if I'm in town, I'm definitely, even for commercials, I'll go to Palace. Because, for me, it's also just inspiration, right? Even if I can't find the right size, something might cue me off into a direction or just help solve a problem. I feel like walking into Palace is like walking in a garden, where maybe there's some meditation to it, and you actually can solve a lot of design problems even if you're just wandering through. Just smelling Palace Costume, you might end up solving a major problem there.

But yeah, in *Loki*, I definitely have looked in the designer room and also for design details. Because I will always want to go back and forth in time for inspiration. *Loki* was so rooted in a mid-century aesthetic, so I went there looking for that. I remember looking for all the mod stuff, like Paco Rabanne. I'll look at the Courrèges and Ossie Clark pieces. And even if I don't end up using something on a project, a lot of times I'll end up pulling it just for inspiration.

MH: I was wondering if, on a film like *Bridesmaids*, you would ever pull a vintage piece for a

contemporary show just to throw in some flair?

CW: Yes, I'm a huge believer in backdating because that's what real people do. We're not dressed in 2023 head to toe every day of our lives. So, it's important to mix that element in. And I'm trying to think in *Bridesmaids* if I really ever went back. I definitely went to Palace for belts and jewelry. And potentially some '70s prints because I feel '70s prints at that time still kind of translated.

They still do translate, and it's very hard. The one thing that Palace still has is some of the good '70s, because a lot of the '70s you find elsewhere is either destroyed or it's the '70s polyester.

But Palace actually has a great collection of some pretty delicious '70s, like Halston and all of that, which is really hard to get your hands on. They still have the natural fiber stuff that really hasn't survived

I don't know because in the last—I'd say probably—eight to ten years, there's been a lot of bad training

in terms of taking care of things, and people are getting desperate as production squeezes the prep time when they cast. So, people do destroy things that they shouldn't.

MH: Was there, or has there been, a particular film or show that really relied heavily on Palace Costume?

CW: Yes. Yes, for sure. Gosh, all of them, all of them have. *O Brother, Where Art Thou?* and really early on, I did a movie called *Dragon: [The Bruce Lee Story]* that went through all the eras. I'd say that almost all the clothes were from there. Like a massive amount of clothes were from there. I think, for sure, on all the Coen brothers' stuff, it's just always been an inspiration. And same with Colleen Atwood. Like when I would work with her, it's like a lot of that; like I said, *Beloved* pieces from there. Every show. I can't imagine a show where you wouldn't want to go to Palace. And even if you didn't end up really taking a lot, you always investigate Palace.

MH: Do you have any Palace Costume ghost stories?

CW: I will say that the top floor of the old building, which is like turn of the century, does spook me a little bit. And I think it's just because it feels like the Titanic up there. And nobody else is ever up there with you. I feel like you're always kind of by yourself in the attic, and there's just stuff around you that always makes you think you're about to go down. But also, those clothes carry so much history and weight. When you start getting into all that teens and turn-of-the-century stuff, you just . . . my mind wanders to who these people were. And it should with every era. But for some reason, I think there's something about Victorian, or anything that's like early, early twentieth century that always feels ghosty, spooky. And you really kind of want to just know more about who wore it.

And also, they have the wedding dresses up there too. And those are always creepy to me.

White dresses are always creepy to me. I have no idea why. I have just seen too many bad horror movies in my youth or something.

MH: Why is Palace Costume such an important resource for you and your peers?

CW: I think it's Melody's eye. I just think her eye is really tuned into something that is, God, it's both fantastic design, but it also has moxie; everything has personality. It is the one costume house you can walk into, and you think you have something specific in mind, and it just gives you more, right? It really does expand your vision. I appreciate that it doesn't expand your vision in a kitschy or an overly sentimental way. It's just incredible design and history. It's a real time capsule. What would we do without Palace?

BEA ÅKERLUND

Bea Åkerlund is a Swedish-born stylist, costume designer, and activist known for her innovative and over-the-top aesthetic in fashion, film, music, and art. For over twenty years, she has styled music industry icons such as Madonna, Beyoncé, Lady Gaga, Rihanna, Katy Perry, Nicki Minaj, Coldplay, Britney Spears, and Fergie, in print, music videos, commercials, and on tour. Her film credits include Spun (2002) and Domino (2005).

MH: You have been coming to Palace Costume since you were a teenager.

BA: I have.

MH: What was it like for you, as a lover of vintage clothing, to discover a place like Palace?

BA: I think Palace actually has a huge part on why I became a costume designer. I don't even know how I found it or who told me about it, but very early in my career, I started styling. I think I was seventeen, and my whole life was built upon creating characters. So, every day of my life I would be a different character, and that's what drove my inspiration and my passion to find myself. And you can ask Lee. I would come in wearing Indian sarees, and I was always in a different character, and when I came in here, I was like blown away. I couldn't believe that a place like this existed. I would say the first ten years of my career were all created in costume houses. This is before I discovered fashion, so I would make my own fashion with the things that I found. If you go back and look at some of my work and some of my videos, you can point out, like, "Oh, that's from there." And there was also Bob Mackie's costume house, EC2 Costumes, which doesn't exist anymore. So, between EC2 and Palace, I made magic happen.

I actually lived around the corner; you could literally walk to my old apartment.

MH: You've styled so many videos for iconic artists: Madonna, Beyonce, Britney Spears, Ozzy Osbourne. Are there any Palace pieces that were featured in those?

BA: Yeah, I mean, there's *Ghosttown*, which is one of my favorite Madonna videos. The top hat that she's wearing is from Palace. Let me see what else. *God Control*, also Madonna video. I mean, that whole '70s section is heavy Palace. There isn't a job that goes by where I don't stop at Palace for sure. Like every job ... Oh, there's another incredible video, which is one of my favorites, it's called *Magic* with Coldplay. There's tons of it, and it's on Zhang Ziyi. There's tons of Palace in that because it's a period piece.

I did a movie called *Spun*, and Brittany Murphy has a hand-painted graffiti bodysuit that's from some weird collection down in the styling room. That is from Palace. I could probably do a museum exhibit, if I looked at all my work, of what is from Palace.

MH: What role has Palace Costume played in your career as a fashion activist and stylist who works with so many iconic artists?

BA: I don't think I've ever done one single job where I haven't gone to Palace. There's not one job where I was like, "Oh, I'm not gonna do Palace today." I usually go everywhere else, and I do Palace last because they're the most expensive, but they're the best. So, you gotta pay for what you want, but you technically could do an entire job just out of Palace if you have the budget and not waste your time anywhere else. But they've always been super supportive of me also through the years for professional or personal projects. Lee has always been very supportive in my career. He's also seen me from a teenager growing to a woman, and the career path that I've taken. So, I feel very

honored to be not only asked to be part of this book but to be part of the Palace family.

MH: And do you feel like it was a place of learning for you? Like a library or a research center?

BA: Well, I mean it's a library and a research center, and I think because Melody's eye is so good, like there's no crap in here. Whatever rack you go to, whatever bin you pull out, it's only good things. You can go to other costume houses, and it's like a bin full of crap, or there's like five giant rows of an era, but it's like a needle in a haystack. When you go to Palace, it's like, do I want this, or do I want that, because everything's great, and that's what makes Palace different from other places.

MH: A higher level of curation.

BA: It's curated, yes. And I also do see Melody at every flea market I go to because I'm a huge vintage collector and antique collector myself, and I always see her.

MH: Have you always been a collector?

BA: The thing is, before I had any money or a budget, I started with garage sales, and I would make my looks and my fashion based on what I could find and what I could afford. So, the garage sales turned into thrift shops, and then the thrift shops turned into designer, and then they became designer clothes, and then I realized that where we were going in fashion was so boring. I find my joy in vintage because the craftsmanship is not the same, and I like to be original. I like one of a kind. I don't wanna buy something where I could see someone down the street wearing the same jacket. So, for me, vintage shopping has always been my biggest joy and treasure hunt, and same with antiques. And my husband has the same passion. So, we're like avid Long Beach flea market people up at 6:00 a.m. on a Sunday. It's just what we do, and if you come to my house, every single thing you see in our house is from a flea market.

MH: Can you talk a little bit about being in Los Angeles as a flea market goer, versus somewhere else in the world?

BA: I'd have to say it's not as good as it used to be. I don't know if the really good dealers have taken their business to the internet, and that's why if you go to the Rose Bowl or if you go to Long Beach, you're not finding as much good stuff. I'm not there for jeans and a T-shirt. I'm there to find that one thing that is special and that no one else has. I mean, I found an Andy Warhol statue at the Rose Bowl, and it's the most incredible thing that I have at my house. I've been going, but I haven't found anything like that in years. But I would say that Long Beach is my favorite flea market right now in Los Angeles. They're getting more clothes. It used to only be antiques, but it's a good size. And as of right now, I think it's the best that people have to offer. But the other thing is vintage shopping and thrift shopping are not what they used to be. Because you could score and find something for $20 that was amazing. Now, if it's amazing, they want $1,200. So, it kinda takes the joy out of it a little bit because, for $1,200, you can buy a Gucci bag.

MH: What does it mean to you to be a collector?

BA: It's my everything, it's my safety net, it's my . . . I'm the kind of person, like, I can't go or be somewhere without my stuff, and I know that sounds ridiculous, but I am a creature of comfort with my stuff. I travel with eight suitcases. I'm always an overpacker, and my favorite place on the planet is my closet. I built my closet as a sanctuary and a room where I can collect my thoughts, I can do yoga, I can do anything. I'm just surrounded by my favorite things that I love the most, which is my collection of stuff.

MH: Does it ever get too crowded?

BA: Yeah, I mean, it does. I just, I purge like every . . . you gotta be in that mode to purge. I'm a hoarder big time. I mean I have stuff that

I've had for twenty-five years that I just won't get rid of. But I feel like I'm a hoarder in a good way, because I feel like I collect good stuff. So, it's even harder to get rid of it. But then, once my closet starts getting like overflooded . . . They say you have a rule: if you haven't worn something in one year, you get rid of it. And then your body changes and things like that. I used to be a zero, and that was the key to vintage shopping, because most amazing vintage pieces are very small. But after giving birth to twins and stuff, my whole body changed, and a lot of the things I can't wear anymore.

MH: Do you ever use those pieces as prototypes?

BA: I do. All the time, yeah, for sure, when I'm designing. I especially did for the ABBA show costumes. For the avatars and stuff, I was here. I came and pulled the perfect suit, a three-piece suit, a '70s three-piece suit. Maybe one thing is for the vest and another thing is just for the fall on the bottom of the pants. It always makes it a lot easier when you're dealing with a designer or someone else who's making it for you so that there's no miscommunication. Because it could start with you sending them an amazing sketch. It doesn't mean that you're going to receive the sketch; it never does. So, the more references you can provide, the closer to the sketch you will get. Because I just know, and I go by feeling and a gut on what is right. And when I look at a pair of pants, . . . not only can I tell what size they are, I'm like an encyclopedia in my head—not only for fashion but also for sizes. I can look at someone and say, oh, he's a 38, he is probably an 8.5 shoe. It's built in, like a machine.

MH: Does your passion for collecting give you a different appreciation for the Palace Costume collection?

BA: Oh, my dream is to have a Palace Costume collection; are you kidding me? This is the ultimate dream, and I can relate to Melody every time they buy another building. And she just keeps expanding because, when you're a collector, it's never enough. It's not like, "Oh, now I have all the best pieces and I'm pretty happy." . . . It's almost like a disease. It's like you could just keep searching and keep searching, and I feel like that's why it's so natural that I turned into a stylist and a costume designer, because I love the search. I love the search of finding that perfect piece, and I also like options. Not necessarily for my client or for the director, I like options for me, because I want to make sure that the combination, the final product is the absolute best. Like if I pull socks downstairs that are vintage, I pull the rainbow because I don't know. Am I gonna want baby blue socks? Am I gonna want orange socks? I don't know. And I only know it when I see the final thing, but if I don't have those options, it's not perfect in my gut.

MH: It's almost like they're paints in your artist's palette, and you have to make sure that your palette is full for your canvas.

BA: Yes, yes. But I feel like whenever they move something or renovate, it drives me crazy because I've spent twenty years learning where everything is in this place. And when they're like, "Oh no, that room is over there now," I'm like, "What do you mean?" When you know every bin and you know every corner . . . I mean, if you ask me, "Where is the 1800s?" I can point you in the right direction. I know exactly where it is. It's, like, I know this place inside and out. But that comes with time and experience. And then I can't tell you how many assistants I've had to school for a return to Palace.

MH: Oh, tell me about that.

BA: Oh, it's very specific. If you know, you know, and if you don't know, Lee will let you know.

I always say a good rule of thumb is always return things better than the way they came; then you know it's good. It has to be in a plastic bag, it has to have the right hangers, it has to. There's a special way to the method, and if you don't know, you

can end up on Palace's blacklist. You don't wanna end up on Palace's blacklist because I know they have one, and it's quite long. And if you end up on the blacklist, you can never step foot back in here again, and as a costume designer, what's your career without Palace? Nothing. You might as well just retire and get another job.

I mean, honestly, it would be like such a crutch, I couldn't even imagine if . . . I mean, even if I'm doing jobs abroad and not in LA, I always come here and bring a suitcase, because I know. I have a rule of thumb, and that is, no matter where I go to do a job, I always leave LA thinking that if I never find anything anywhere else, I could always pull the job off. So, it's like whatever else you find is a bonus, but I don't ever leave without knowing I have it in my bag.

MH: So, you're not shy about overpacking.

BA: Oh, I have a record. I did a job with ninety-six suitcases for Swarovski. I prepped it in three different countries with people flying from LA,

New York, and London. I was in Sweden. I prepped the entire job from my computer because it was during COVID.

And it was making my hands itch that I couldn't get in there and get my hands on the pieces. I was like, "No, no, no, you gotta go to that aisle, that bin, and over there they have that one jacket with a crisp . . ." Like to explain to someone who's not as experienced and doesn't know. Luckily there's like a Palace Costume map in my head.

MH: When I think about your style, I'm imagining you in the stylist room, or maybe the men's warehouse for some of the leather stuff. Do you have your favorite rooms?

BA: You know what I love? I love the '70, '80s in the evening gown room up the elevator on the second floor where the Kate Moss door is. That's my favorite room.

MH: Tell me about that room.

BA: That room is magical. My favorite piece at Palace is in that room. That room has some serious gems. Like as far as references and things go, that room . . . I feel like that room is underrated, because everyone automatically goes to the stylist room down there, but I feel like the evening gown room is the one. There's all kinds of stuff up there. I've really surprised myself a few times and have been just like, "Wow, this piece is incredible!"

MH: Are there any rooms that didn't catch your eye at first but now you've fallen in love with?

BA: Well, another room that I love is the distressed room. That room is incredible. You can get the perfect distressed tank top for like $100, but it's so worth it. And you don't have to go through the trouble of doing it yourself. But there are some incredible pieces in there; that's another room that I really like. And I, of course, love the upstairs, the 1800s room. I would say between that and then the evening gown room, those are probably

the two places I go the most, as well as the '20s, the '30s feather section, which is incredible. I've used that a lot.

Also, a room where I don't go a lot but I kind of like is the '60s, '70s, '80s day wear room, which I feel is also overlooked a little bit because it's upstairs, kind of out of the way.

Another job that I did when Palace just really nailed it was for the Ozzy Osbourne video *Under the Graveyard*. Jack Kilmer and Jessica Barden played young Ozzy and Sharon. My husband directed the video, and it was like in the '70s when they met, and she was very "momsy" and like this sort of not super sexy or wild woman. I found the perfect dress from that day wear '60s, '70s, '80s room that's in that video too.

MH: Why is it so important to find that perfect piece?

BA: Because I'm only interested in making iconic moments. I'm not interested in getting the job done. I'm interested in making history, and I don't "work to work." I work because I love it and because I want to be proud of my art and what I do. But that's why I've sort of taken a step back and focused on other things, because I gave my work my life, and it almost killed me. So, I had to take a step back and sort of enjoy life for a little bit. Because I go that deep into my work, it takes my everything.

MH: Do you have a favorite Melody or Lee moment?

BA: I have so many Lee moments. It's kind of a highlight when you get to chitchat with Lee when you're waiting for your checkout. I don't know, Lee has always been a joy. I feel like there are certain people in my career, in my life, that have seen me as a talent and seen what I'm capable of, and I would say Lee is one of them. The other person was Manfred Mugler. They looked at me in a way and saw something special in me that not everyone could see. I would say Lee is one of those. He

was just always very encouraging. I think he can probably read people according to what they pull. He can see the people that have an eye and are actually talented, and he can see people that are just there to do a job. And that's a talent in and of itself, to read that.

And I feel like, over the years, from my pulls, we grew closer, because I think he saw something in me. Like I said, it's like searching for a needle in a haystack here, and to find that prized gem piece, you almost need to have radar. I feel like my body goes, "Stop! Stop!" It's like, "I'm going to go in this direction," and it just takes me to it. It's a feeling. And you have to come in here with the right mindset. You can't come here at the end of the day super exhausted. I mean if it's for something specific, you can go and get it, but if I'm coming here to actually pull a feel of an entire job, I like to start here in the morning, so I'm fresh. "You have to have the energy to go through it."

CHRISI KARVONIDES-DUSHENKO

Chrisi Karvonides-Dushenko is an Emmy Award-winning costume designer for her work on American Dreams (2003). She is a full professor and the head of Costume Design at the School of Theater, Film, and Television at UCLA for both the undergraduate and graduate programs. Her film credits include Big Love (2006-2011), American Horror Story (2011), Barry (2022), and The Mysterious Benedict Society (2022).

MH: I would love to know if you can remember the first time you walked into the Palace. Do you remember what you were doing? What job you were working on? What your first impressions were?

CK: The first time I ever came to California was in 1987, when I got a project to work with Dona Granata, a costume designer on *Scenes from the Class Struggle in Beverly Hills*. And when she brought me here, I just thought this was nirvana. I couldn't get enough; I just couldn't believe it. And that project was contemporary, but Melody had, even back then, amazing, unique, contemporary pieces, and we were using them a lot for the jewelry. We were mixing contemporary with a lot of the Bakelite jewelry, which was a favorite of Dona Granata's.

And then, when I moved here in 1991, and as soon as I started getting my own shows, then this became my movie home. This was really such a treasure. Every time I would come here, no matter how frazzled, Melody would always be open armed, getting me some tea or something, and off I would go to pull all the clothes. Where it really became my true home away from home was when I was doing a project called *American Dreams* for NBC. And that project was complicated, and the producers were complicated, so I felt like half the time I would come here, I'd sit down on the couch and start crying first before I started pulling the clothes. And then, I think one of my favorite

dresses I ever designed in my career at that time was a garment that I'd created for LeAnn Rimes. And what I did was I came to Palace. She wanted a stylist to do the dress, but it had to look like it was from 1958. It had to really evoke the character of Connie Francis.

So, I didn't want her to be portraying herself. I really wanted to portray her as this singer. So, I asked if I could have one fitting and see if she liked what I had to offer. So, I came running. I got a note saying, "Okay, we'll do one fitting." We did it at the recording studio. I came running into Palace, because I had like two hours to make this happen. I pulled a half a dozen amazing mid-calf-length dresses from Melody's beautiful '50s inventory, tossed it all into the car. I don't even know if we had time to write up the loan to get to the recording studio in time. Brought it all in, set it all up. I actually did a couple of quick sketches based on the dresses that I had pulled. I didn't think it would work out that LeAnn was going to maybe wear one of those actual dresses. What ended up happening was she loved what I pulled; she really loved the sketch. She liked the pleating from one dress, the shape of the collar from another, the skirt from another one. Then, I went to Sylvia's Costumes, and they made the dress in forty-eight hours, and we filmed it. It was a Friday, and we filmed it on Monday.

And there were some times where I literally ended up spending the night here, where Melody said,

"Here's the code to the alarm, stay here, get some sleep." A couple of times, I called at like quarter of six, saying, "Oh my God, they just gave me a new script, and we shoot it in the morning. I need help." And Melody was like, "No problem, come on over, get what you need. Write it up on a piece of paper. We'll take care of it tomorrow." Yeah, that's why I love Palace Costume so much. It is like my little home away from home.

And then what happened was I collected vintage clothes when I lived in New York like everybody does. But living down in Hermosa Beach, everything kept getting covered in mold. We had a problem with moisture in the closets and everything. So, after my third round of dry cleaning all the vintage clothes, I finally said, "Melody, do you want this?" She was like, "Bring it on." So, I brought three or four carloads of vintage clothes from the East Coast, and then that just never stopped. Every time I did a show that I was designing the costumes for, especially if it was for HBO, I would literally bring the truck and have them offload the truck when we were done, because it's such a joy to have all my little treasures hidden here at Palace, along with everybody else in town. We all kind of do it. Any of my favorite garments, I try to make sure it ends up here, because I know if I ever need it, I could find it.

MH: You helped to facilitate the relationship between UCLA costume design students and Palace Costume.

CK: So, about a decade ago, I started to teach at UCLA. I run the undergraduate and the graduate program at UCLA. In the beginning, I tried to juggle, still designing for episodic TV. I had no idea what I was getting myself into as a professor. But somehow, I managed. I cut down the amount of work that I was doing for episodic TV, but I still do it. I did *Barry* season three a couple of years ago, and I just did *Mysterious Benedict Society* set sort of in an alternate reality spin on the early 1970s. Running both of those programs is a bit of a bigger endeavor than I thought it would be in the beginning. But I love it. It's extremely rewarding. I love mentoring all these young people who really, truly want to become part of this world of costume design, costume construction, styling, working on set with film and television projects.

About six or eight years ago, Melody came up with this idea and asked if I had students who would be interested in working here part-time. They have to do four-hour shifts. Lynn put it all together, and the students just love the idea. So what I started to do was to recommend them by seniority first, to come and interview and to come work here. And they work around fifteen to twenty hours a week. It has been one of the great finds for our students. What it means is while they're training in this career path, they're getting hands-on experience. I feel like they understand period clothing better when they actually touch them, take care of them, put them away. They get to meet so many designers while they're working here.

It's also an amazing calling card for them to have on their résumé that they worked not just for a month or a semester but for several years while they were in school. Often they will get first dibs on a job because of the experience of working at Palace Costume.

But it's amazing, like when we did the pilot of *Hacks* as a project. We actually did a tour with the undergraduate designers and came and looked at the caftans and got their hands on them and saw the Pucci collection. And then they take photographs, and they use that in their designs, and it looks amazing when they have their style sheets where they actually will have items from Palace. And then they have their rendering of how they would use that piece, or how would they, like, in theory, do photo sublimation of a design or a print of fabric and use it in their design.

It's incredible. It's absolutely incredible. And I bring the students once a year. We come and do a tour here, and . . . their jaws drop whenever they come.

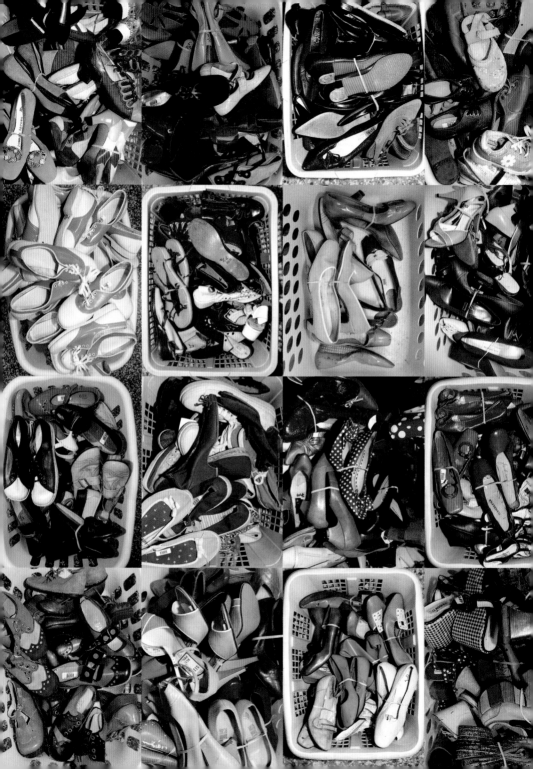

Everybody thinks it's so glamorous being a costume designer, but actually, it's like we are the ones who are in the bins pulling everything out, trying to find the perfect shoe, the perfect hat.

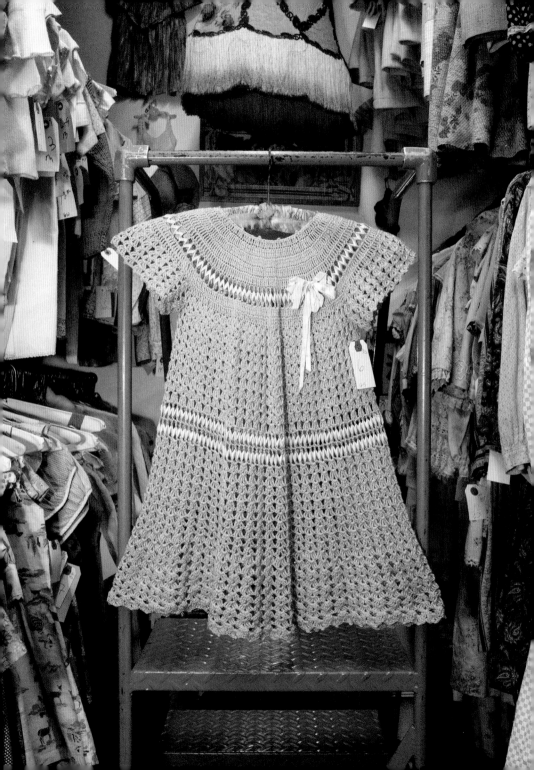

DANIEL ORLANDI

Daniel Orlandi is an Emmy Award-winning costume designer for his work on a television special for illusionist David Copperfield (2014). He also received a BAFTA nomination and Costume Designers Guild Award for Excellence in a Period Film for Saving Mr. Banks *(2013). Additional film and television credits include* Silicon Valley *(2014),* Jurassic World *(2015),* The Founder *(2016),* Logan *(2017), and* Ford V. Ferrari *(2019).*

MH: What is unique about Palace Costume?

DO: The fun thing about Palace is the clothes here are all Melody's taste. There are certain things that she would never have in her collection, which I think is so funny and interesting.

MH: How would you describe Palace Costume to someone who is not a costume designer?

DO: It's almost like an imaginarium of stuff. You can come here and just get lost. I'll come here and be looking for something specific, but then I sort of just go down a rabbit hole of looking at other things, looking at their jewelry, and so there's always something new. I always love coming here because it's small, concise, and they have the best children's clothes of any place.

If you need children's clothes, come here. Nobody else has what they have, and they take such good care of them. They love their clothes, and that's what I love about it. They really do love their clothes, and they *know* all their clothes. And I'll see old favorites and things. My friend Ret Turner, who's no longer with us, had a rental house with Bob Mackie in the Valley. He gave Melody a bunch of stuff. So, it's funny to see it here. There was a show that Bob designed and they produced called *Movie Star*. So, I see some of the *Movie Star* costumes here. These, like, quick-change cowboy outfits. It was a Broadway-bound review that they did at the Westwood Playhouse in the '80s.

MH: You were assisting Bob Mackie on *Pennies from Heaven*. Was Palace Costume a big part of the costume design?

DO: Oh, yeah. I'm sure we were here. I came here with Bob. That was my first job when I moved here after college. And I was so lucky that he just happened to be looking for an assistant, and he hired me with absolutely no experience. I had gone to help at his shop for two days. A friend of mine was working there, and he said, "Could you come in and do a little craft project for two days?" And I thought, "Oh, do I really wanna do this?" And I did. And then, at the end of the second day, the head of the shop said, "Oh, you're good. Why don't you go up and organize all of Bob's stuff?" He had all these trims and samples, and I spent the day organizing it all. And Bob came down and said, "Hey, are you the guy that organized all my stuff? I'm looking for a new assistant."

MH: Was he one of your costume design icons at the time?

DO: Oh, of course. And it's funny because people liked all of the glamorous looks he made for Cher, but I liked his funny stuff that he did for Carol Burnett.

MH: So, you were interested more in the character-driven side of Bob Mackie's work?

DO: I love doing characters. That's why I love coming here. They have great characters.

When I work with an actor, rather than presenting them with a sketch, I like figuring out the character while trying the right things on. And I learned a lot of that when I first started to work with Robert De Niro because every detail to him is important.

In the morning, he'd call me to ask, "Are these the socks we decided on?"

But that's the thing about coming here. You can find the right character item. The right vest or the right socks or the right shoes. You find a crazy pair of shoes that you wouldn't normally think of. I like actors who are willing to try things on. I'm happy to try whatever you want, but just try something else as well. And *I've* also learned to be more willing to try things, try ideas. Because that's the best thing about movies and theater. It's a collaboration.

MH: How do you utilize Palace Costume as a resource?

DO: If I'm doing a period movie or even a semi-period, the '50s or the '60s, I want to make time for myself to come here. You can have assistants and wardrobe people come, but when you look at it yourself, plus it's fun to do, that's part of our job. I love rooting through a box for shoes. And I always think that lazy people just pull the stuff off the top. I like to get to the bottom. Even if I have to then put it all back in. I love the hunting and pecking. Melody has such eccentric taste in clothes, she'll find things that another rental house would say, "No, that's not going to rent very much."

But here you just come for the period thing that nobody else might have. Especially their children's clothes. When we did *Saving Mr. Banks*, we had the day at Disneyland. I think we had 250 to 300 kids to dress in 1961/'62 clothes. They had them here.

MH: Are there any other rooms that you go back to?

DO: I like all the rooms. I like all the shoes. They have great shoes, and they're not all size five, which is good. She has just a great eye for stuff that nobody else has. It's character stuff. It's interesting stuff. You can look at the costume design in some movies, and it just looks like the pages of the costume history book. There's no personality. I think the one thing that's never changed in human history is human nature. Some people are sloppy, and some people are neat. If you're digging a ditch, you might not have your hat and coat on.

MH: How do the vintage men's ties help to build your characters?

DO: I think ties tell a story. Especially like coming here and going through the ties, you look at them and say, "What does this tie say about the person?" And sometimes you have characters that have a small part in a movie that you can telegraph more with the tie or something. You say, "Okay. This is the sleazy salesman; this is the glad-hander." Whereas if it's the lead character, you don't want to give that away. If a character is a used car salesman, their suit's going to be a little flashy.

MH: And the tie can be a great vehicle for that message.

DO: Yes. In *Saving Mr. Banks*, we have the flashbacks to when P.L. Travers was a little girl, and we have her wearing her father's ring. Nobody but the actors would notice it. But it makes them feel connected. It's all about the actor and telling the story. I love working with actors, and it's just fun to bring them something that makes them feel like the character. Maybe it's something unexpected, and that's what you find here. And it's historically correct and period correct. But it's not just from one of those pages from a costume history book. The real designers don't just look at that.

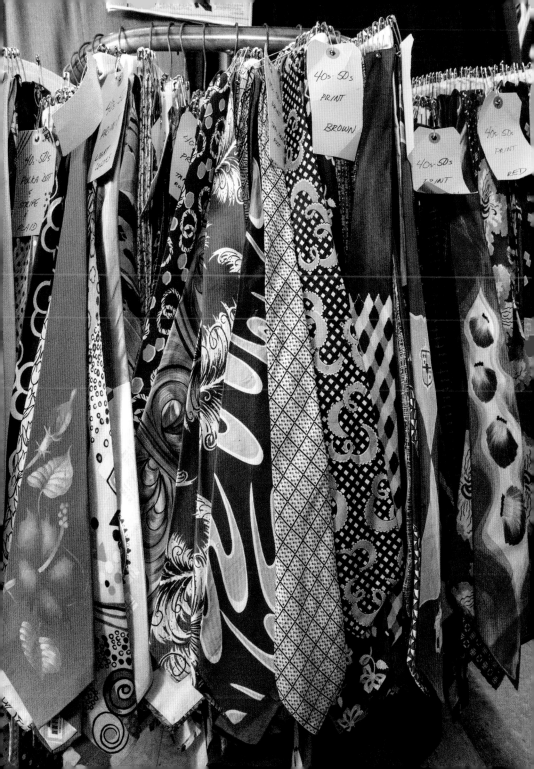

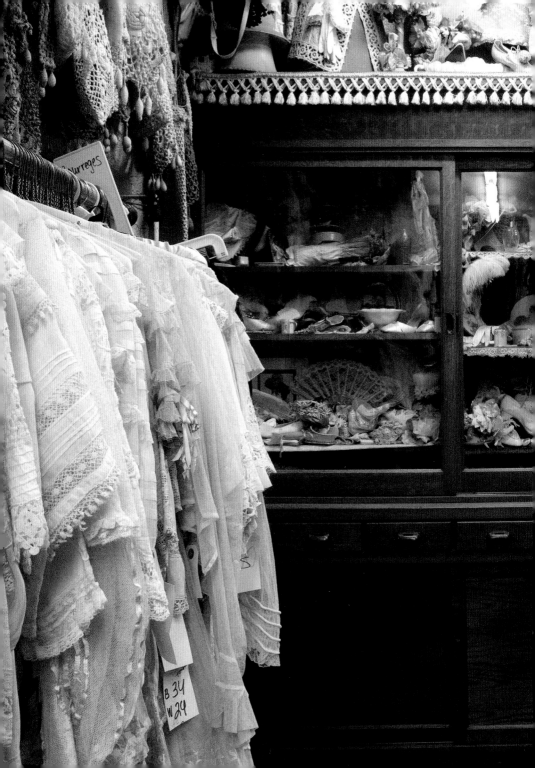

DEBORAH NADOOLMAN LANDIS

Deborah Nadoolman Landis is an Academy Award-nominated costume designer for her work on Coming to America *(1988), as well as a historian and a Distinguished Professor and founding director and chair of the David C. Copley Center for Costume Design at UCLA. Her film and music video credits include National Lampoon's* Animal House *(1978),* The Blues Brothers *(1980),* Raiders of the Lost Ark *(1981),* An American Werewolf in London *(1981),* Trading Places *(1983), and* Michael Jackson: Thriller *(1983).*

MH: How would you describe Palace Costume to a friend who has never been here?

DL: Palace Costume is, it's like Aladdin's cave, that's what I would say. And for someone who is passionate about fashion, costume, textiles, it's just about nirvana, period. As far as I'm concerned, it's a difficult place to be because, as a costume designer, I can barely focus on a conversation like this one because my eyes are being caught by things that I need to look at. I can't be here without having whiplash. It's very hard for me to focus after a lifetime of loving clothes. So that's how I feel about it. I'm passionate about the people in the place.

MH: You have championed the role of costume designers in creating excellence in cinema and storytelling. Can you talk about the role Palace Costume plays in helping costume designers tell a story?

DL: Because Palace houses close to a million vintage and antique pieces, every single item, every single pair of shoes, every single dress and slip and jersey has a history already, and that's what costume designers aspire to because the role of a costume designer is to create real people and to create personalities from written text. Well, if you're looking in Palace for an object, for a textile, for a blouse, that blouse comes with a ready-made personality. It's so much better than making clothes from scratch. It's so much easier to come into a place like Palace than to struggle to design a period blouse, fit it on, find exactly the right fabric, fit it on the actress, and then age it to make it look like it had a life before the film began.

DL: When you walk into Palace, you can look through rows and rows and rows of vintage blouses, and each of them has a story to tell already ready-made for any costume designer who walks in. And then it's simply a moment of pulling those blouses off a rack, bringing them into a fitting room, and seeing which one speaks to the character that you are creating on your actor. So much of the work in creating personality is done for you by having this amazing, bottomless warehouse of stories and clothes.

MH: The pieces themselves are living characters.

DL: Clothing is character.

Clothing is identity, there's no separating it. Clothing is performance. We could say that each one of us is performing ourselves when we get dressed in the morning, and here you can nearly smell the individual . . .

From each—truly, from each item of clothing.

MH: Another role you have is as a professor and a mentor for so many students. You have worked with a countless number of students who have either interned here or visited Palace Costume. Did you have anything like Palace Costume that

you could use as a living museum when you were a student studying costume design?

DL: Yeah, because I grew up in Manhattan, I grew up in New York City. I think that's such a huge advantage. And I grew up with the Metropolitan Museum at my doorstep, and I had the Brooklyn Museum, and I had the Museum of the City of New York, and I had the New York Historical Society. And I went to all of them as an elementary school student, as a junior high school student. I mean, my first love was history. It was just that I was also good with my hands. I loved the theater. So, to quote Mark Bridges, "It's everything I love in one job," and he said it first, but that's the truth.

MH: When you walk through Palace Costume, you pass by the repair area, which houses fabrics, patterns, buttons, and notions. Can you discuss the importance of the preservation and repairing of vintage items?

DL: The repair of vintage items. Well, I can show you all the black-and-blue marks that I got at the Victoria and Albert Museum when I used the word restore, because I was at the V&A for five years preparing the Hollywood costume exhibition. And if I never knew anything about curation and textile conservation, I was taught it there. And so, I understand that for the film industry and television industry, clothing and "vintage," which is—not so sure about that word, but—old clothes, which are sometimes really relics of another era, they really shouldn't be restored, they should be conserved. But Palace Costume is not a museum. If everything here—which could be a museum, because the wealth of the objects where we're sitting right now—if we lock the door and someone paid to make Palace Costume the Palace Costume Museum, the clothes would no longer be restored. They would be conserved, because they would no longer be worn by any individual, and they would be seen and appreciated by the general public. They could be, because that's the value of what is here under this roof.

MH: It's a living museum. It's a living costume museum.

DL: It's a living museum of inestimable value, inestimable value. And if that wasn't enough, it could be a museum simply because of Melody's vision. We're sitting in the living room, but this could be Freud's office. Her vision is surrounding us. So, actually, and I'm going to get back to your question in a minute, but actually, it's obvious it could be a museum for two reasons. First, the talent and vision of the person who created it, and that's the most important thing. That it was one woman's vision, and this is her creation, and that must be acknowledged. And then, for the second reason, is what she has accumulated, which is historic. So, if the door was locked today, the clothes would be conserved, and conserved in a much different way than they are restored here because they need to be used and to continue to live and to work. Because every object in this palace is a working object. They live to work again.

That's also very inspiring. I don't mean to denigrate in any way the purpose of Palace Costume, and Palace Costume is providing a service not just to costume designers but to all audiences, to every audience that sees these people in the movie come to life.

If they were subtly transported to a museum collection, that would be their retirement. They would be retired, and from that point forward, they would be conserved. And that's quite a different way of approaching clothing. I do want to say that I had a very nice friendship with Debbie Reynolds, who had a very large and important, maybe the largest and most important private collection of Old Hollywood costumes ever. And when I went to visit that collection, she very proudly told me that whenever she needed to have these very important, and I hate to use the word iconic, but these were iconic clothing from the golden age of costume design in Hollywood. She told me that anytime she needed to have them repaired, she sent them to the dry cleaners. So, I just smiled and

nodded, and you couldn't help but love her, and that's what she did.

All you want to do at a museum is to stabilize a textile with as little change as possible.

MH: It must be an incredible value for the students who intern here in terms of handling the clothing and being able to observe the stitches and details.

DL: Incredible. Yes, it's not just seeing the stitching; it's the touch. And students need to learn to handle fabric and know the hand of a fabric. And they need to be able to know the difference between silk organza and polyester organza. They need to learn their textiles. And for me, there is no better class than Palace Costume. This is the course that every graduate student needs to take, to intern here.

MH: Some of the pieces that you designed for *Coming to America* are downstairs. How does it feel to have some of your designs as part of this collection?

DL: It's incredible. It's incredible to have anything survive that I've designed. And anything that I've designed recognized so many decades later; it's very strange. I think every costume designer would say that we do our best on every single production, and we never know if something's going to be a flop, or a hit, or forgettable, or a classic, or God knows, iconic. How is that even possible? Sometimes they think, "Oh, I was in the right place at the right time." Other times I think, "Oh, if someone else designed it, it wouldn't look quite like that." And I have a unique point of view. It's not false modesty or being coy. I have a hard time figuring out why some films are magic and some films are not. I don't think anybody knows.

And then the other thing is costume designers leave a movie and then the movie is edited. And movies are made in the editing room. And often costume designers, including myself, go see the

movie, and then we're completely surprised by how it turned out. And sometimes we love it, and sometimes we're really disappointed. But at this point in my life, I'm just, I'm fiercely proud, fiercely proud of my contribution to *Coming to America* that has sustained and is so beloved in the African American community. Can you imagine? I am just so proud. And then look what happened with *Raiders of the Lost Ark*, oh my goodness. And look what happened with Michael Jackson's *Thriller*. And even *Animal House*, all I did was press "COLLEGE" on a sweatshirt for John Belushi, and you can still buy it everywhere. So, I have had touchstones in my life, and at seventy-one years old, I can't believe that these designs are still around. So how do I feel? I feel amazed.

MH: As a costume designer and costume design advocate, author, and historian, what does Palace Costume represent to you?

DL: I just would like to see Melody's contribution celebrated, and if it was up to me, I would give her an honorary Oscar.

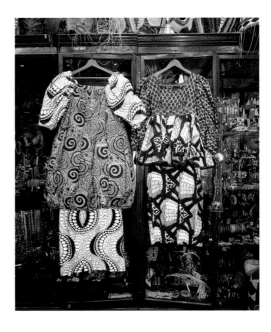

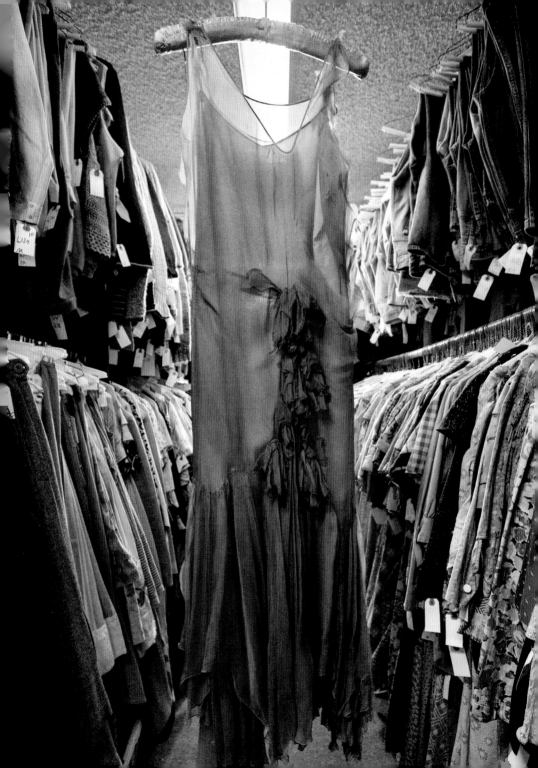

LOU A. EYRICH

Lou A. Eyrich is a two-time Emmy Award-nominated costume designer for her work on Glee (2010, 2011) as well as a producer. In 2012 she was awarded a Career Achievement Award in Television from the Costume Designers Guild. Her costume design credits include: American Horror Story (2011-2022), Ratched (2020), The Prom (2020), and The Watcher (2022). Her producing credits include: American Horror Story (2017-2023), Pose (2018-2021), Hollywood (2020), Halston (2021), and Dahmer (2022).

MH: How do you describe Palace Costume to someone who has never been here before?

LE: I would describe it as a wonderland. Like Alice in Wonderland, going down and down and down and down. Like every room opens up a whole new group of treasures. Every room has this unique flavor, and I'm in awe and wonder every time I come and visit here. And I see new things I've never seen before. It's a treasure trove. . . . I want this to be more open to anybody who doesn't live in LA, but it's, like, to me, it's as exciting as going to the Rose Bowl, but every room holds those treasures. It's curated in such a magical way and a wondrous way. Like the denim room or the cultural room, the jewelry room. Just those specialties. I love going through each room, depending on the project, finding vintage bathing swimming caps or the perfect vintage tennis outfit. Like no matter what it is, it's just, I'll come running in the door to look at one thing, and I'll always get stopped by something I see that completely pulls me out of focus, because I have to look at it.

It's a magical wonderland, and every room holds these treasures that have been curated in such a unique way that it makes you just want to go from room to room to room, and you forget that you're here to work.

MH: Can you recall the first time you visited Palace Costume, and were you with someone?

LE: It's been thirty years. It was with a stylist named Fiona Williams, who was a big stylist when I first moved to LA. She designed for Bowie and the

Stones and Bruce Springsteen, and I was brand new to LA and kind of like a country bumpkin from Minnesota. And I think that's who brought me here the first time to pull for one of the bands that she was styling for. And I was her assistant for a short time.

MH: Are there some rooms that resonate more than others with your personal aesthetic?

LE: Well, I go through stages. But I've always had an affinity for the lingerie room with the 1920s pieces because they're harder and harder to find. And it's such an amazing collection here. Like the little silk chemises and the little tap pants, for example. There's one section upstairs, the Depression Era room, where everything is worn out. I get some of my favorite inspiration from there. Faded calico prints or ripped dungarees. I go in there and I get really inspired. The closet between the jewelry room and the '30s, '40s women's. There's a closet filled with scarves, and they're all sorted by print, color, style. I can spend an hour in that closet. I love it because I love scarves. And it's so organized.

MH: Can you describe how clothing, whether through touch, sight, or smell, can evoke memory?

LE: Well, just looking up at the wall here and seeing that patchwork quilt reminds me of my mom, who was a quilt maker. She would have all her siblings and cousins, and they would have a quilt day, and they would have this big quilt frame, and they'd all just have the best time drinking their coffee and making these quilts. So, when I looked at that, it did take me right back to that living room forty

A glimpse inside of the Depression Era room.

years ago where my aunties would be sewing quilts together. So that evokes a memory right away when I see that. The patchwork everywhere there and the braiding, the rug braiding as well, takes me right back to my childhood. I'm just trying to think of the smell. What would it be?

I've collected vintage for a big part of my life, and I worked at vintage clothing stores to get myself through college and beyond before I got into this business. So, when I touch the pieces, in their kimono section—I used to have a collection of kimonos, and I got the pleasure of going to Japan and going to some of the kimono factories and such, at the time. And so, just the beauty that goes into the fabrics . . . from the Happi coats to the big wedding ceremonial versions. It instantly evokes that feeling of when I got to go to Tokyo or when I used to wear kimonos belted or the Happi coats back in the '80s, and I would wear it with a beret and my little leggings and these booties. And so that is one way it literally takes me back to that. And again, the quilt, seeing the quilt and that memory that takes me back. And definitely, when you walk into certain rooms, there's that smell of vintage; it makes me happy.

And also, because I've been pulling here for years, I can walk through certain aisles and go, "That suit was for Annette Benning in *American Beauty*," or, "Sandy Powell made that great suit for that film." It'll instantly be like I can see it in the movie. I'm like, "That piece is so great. They used that on such and such."

MH: Yeah. They almost become their characters in a way even without the actor.

LE: Exactly. Because it's so iconic.

MH: You work on such a range of productions and styles and genres. Are there specific shows that have pulled more heavily from the Palace collection, and if so, which seasons and/or episodes?

LE: We pulled a lot here for the second season of *American Horror Story*, which was called *Asylum,* because it took place in the '60s. So, a lot of our stock came from here. Sarah Paulson wore a couple of the dresses, as did Jessica Lange, definitely from here. And then *Freak Show*, which was the '40s, '50s, that pulled a lot here. And sometimes, from the Depression Era room, especially because we needed a lot of very beat-up clothes, for both seasons two and four. We pulled a lot from the Depression Era room, especially for *Asylum*, and then also just used it as reference to build that I would then copy—or to take to the printer to have the fabric reprinted or have the print reprinted onto different fabric. And tons and tons of their hats. And then on season five of *Hotel*, we pulled many pieces from here for Lady Gaga because we had a lot of flashbacks of her from like the '20s, '40s, '70s, '80s, '90s, and then even into the future.

MH: And for something like that, would you have the actor wear the actual piece rather than reproduce it if it's just for a quick scene?

LE: We did both. I mean, for the quick pops, definitely kept it. And she certainly didn't care. She was in whatever is on, whatever works for the scene. Didn't matter. But sometimes we would use several pieces from here straight off the rack. Same with Dennis's character too. We pulled a lot here for that show, even though it was technically contemporary. Some of the people were killed technically in the '70s and '90s, so we backdated a lot. Your typical *American Horror Stories* stuff.

MH: How does your experience working in a vintage clothing store have an impact on your appreciation of the collection in terms of the act of collecting, organizing, and the maintenance of the items?

LE: Well, it was like the early '80s when I started doing it. So, vintage was really vintage. Like you could still get turn-of-the-century, '20s, '30s, '40s. Not like now, where it's all in kind of rough shape

and it's disappearing, or it just doesn't fit the average body. But I definitely learned my love of vintage from working at the rag houses. So, the *actual* rag houses where you would get the clothing to put in your vintage store. There were huge bales that they would click open, and you would sift and sift through all the rags to find the treasures. And you would get into these huge bins on wheels, and you would climb up in there. So, I needed like forty pairs of men's corduroy pants or Ralph Lauren khakis, whatever was the big seller back then. I would have to really pull, or you could say I need to fill my order of twenty-five 1950s dresses, and you could find it still. And in good shape.

Back then, I only wore vintage, only bought vintage. And then, when I got my own store to run when I was up in Minneapolis, things were shifting a bit, and it became a little more, like, *FlashDance*, and everybody wanted the cutoff sweatshirts and everybody was wearing leggings, and it shifted to a more modern look.

LE: My favorite thing was doing the displays, the window displays and the store displays, and to try to influence what the customers were buying. So, if there was a rack of men sport coats that weren't selling, for example, I would look for the sports coats where the linings were amazing paisleys and polka dots. I'd turn the sport coats inside out, and I'd throw it over a dress or a skirt and then belt it with a big belt and throw a Fedora on it and do a window of that.

And then, all of a sudden, we would be selling tons of sport coats. It was a fun game for me to try to influence what was going on and what influenced what the customers would buy. Then the same with the displays that were inside the store too. Like sweatshirts that never sold, and they were on the rack forever, and then you'd hang it up with the fun little ensemble, and all of a sudden, "Can I have that sweatshirt?" I'm like, "I just put that up there." But it was a fun challenge for me. And then, when I segued into costumes, not even as a designer but

when I was just learning, I realized that, actually, the costume designers were doing that same thing. They were telling a story and dressing a character. It was before all those websites of Who What Wear, and Fashionista, and all those fabulous sites now. You could see the influence costume designers were having on fashion and everybody wanting to wear what Annie Hall wore.

MH: How do the vignettes that are found around Palace help to tell a story?

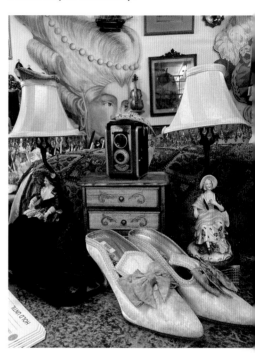

LE: They are all throughout, even every staircase you go up, every little nook and cranny, like the stairs going up to the next floor, everything on the wall, the theme; it makes me smile. It's uplifting and clever and creative. And I think that's what I love the most about Palace Costume. It's not just a bunch of costumes on racks that you weed through. Every vignette tells a story. And I appreciate whoever took the time to do it. It's joyful.

MH: If you were to be asked to make vignettes for one room, which one would that be? What things would you use?

LE: That is a really good question. My brain's walking through each room.

MH: It's kind of going back to your favorite room, but maybe today you have inspiration from one or another.

LE: Maybe just something different would be to go up to the very top floor. Where all the tuxedos and old military wear and stuff live. Maybe doing a more modern take on a woman dressed in the military or a woman dressed in the tuxedos. Just update it, or like the big prairie skirt, but with a fun blouse and a tie. Maybe taking it and mixing the boy-meets-girl kind of situation but do it in a fun way with a parasol and just do a kind of mashup *Vogue* editorial. But with all those clothes up there, that's really menswear, but with a feminine twist. I think that's what I would do.

Oh, you know what else I love? Oh, I love the western collection in the kitchen area. The gabardine shirts with the soutache. The embroidery, the cowboy boots, and the turquoise jewelry. That room definitely causes a reaction, but . . . I can't pinpoint it. Yeah. I used to love to wear the gabardine shirts with the fringe in the '80s. I would wear them with really-high-waisted pants.

MH: Do you have your favorite pieces in the collection?

LE: I do. I'm trying to think what they would be. Well, okay. In the women's '30s, '40s suiting, there are a couple of '40s suits that I've used on shows that just are so beautifully made . . . from the quality of the fabric to the broad shoulder and that narrow waist, and it's just, the details in that room always make me really happy. To see the gorgeous '30s dresses. That probably is my favorite room, and I love digging through there. That would be along with going through all their kimonos in the ethnic room. Oh, and that back wall with the coral and the turquoise. The big chunky necklaces. The African pieces blow my mind.

MH: Last question: As a costume designer, what does Palace Costume mean to you?

LE: Inspiration stimulates curiosity. It's saved me over and over again to come in and find that perfect monocle or old beaded purse tucked underneath the rack. That just is like that perfect piece. It also has to do with the people who work here as well. People who I've known for thirty years. And that comfort zone, that familiarity. Like you keep coming in and you get—for me, because I've been coming here a long time—you get a hug. You wanna catch up, you wanna talk and see what's happening.

And also, I can come running in a hurry and say, "This is what I need," and they will stop what they're doing and walk me back and help me find it. Or say it's on the second floor and that third rack, you're gonna find it there. They help me cut corners when I'm really in a rush. And that's a big one. But what it really means to me is that when I'm really struggling with a concept or a design, I can come in here and walk through and just, like, even not pull anything but just get the stimulation and the inspiration that I need. Just like writers get writer's block, I get that design block, and I can come and walk through here, and it's so unique, and every room just has its own vibe, and I get really calm when I come here.

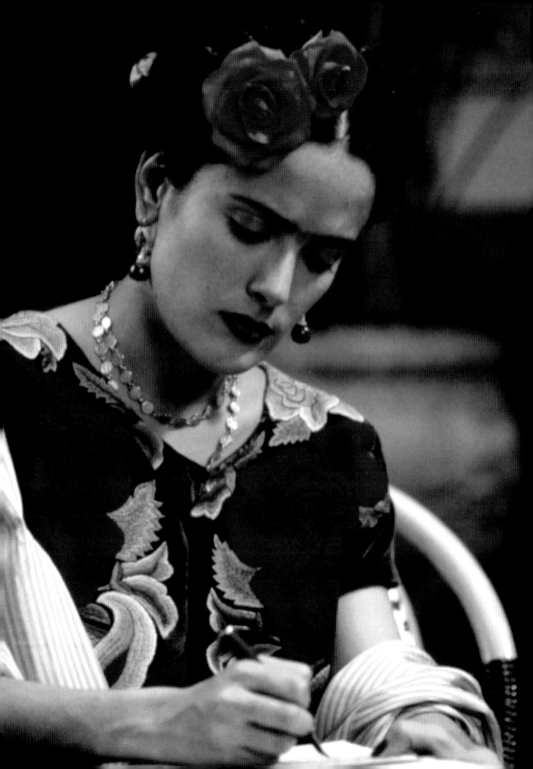

JULIE WEISS

Julie Weiss is a two-time Academy Award–nominated costume designer for her work on both 12 Monkeys *(1996) and* Frida *(2003). She has also been nominated for a BAFTA award and seven Emmys, winning two for* A Woman of Independent Means *(1995) and* The Dollmaker *(1984). She is the recipient of a Career Achievement Award from the Costume Designers Guild Awards. Her film credits include* Steel Magnolias *(1989),* Fear and Loathing in Las Vegas *(1998), and* American Beauty *(1999).*

MH: Can you tell us what has made Palace Costume such a special place for costume designers, stylists, and for you personally.

JW: Palace Costume, one must remember, is a home for many designers. And if it's not initially a home, it eventually becomes a home. Melody, Lee, and so many people have grown up here. Many people have become designers who have seen the murals outside and who have discovered this place. It truly is a palace except that on the walls is the history of costume.

All of these beautiful pieces of clothing are clothing that people have worn. That means that when you touch these things, you know that when the camera sees these costumes, when they merge with the actor who tries these costumes on, and when the character then merges with the actor, the history of these garments becomes an integral part of a larger story.

Palace Costume embodies the work of so many costume designers and their contributions to cinema. It's the history of one's work, whether it's myself or Milena Canonero, Colleen Atwood, Mary Zophres, Mark Bridges, so many designers, they are all here. Their work is here for all designers to rent. When I was beginning, I brought my drawings in and I laid them out and I had very little money. And I said, "Please, these are my drawings. Can you help me?" And they always helped me, whether it's a very small movie or a large movie. The point is, is that Melody will believe in you as you are becoming the designer that believes in yourself. I would not have a career without them.

MH: Can you share with us your experience in creating *Frida* and having Palace as an indispensable resource?

JW: It was such an honor to design *Frida*, to visualize and understand Frida Kahlo. Imagine Frida Kahlo from the time she was young, experiencing pain that so many elders experience, the wonderment of whether or not pain ages or makes you understand those moments that you must do what you have to do in your life because you don't know what's next. Walking into Palace,

Frida, Salma Hayek, 2002. © Miramax/Courtesy Everett Collection.

Frida blossomed into who she was as an artist because of her Oaxacan roots. Her signature style included her traditional and colorful Tehuana skirts and blouses, the fresh flowers adorning her braided hair, as well as her ornate Mexican jewelry, including the jade necklaces, the amulets, and her unique mixture of treasures and trinkets.

you see a room of Frida and you wonder before you go to the Blue House, before you see her closet, is this where she lived? There are Tehuanas, there are Rebozos, there are her skirts, there are her beautiful embroidered blouses that she wore with her jeans.

Then we could go to her twenties and her thirties and get the pleated men's trousers that she wore. Palace understands Frida. Frida blossomed into who she was as an artist because of her Oaxacan roots. Her signature style included her traditional and colorful Tehuana skirts and blouses, the fresh flowers adorning her braided hair, as well as her ornate Mexican jewelry, including the jade necklaces, the amulets, and her unique mixture of treasures and trinkets.

They came together with her. But she will always have that struggle from the accident, the lift in her shoe, the memory of when, in one moment, she was almost not there. And the years of the cast

on her, the body cast where she painted those butterflies. And when she met Diego, that was in the '20s. So once again, Palace had the history of the world around Frida and the authenticity of who Frida is. But as I have said many times, when she walked down that street in her Oaxacan dress with Diego, it was, "This is who I am, and this is who I will be." And this was who she is and who we think of her. And this is the honor that I, as a costume designer, was able to be part of in telling her story. And as I walk into this room, I see Frida. I see her everywhere. And I am so grateful that I could begin my journey in this room at Palace.

MH: Tell us about the early days at the Crystal Palace on Melrose when you first met Melody.

JW: At the time I met Melody, she would dress in 1930s clothes. She looked beautiful, as she does today. Her hair was full of curls. She looked like she could just burst into song, but it was her costumes that knew the music of each year.

And I would come in and I would be dressed somewhat appropriately, not to the world but to me. And then I would get dressed to go out, and I would leave the clothes in a paper bag. My favorite dress, which I still have, it is snagged and torn, was a green 1920s dress with fringe, great fringe, layers and layers. And I would wear Victorian shawls, beautiful shawls, one of which had the fringe caught in Mick Jagger's three-button fly. But at that time, I could buy things at Crystal Palace. I was a large woman. I still am. But size never made a difference in rentals, because the world consisted of many different people as did all of the costumes at Palace. The purses, what did they hold inside? Identifications. Maybe one still has that card, that picture from Ellis Island. One didn't know what you might come across. Maybe there was a pair of trousers that had an old cigarette or a pair of matches still in that cuff. That's magic. And that magic is still here.

MH: Can you tell us about some of your favorite pieces at Palace:

JW: There is just so much. The stories that are put together on these windows, these beautiful windows, we call them "windows" but they're merely glass cases of Melody's collections that Lee helps to create. I get inspired here. The silver combs, the mirrors. I have some from my grandmother and now I look at them and wonder how she looked in them as she wore her dresses in 1900. All of the Victorian section, the white section, blouses, dresses, slips, corsets, a room of all white.

And then you see crochet, you see bottoms, you see tops. And you hope that as you pick these beautiful fabrics, laced, dotted Swiss, the sleeves, the high necks, you hope that the cameras capture more than headshots. I've used so many of these things. And then you turn around and you look up and it's black. The funerals, the early death, the loss of children. And you go straight ahead and you see the hat boxes. Oh yes, what is in there? The hats. And then you know about the hat pins and you wonder, "Hmm, who had the poison on

the end?" And the stockings, all of those stockings, those silk stockings, and you remember when your grandmother had to wear the support ones. And then we come to the velvet capes. And we know when the actor wears these beautiful velvet capes they will break through that screen and the viewer will feel as though they are touching these fabrics. They are magnificent, more than magnificent.

MH: How do the costumes themselves evoke stories?

JW: In so many ways. So this is called the Depression room, but for me it's the inspiration room. These things have a past, whether it's the beginning of someone's journey or the end of someone's journey. Things have been rained on, babies that were wrapped in hand-knit blankets, crops that went dead, slavery, horses, farms. You can sense the lives that lived in this clothing.

And then there were these magnificent 1930s silk dresses from Shanghai, probably some of the best costumes I have ever done. And as the costume designer I begged the producers, I said, "It's going to rain. Please cover up these women in these dresses," and they said no. And these clothes were ruined. They were ruined and Palace took them back, and they ended up in the Depression Room, and they continue to have a life and be rented over and over again.

Their past looks like they've been in a hurricane, in a flood, or someone swimming to their destiny, or left abandoned by a lover crying in the rain. These are different stories. Different stories. Polka dots, '30s patterns, farm dresses, formal shirts with collars, patterns used by the best designers, hand-knit sweaters, work shirts. Of all of the rooms in Palace, I would say this room and the Victorian room, maybe the undergarment room with the beautiful corsets, the beginning of the new shapes and the shapes that when they were undone set women free, maybe that's where I will lie down between these racks at the end and have a great party.

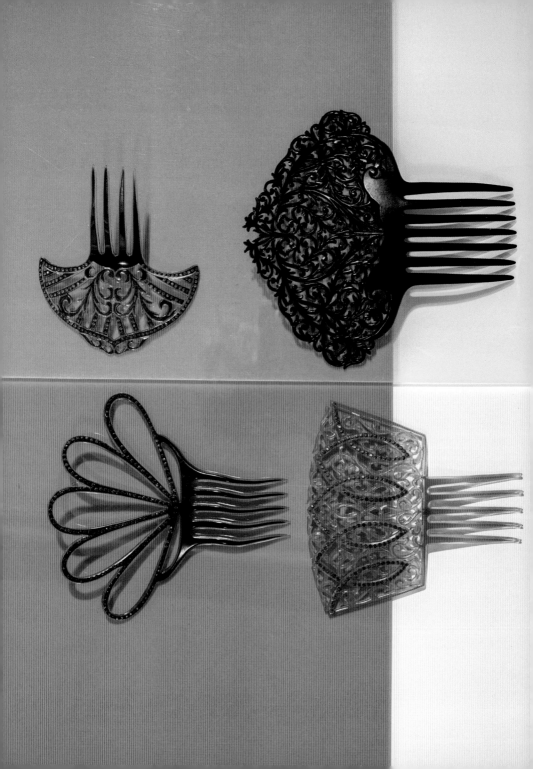

Collection

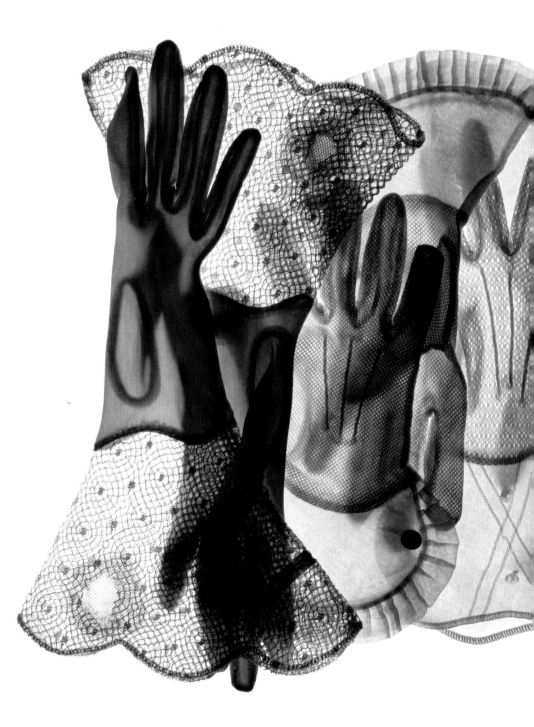

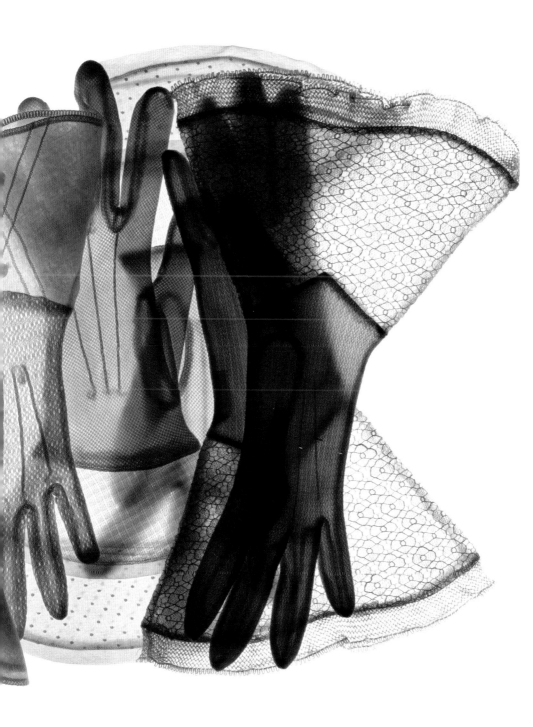

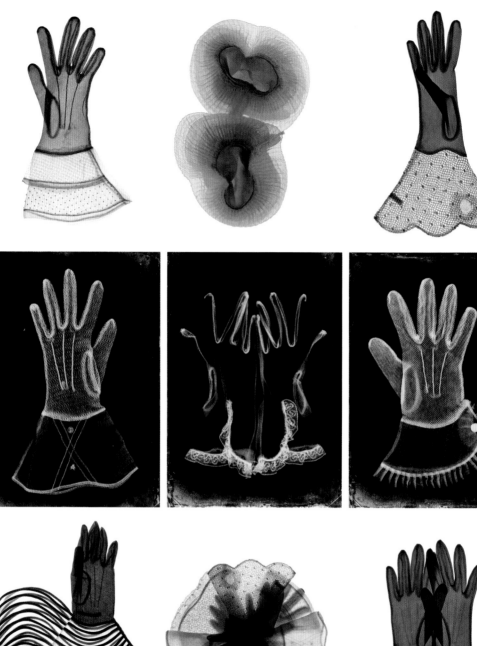

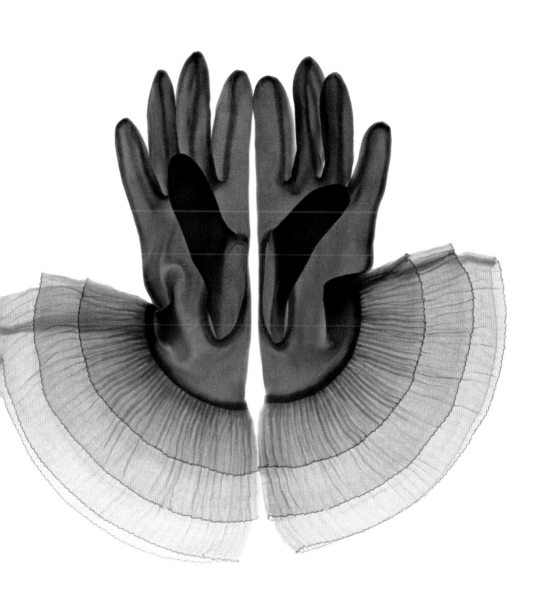

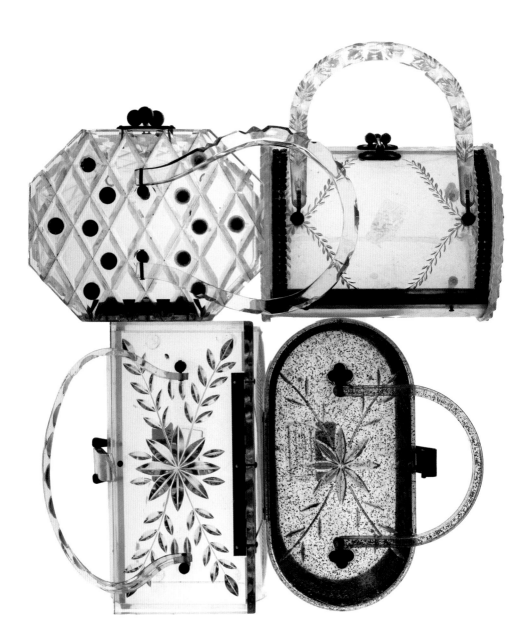

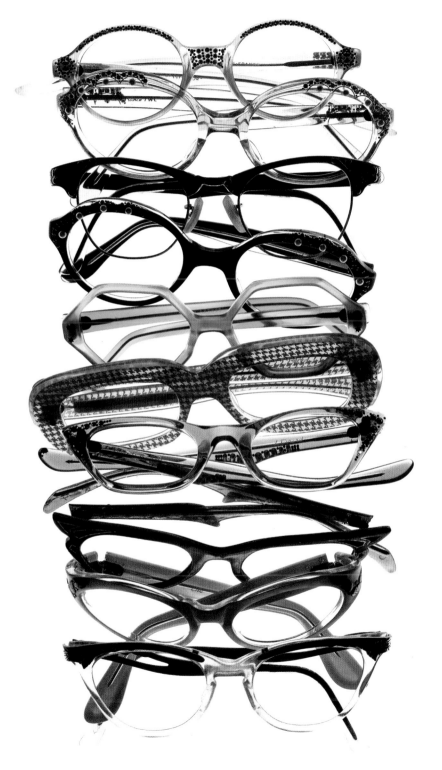

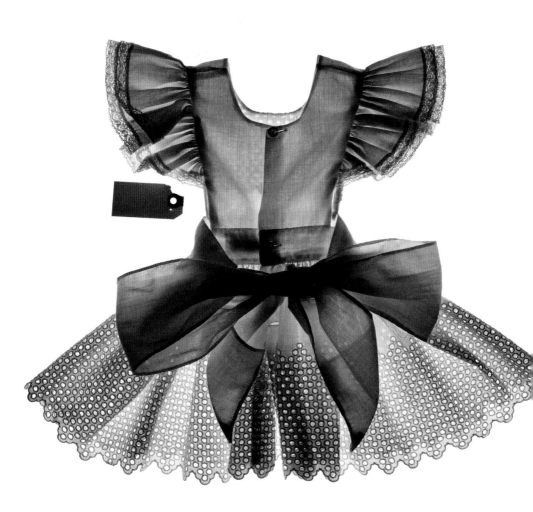

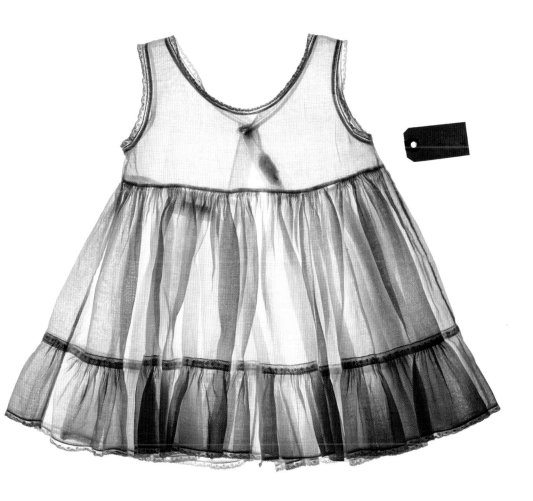

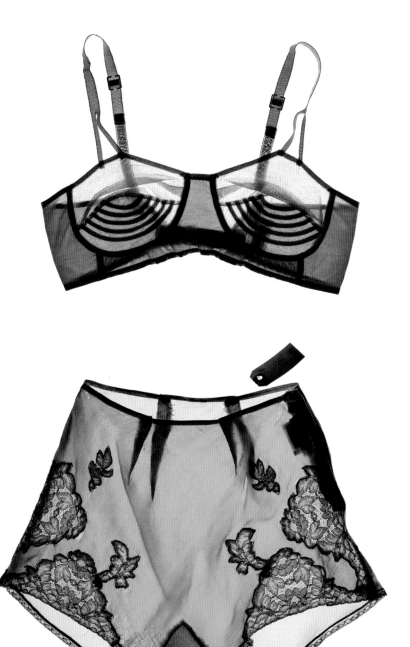

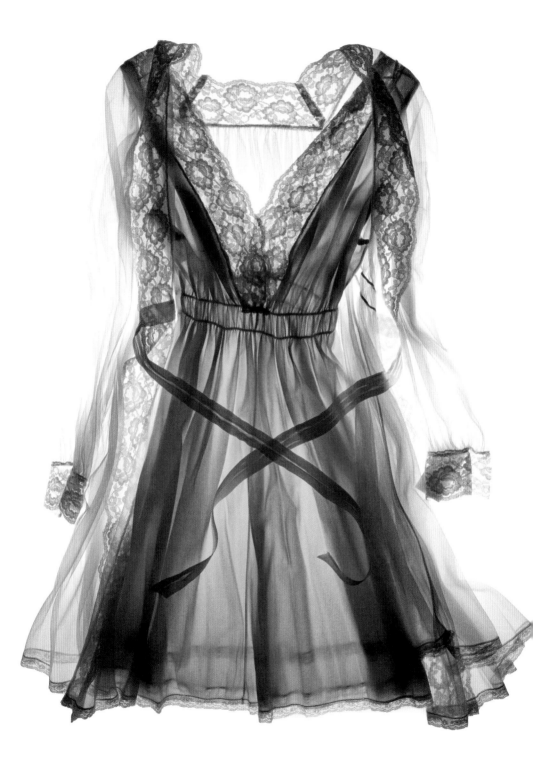

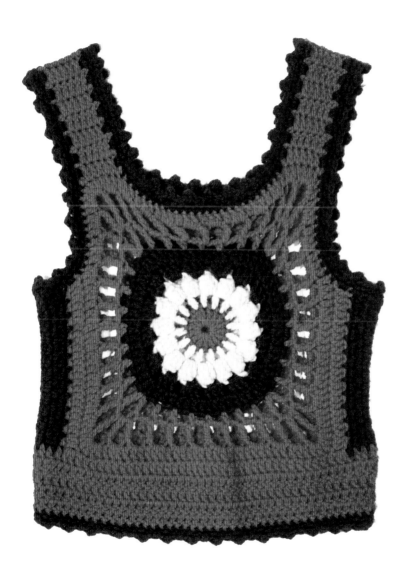

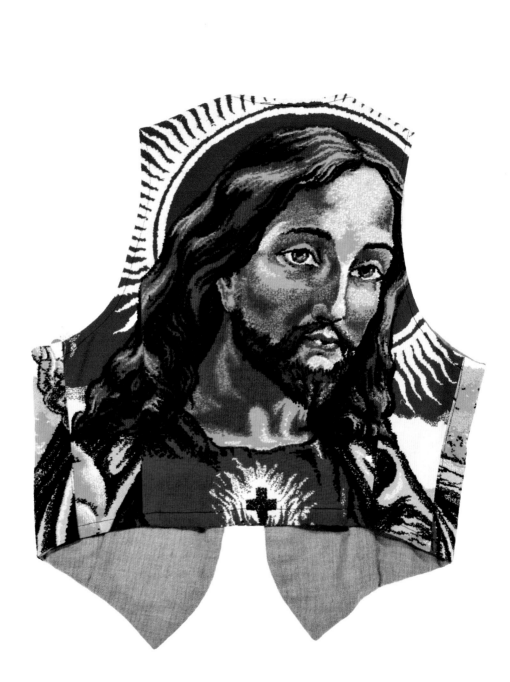

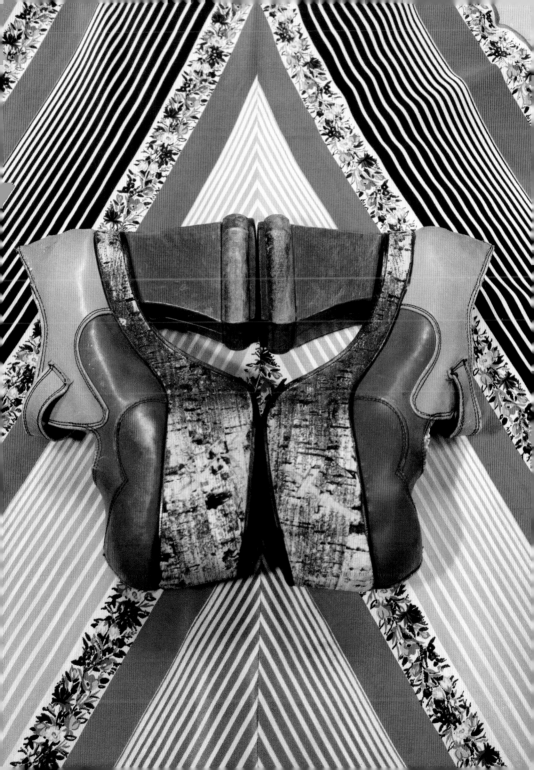

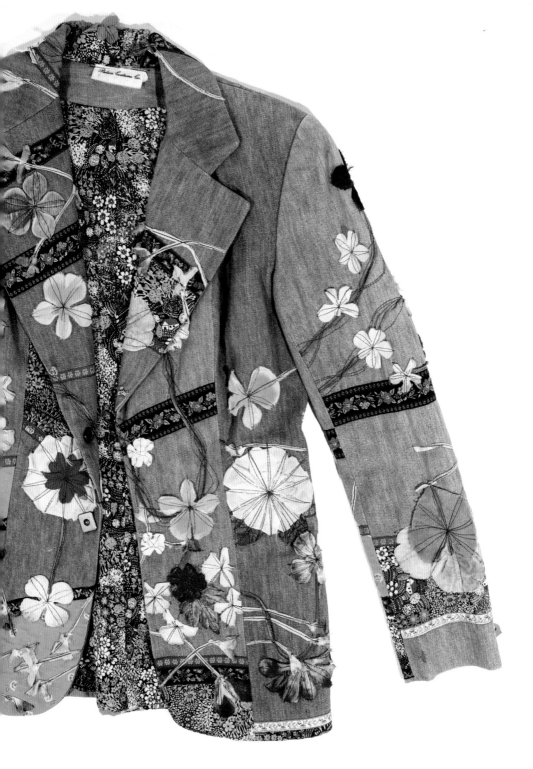

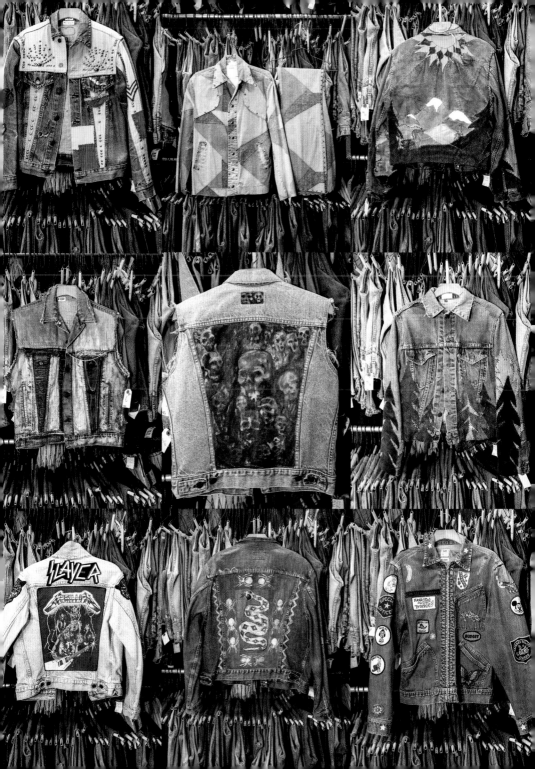

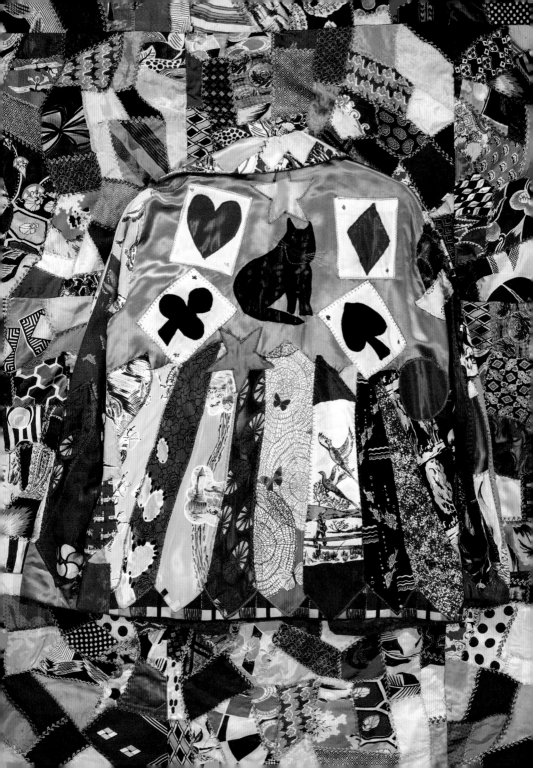

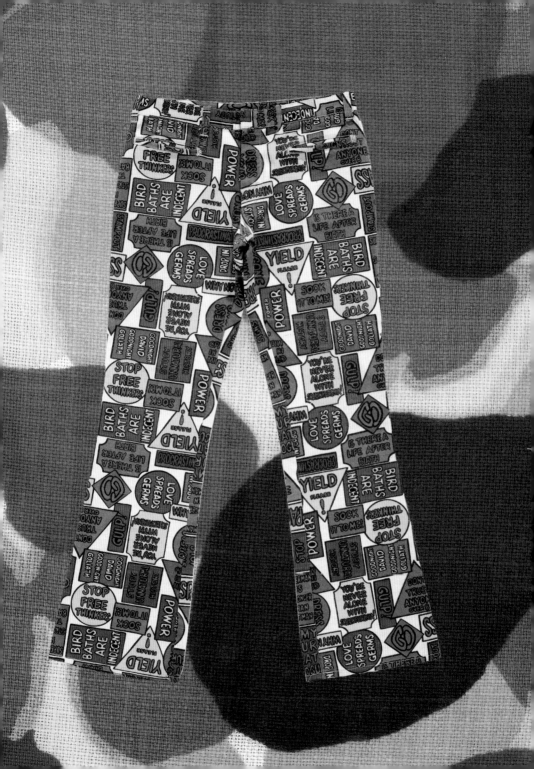

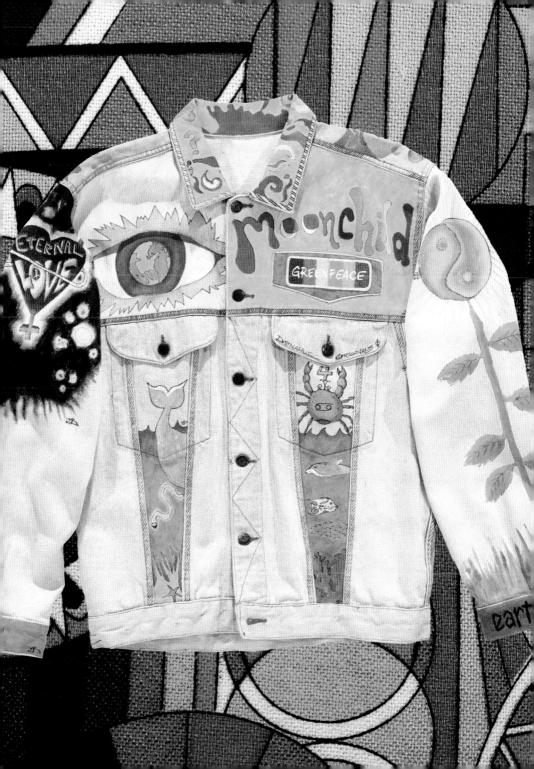

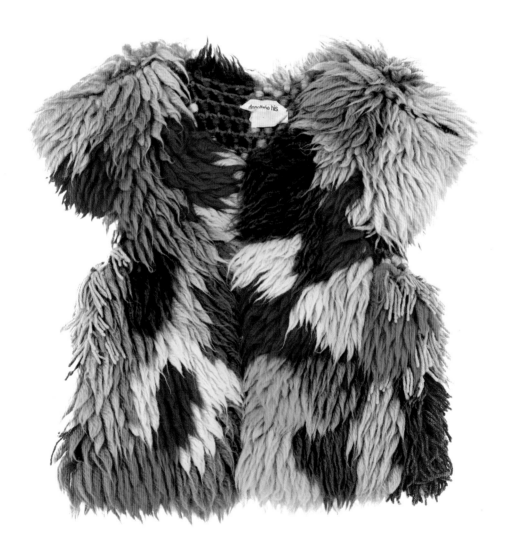

Palace Costume Co.

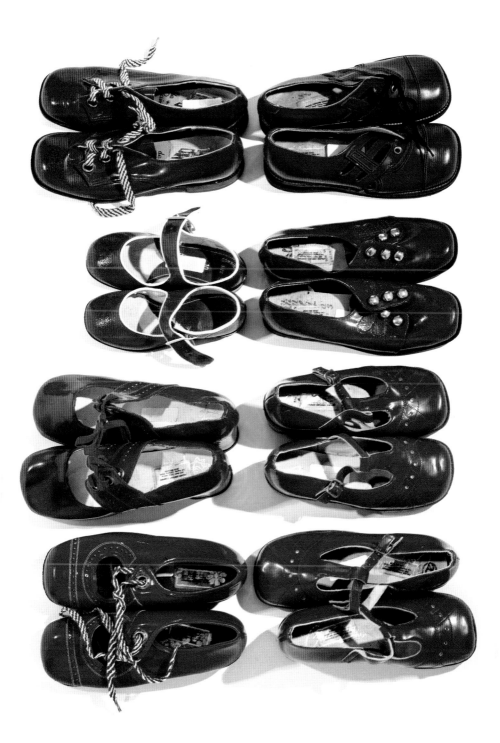

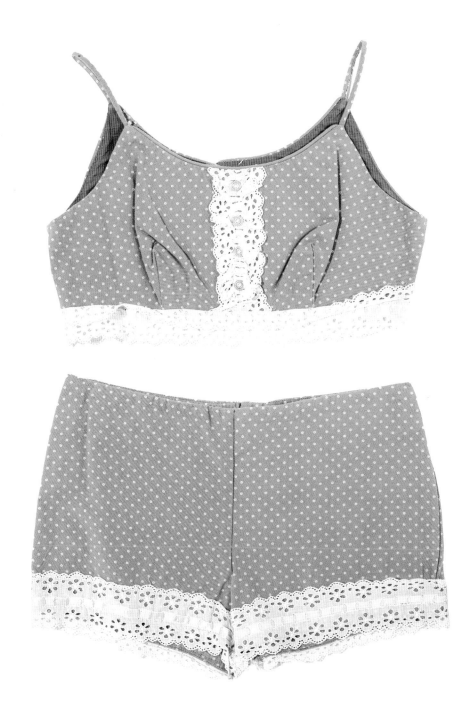

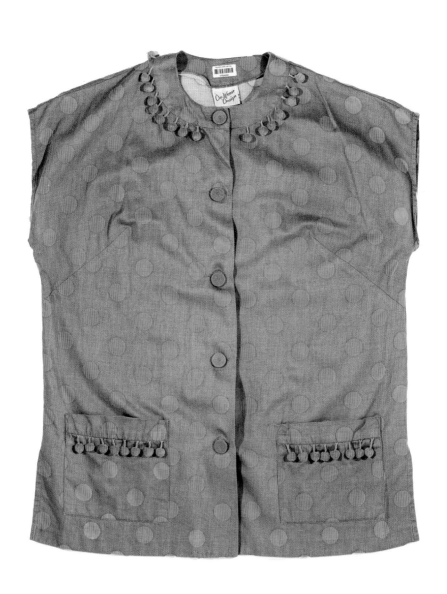

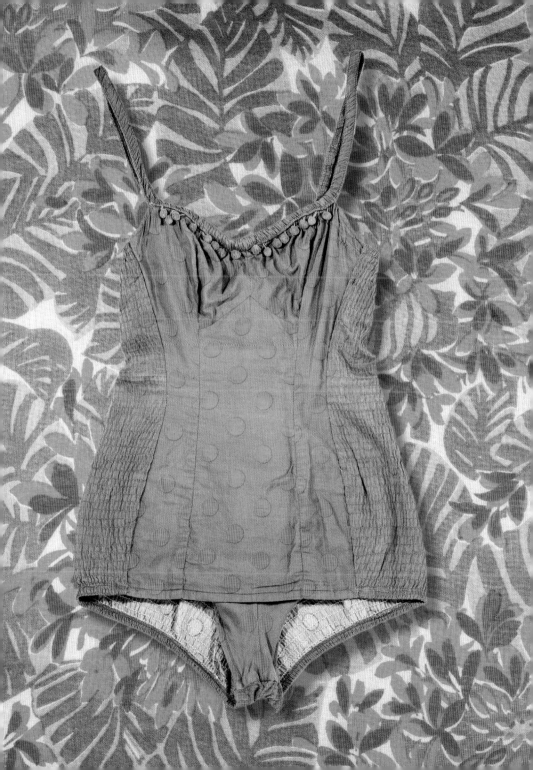

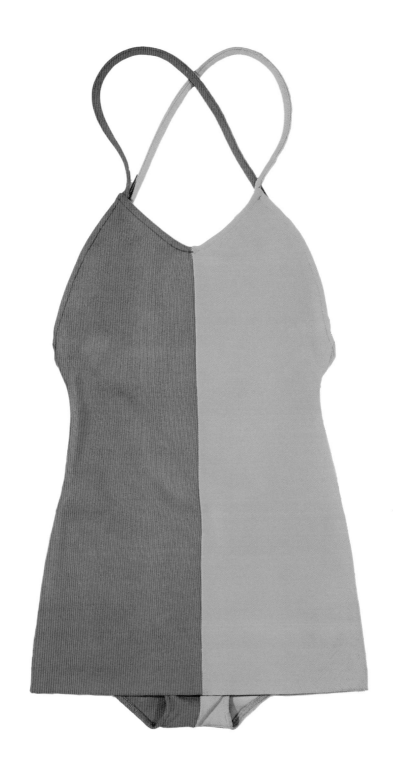

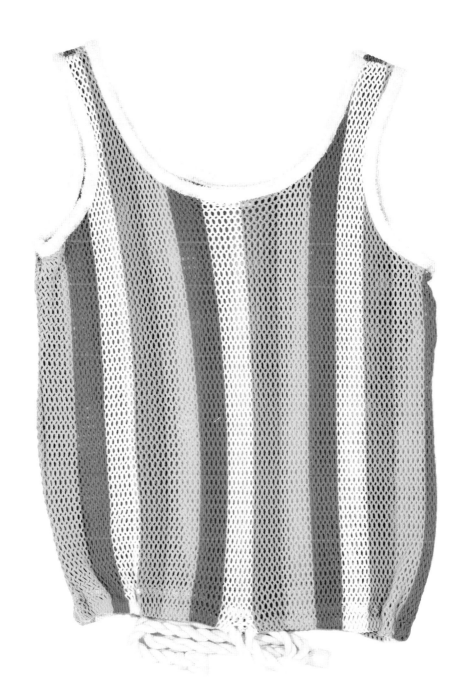

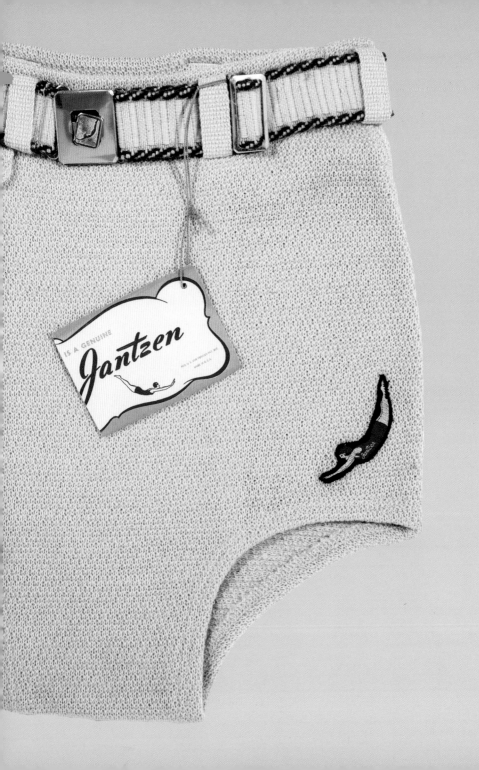

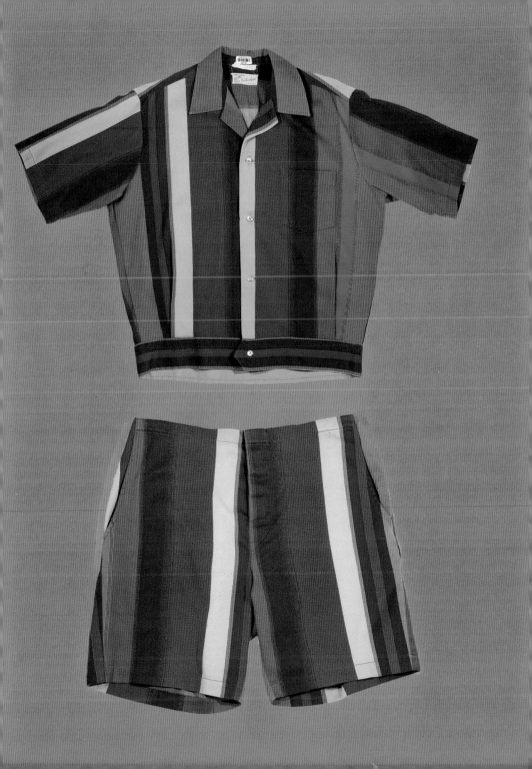

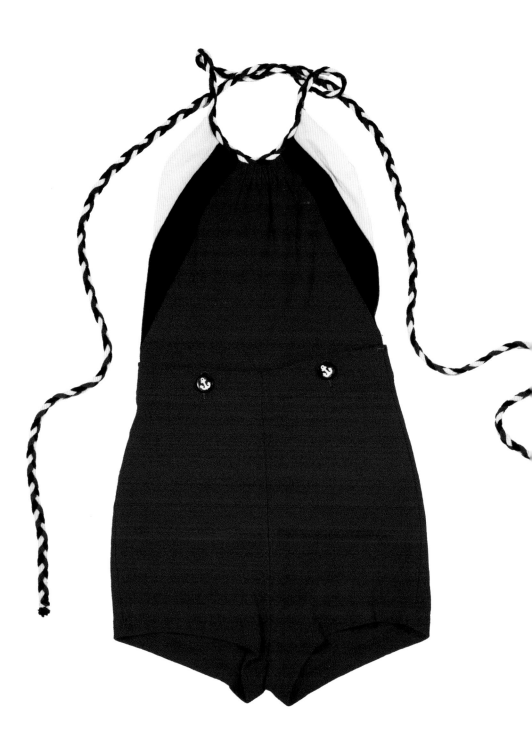

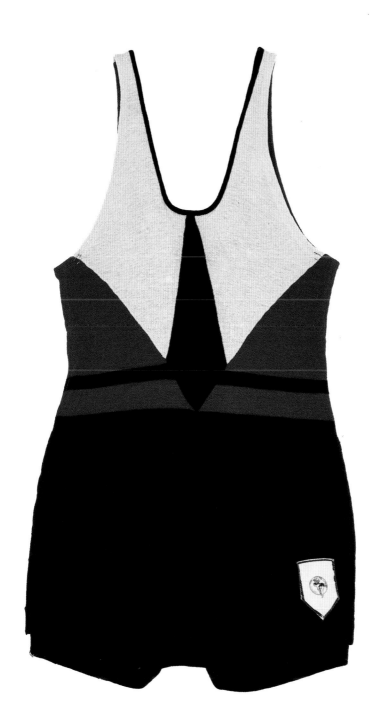

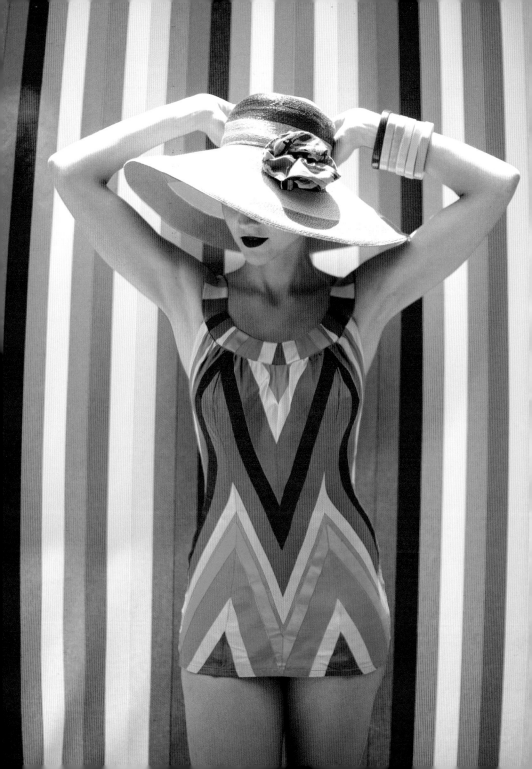

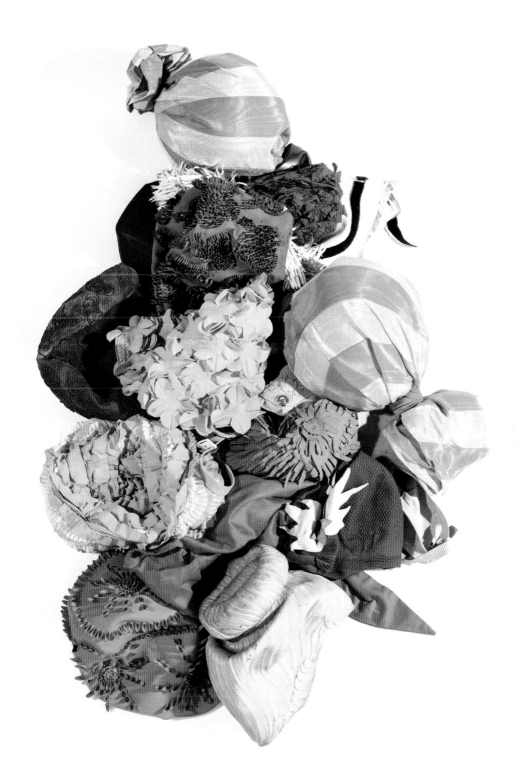

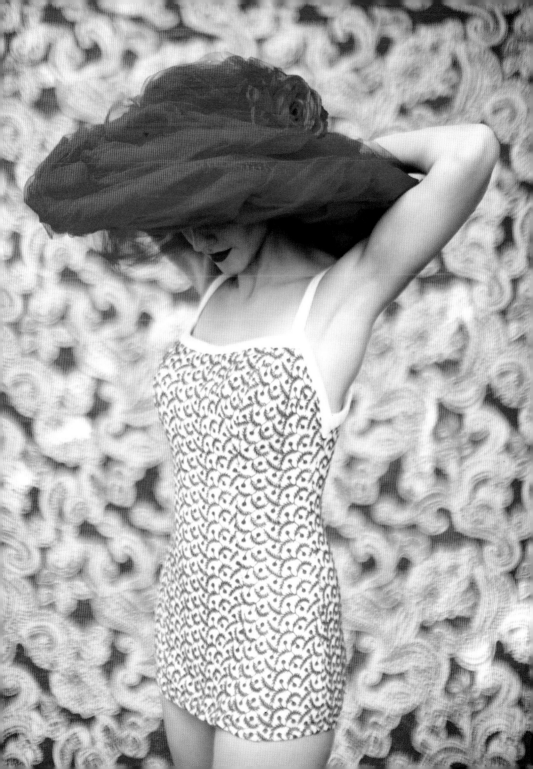

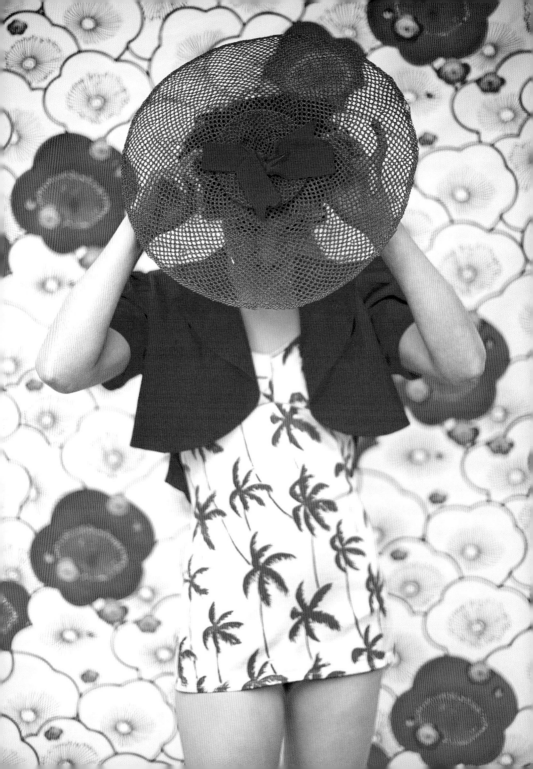

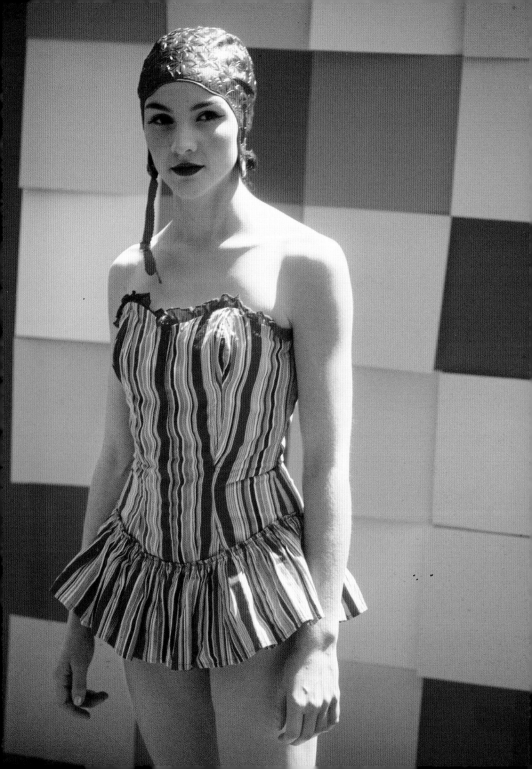

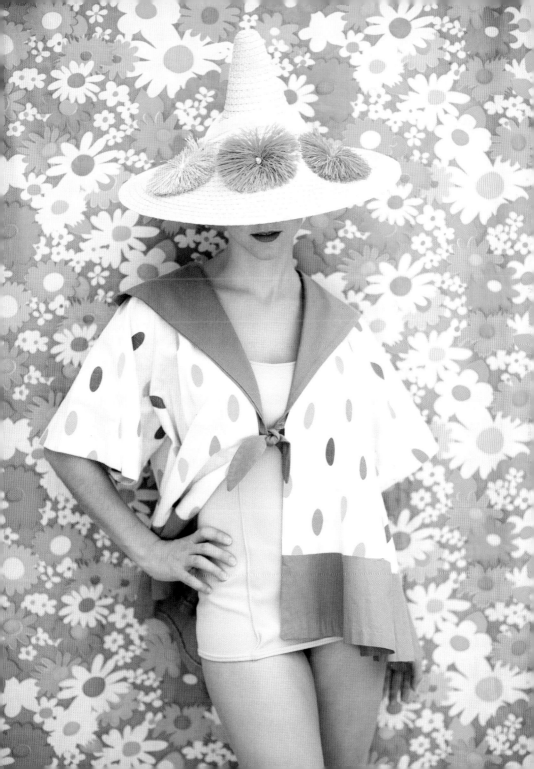

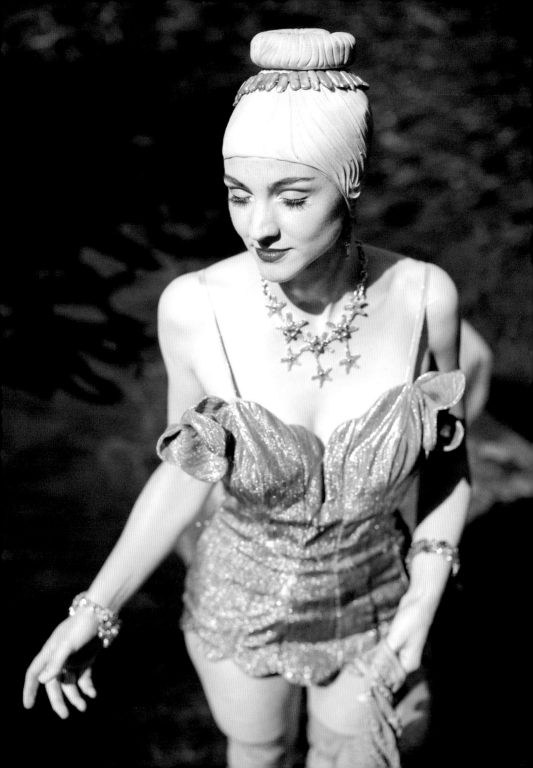

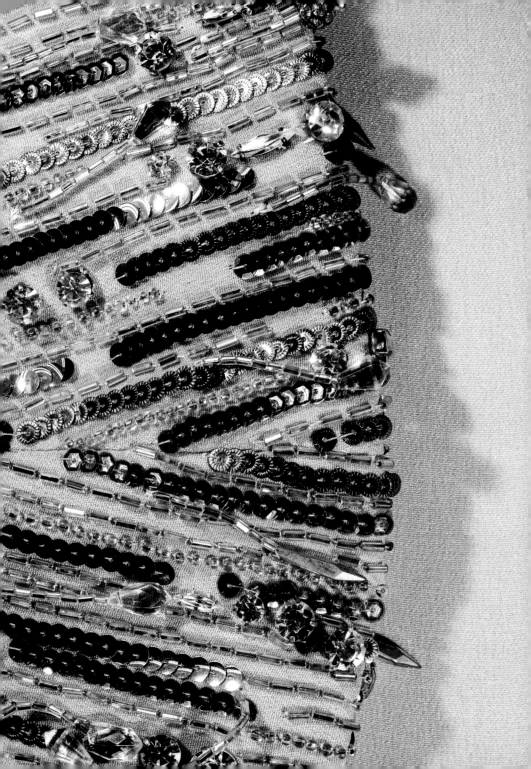

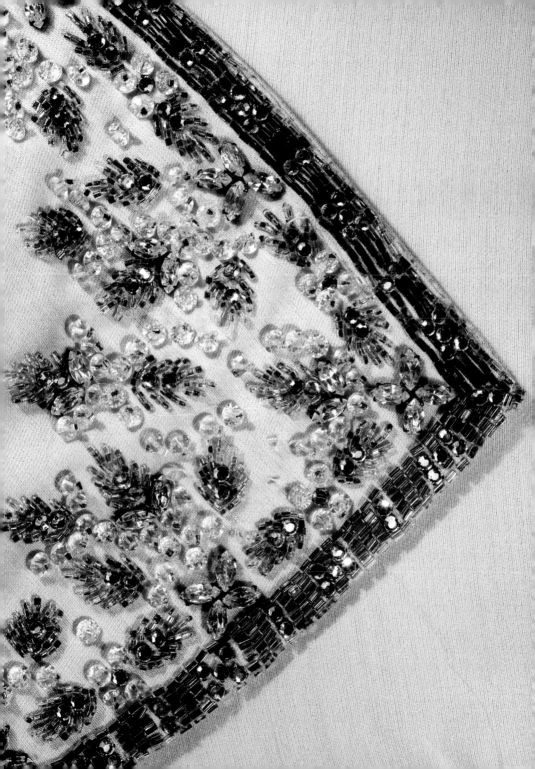

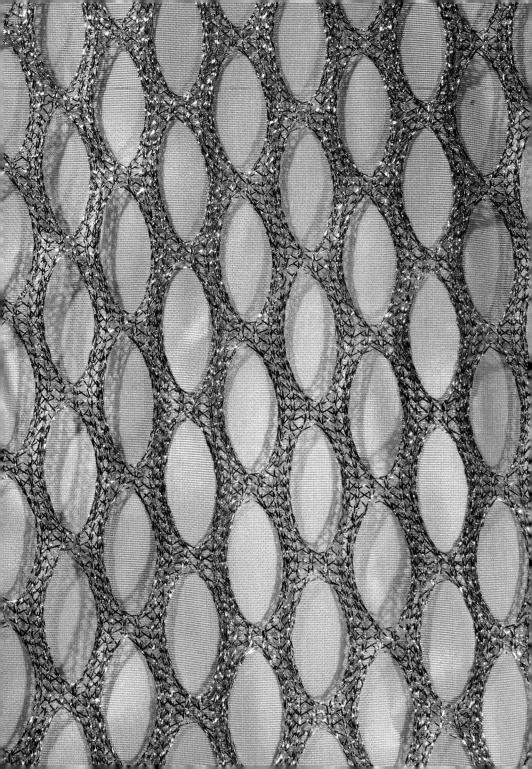

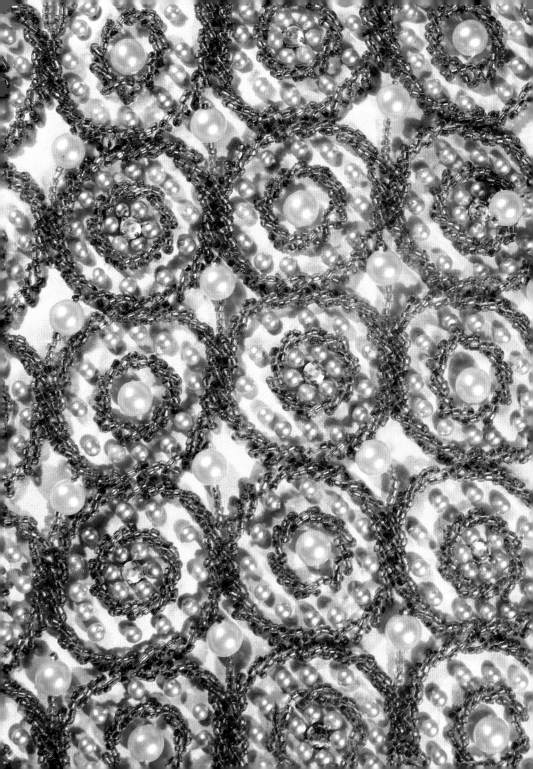

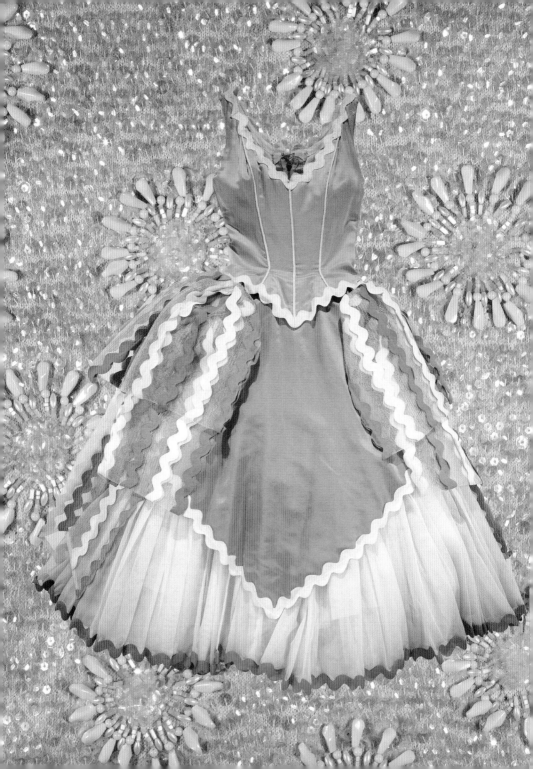

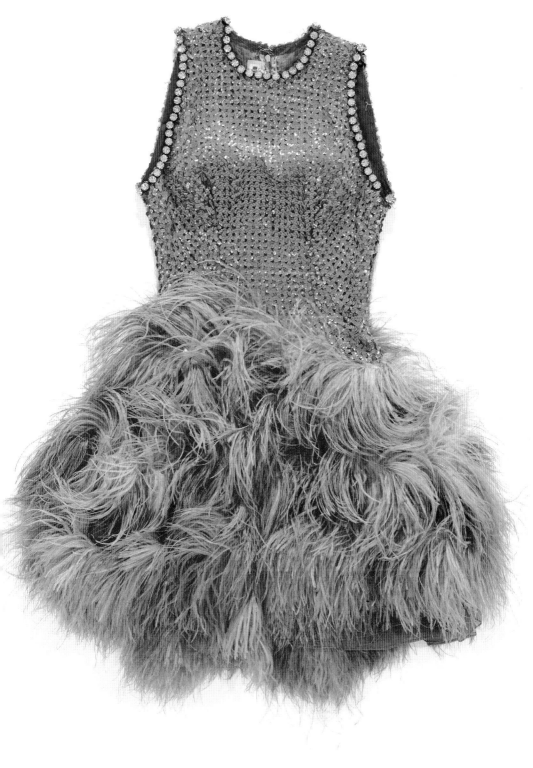

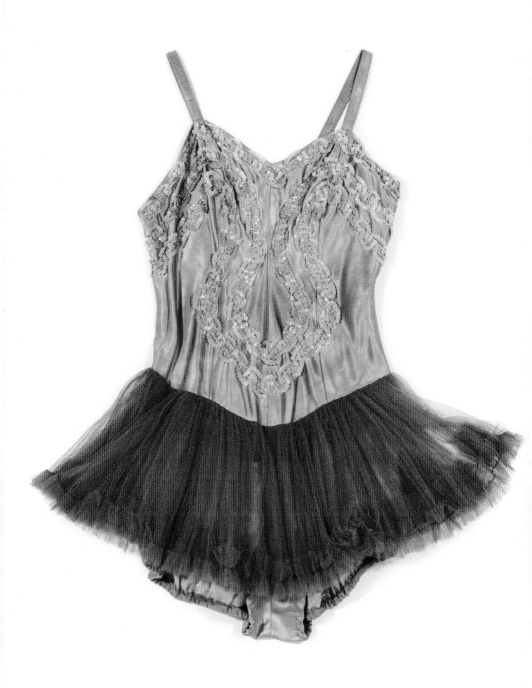

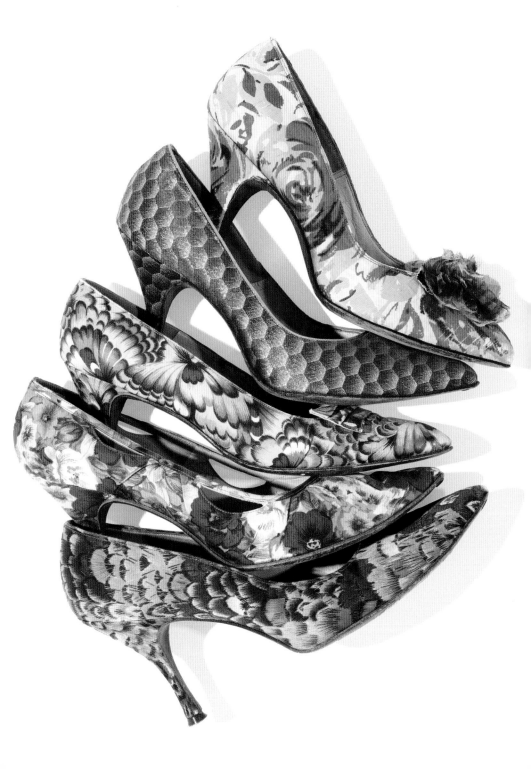

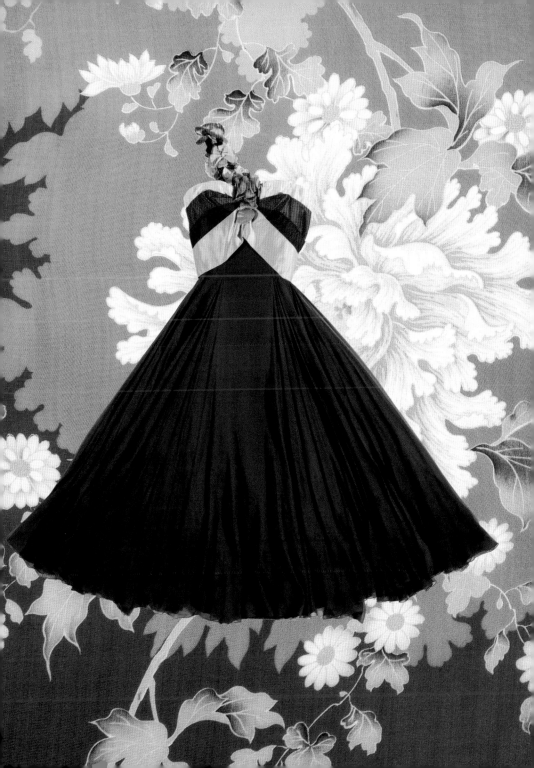

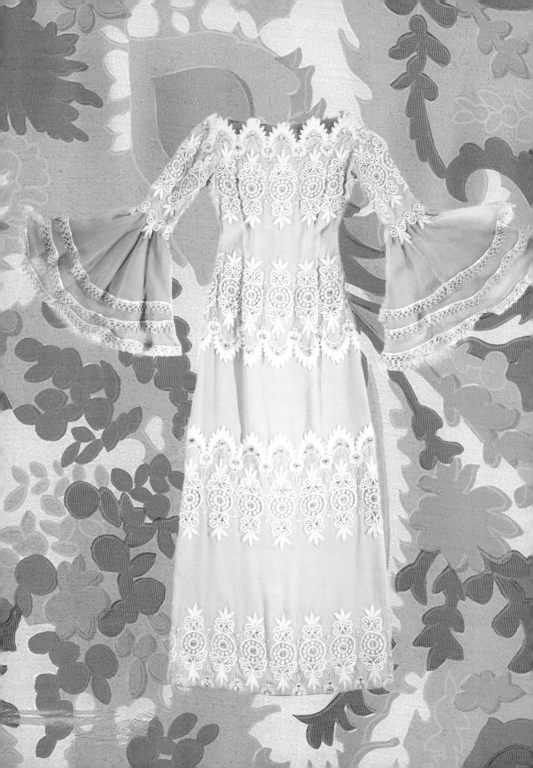

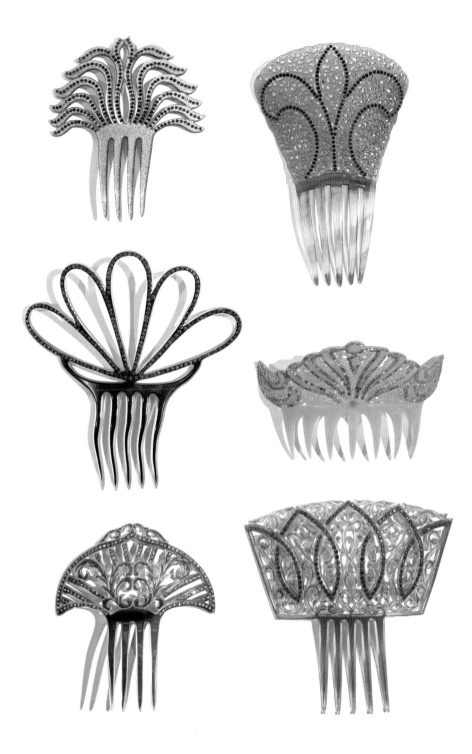

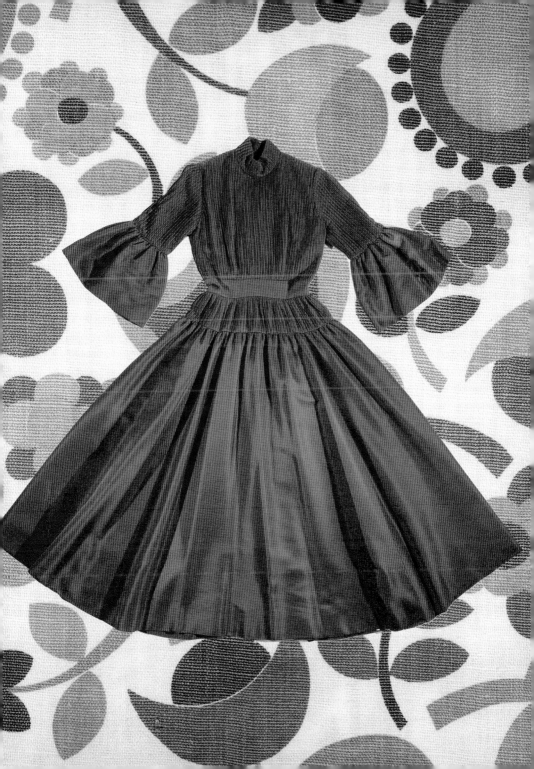

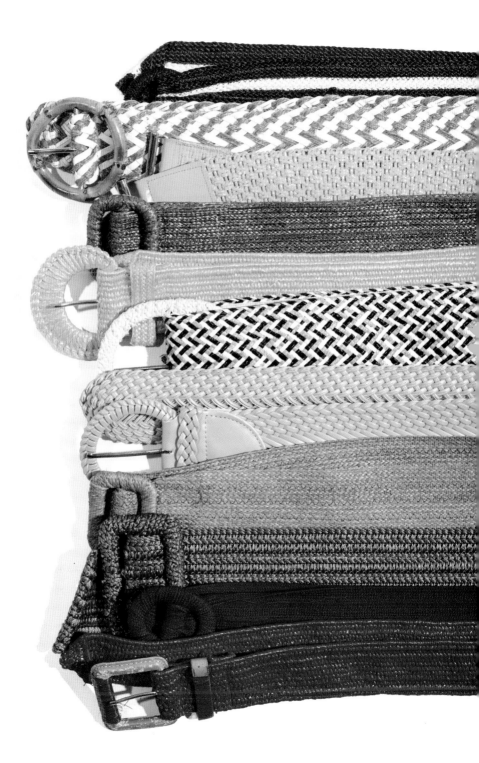

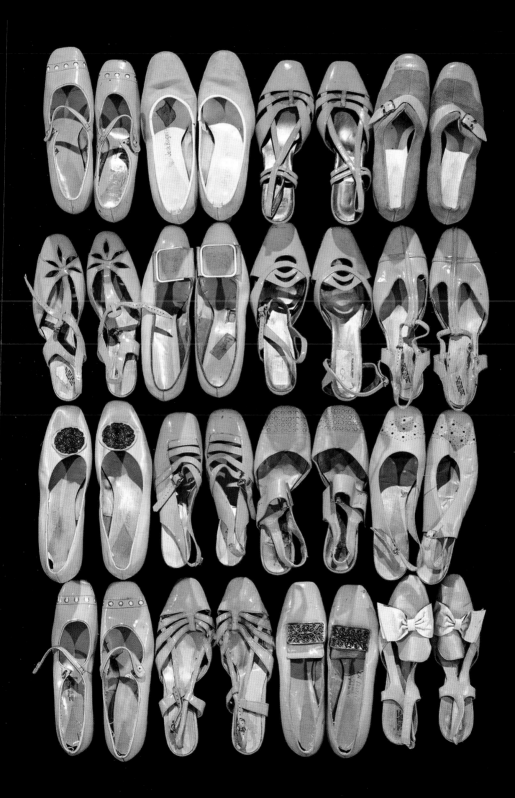

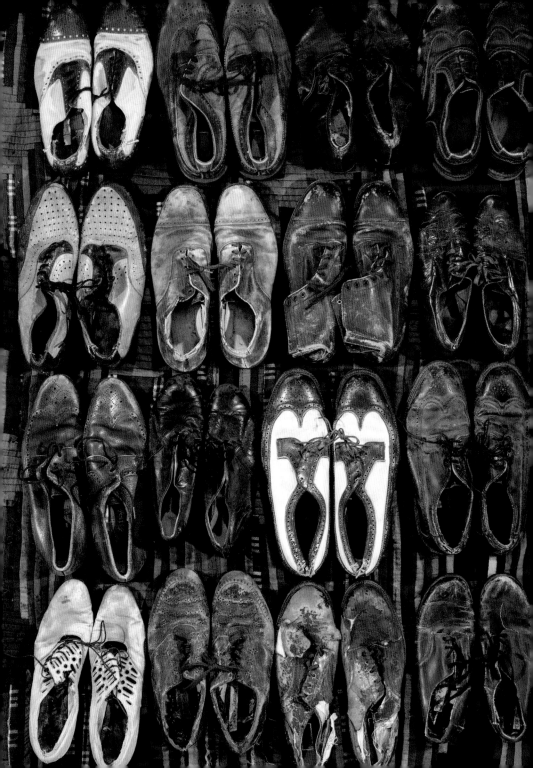

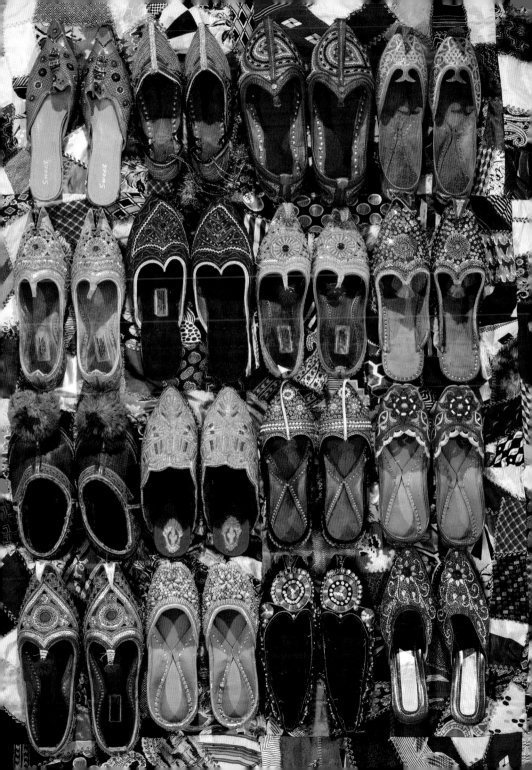

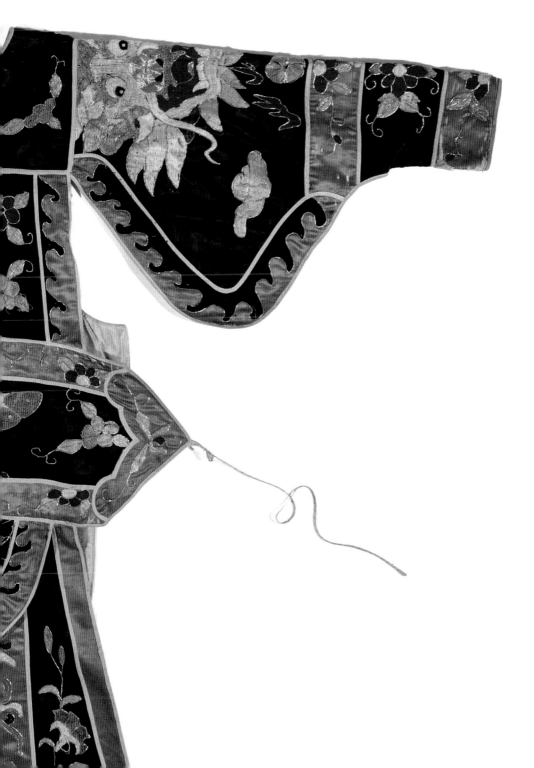

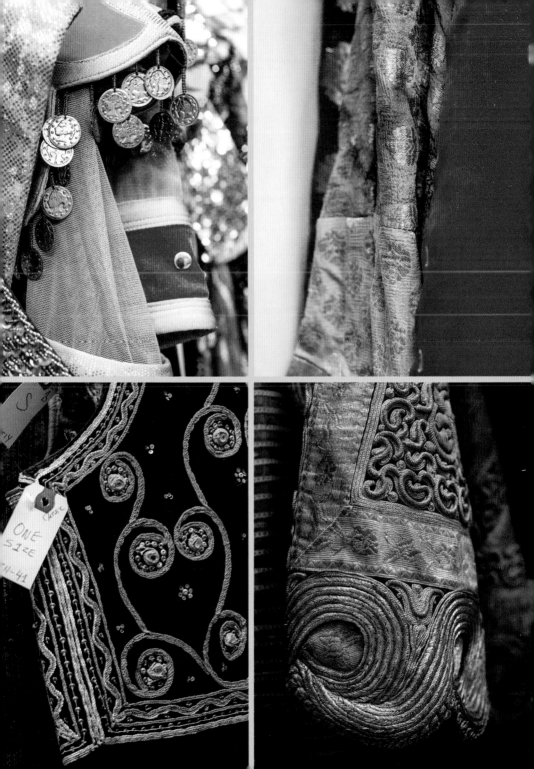

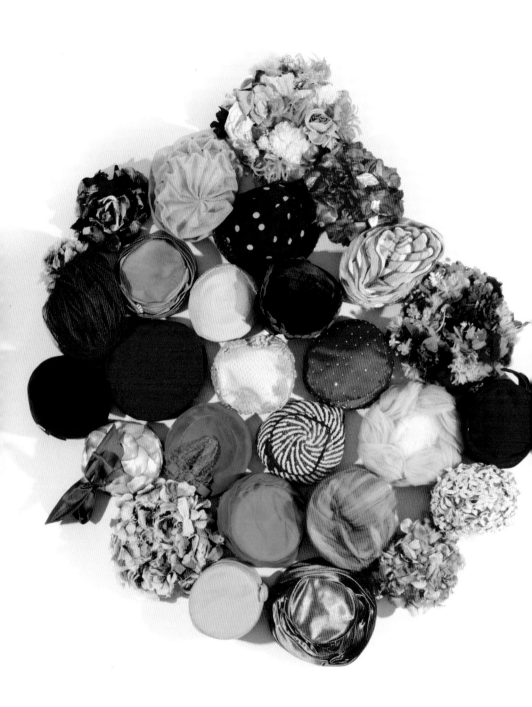

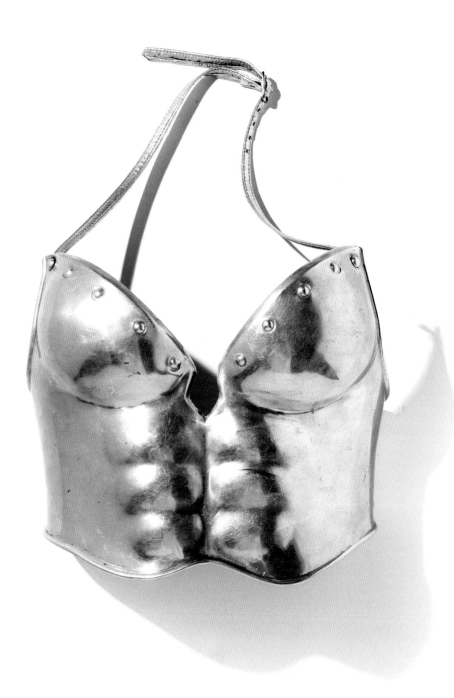

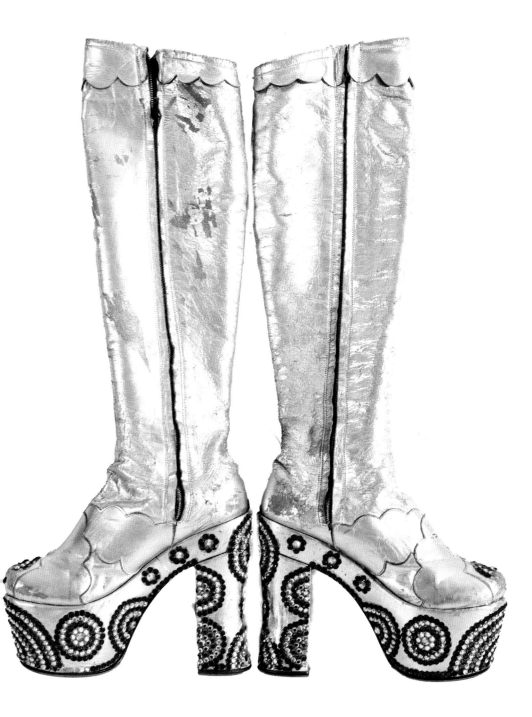

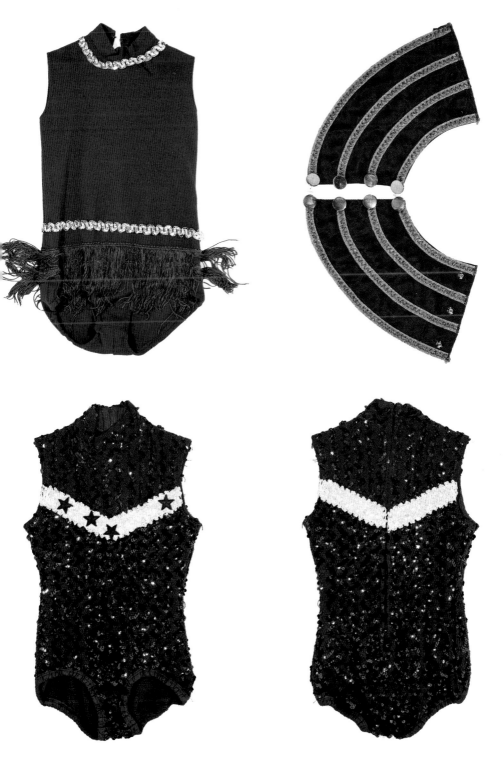

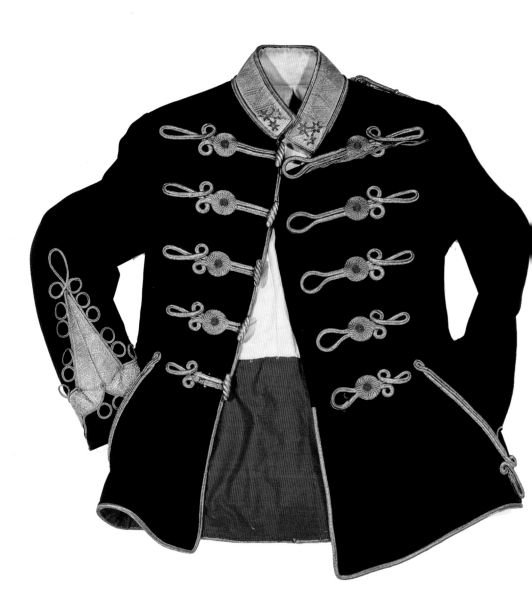

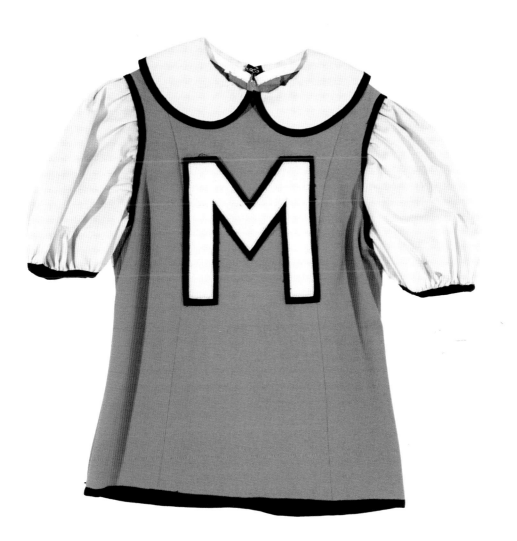

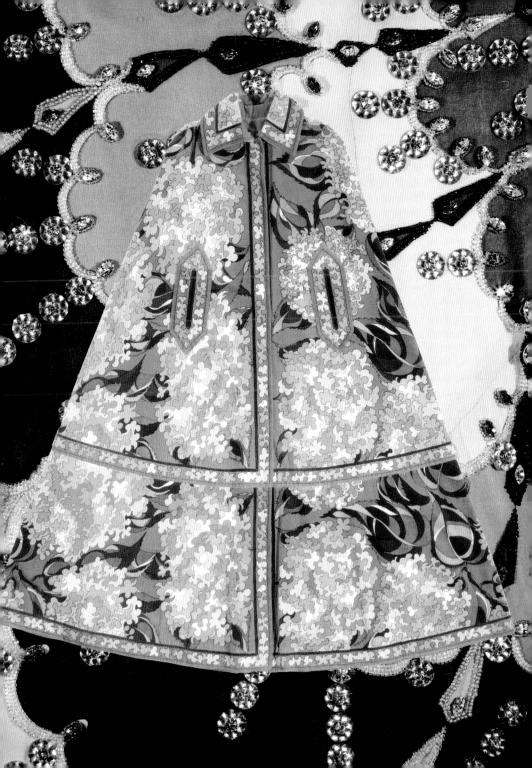

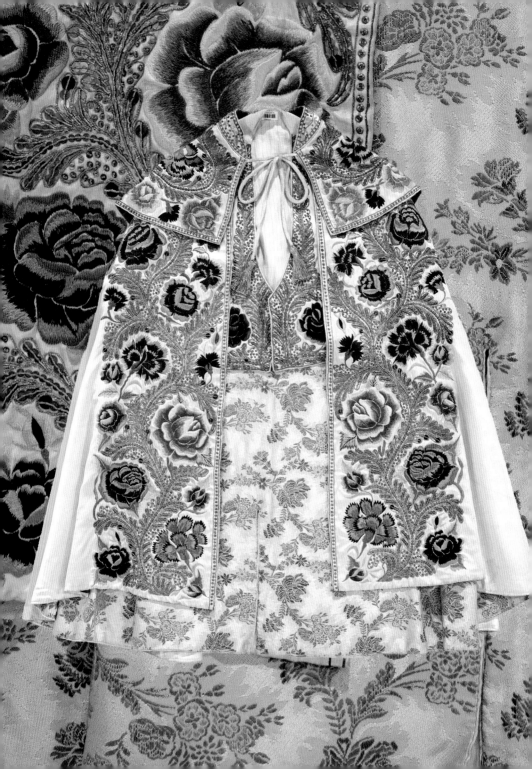

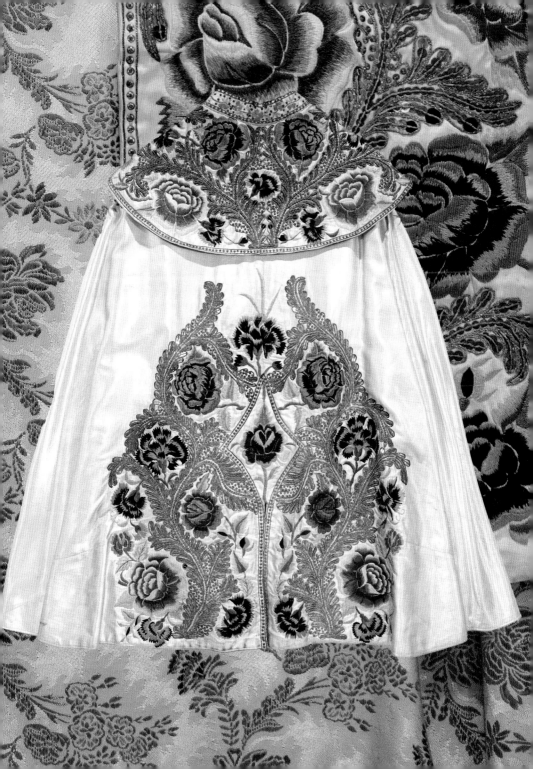

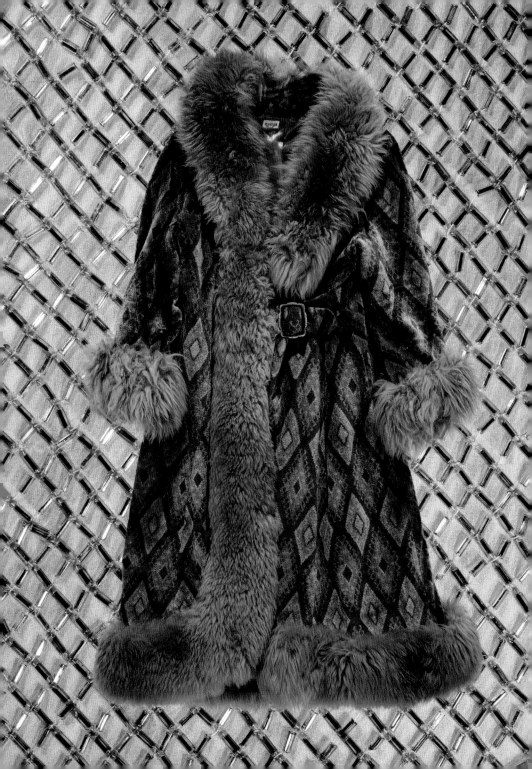

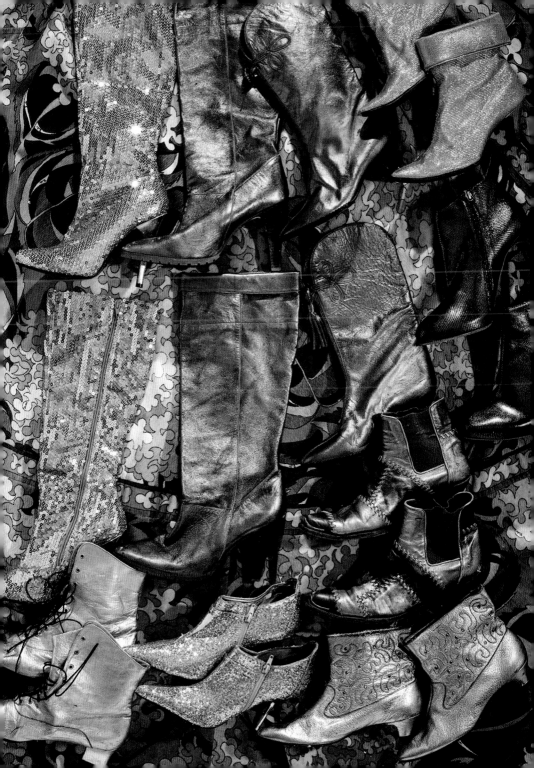

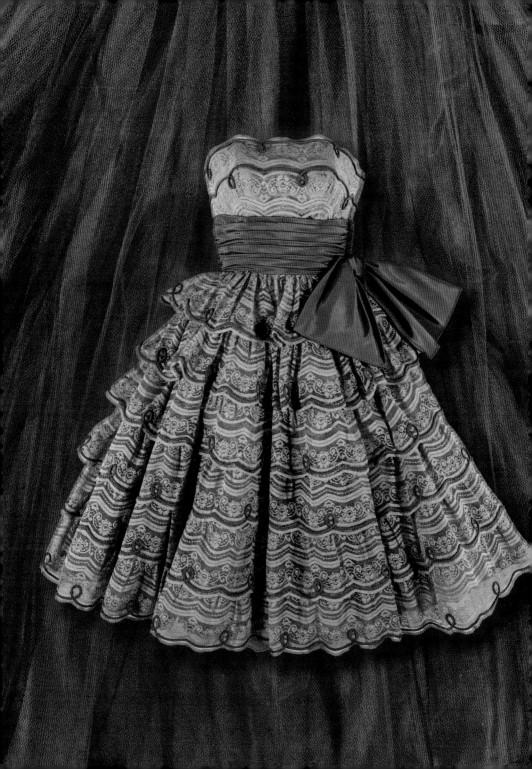

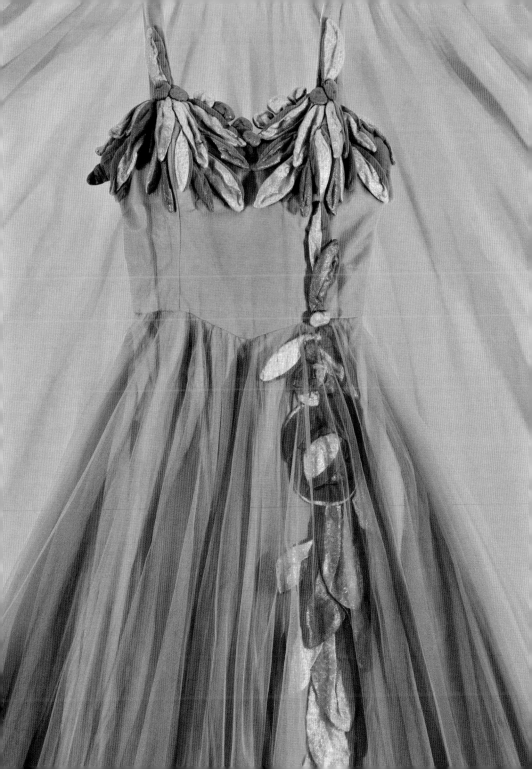

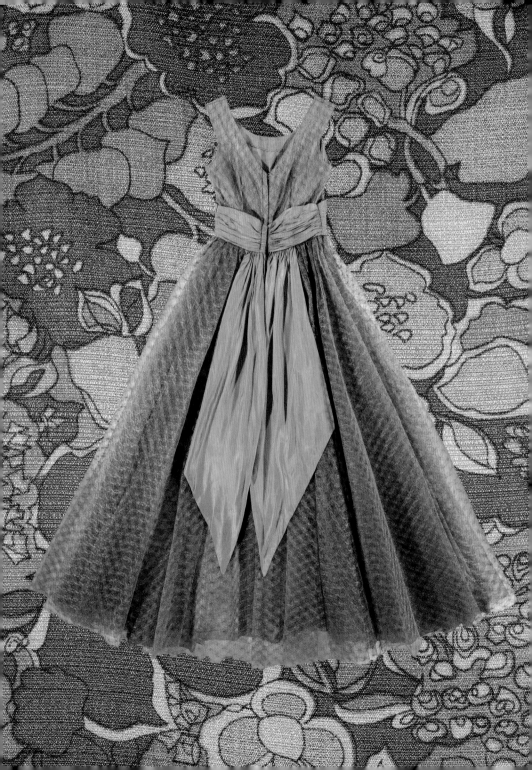

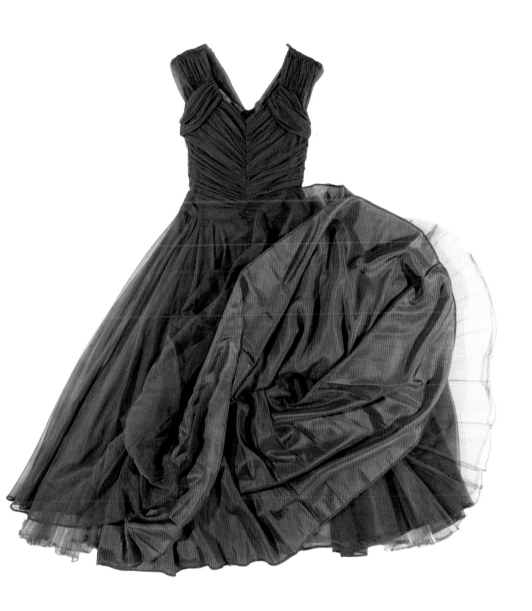

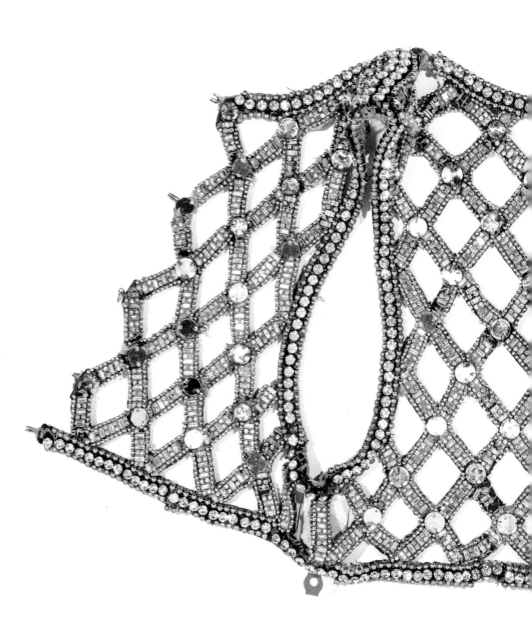

Souvenir from France

Acknowledgments

Thank you most of all to Melody Barnett for opening up her Queendom and the exquisite Palace Costume collection to me. Enormous appreciation goes to Lee Ramstead for letting down the drawbridge time and time again. To the love Palace staff and family, many thanks for helping me navigate this castle of couture, costume and collectibles: Lynda Hayden, Lynn McQuown, Vicente Tobar, Marta Arcia, Rosa Gamboa, Timothy Walker, Gabriel Toscano, Karol Lara, Emily Roman, Catherin Fromell, along with Melody's sister and brother-in-law Valerie and Louie Speaks.

Laurie Kratochvil truly made this book happen, and to her I am forever grateful. She brought her sophisticated eye, intelligent curiosity, and wicked humor to shaping the voice of the visuals. Her love of vintage, style, and Hollywood history helped to build the foundation of what the book is today.

A huge thank you goes to the astounding costume designers who have been so generous in sharing their personal experiences with the Palace Costume collection.

Paul Smith, thank you for your support and belief in this project from very early on.

A heartfelt thanks to my friends, teachers, and collaborators: Gloria Fowler, Steve Crist, Alexandria Martinez, Chronicle/Chroma, Tom Lowe, Meghan Bensen, Mick and Gill Hodgson, Aline Smithson, Nick Knight, Rebecca Arnold, Cassia and Laurel Lupo, Sharon Kagen, Carol Shaw Sutton, Diedrick Brackens, Marie Thiebault, Tanya Aguiniga, Rebecca Sittler, Carrie Burkle, Lesley Kice Nishigawara, Andres Payan, Anne Bennion, Leigh Wishner, Jodie Dolan, Doris Raymond, Peter Savic, Claudia Reisenberger, Kolby Keene, Cody Brunelle-Potter, Curtis McElhinney, Barbara Kosoff, Maxine Meltzer, Karen Florek, Barbara Cooper, and Grace Lecanu-Fayet.

JoAn and Jim Gaines, I give you a standing ovation.

Merci mille fois to mes amours Finley, Lilly, and Reynald. We will always have Seydisfjordur.

Palace Costume: Inside Hollywood's Best Kept Fashion Secret by Mimi Haddon

All photography featured in this book by Mimi Haddon, unless noted otherwise. © 2024 Mimi Haddon.

Publisher: Steve Crist, Gloria Fowler
Art Director and Editor: Gloria Fowler
Copy editor: Sara DeGonia
Designer and Production: Alexandria Martinez
Production: Freesia Blizard
Pre-Press: John Bailey

ISBN: 978-1-7972-2885-3

Library of Congress Cataloging-in-Publication Data available.

Manufactured in China

FSC
www.fsc.org

MIX
Paper | Supporting
responsible forestry
FSC™ C104723

CHRONICLE CHROMA

Chronicle Chroma is an imprint of Chronicle Books
Los Angeles, California

chroniclechroma.com

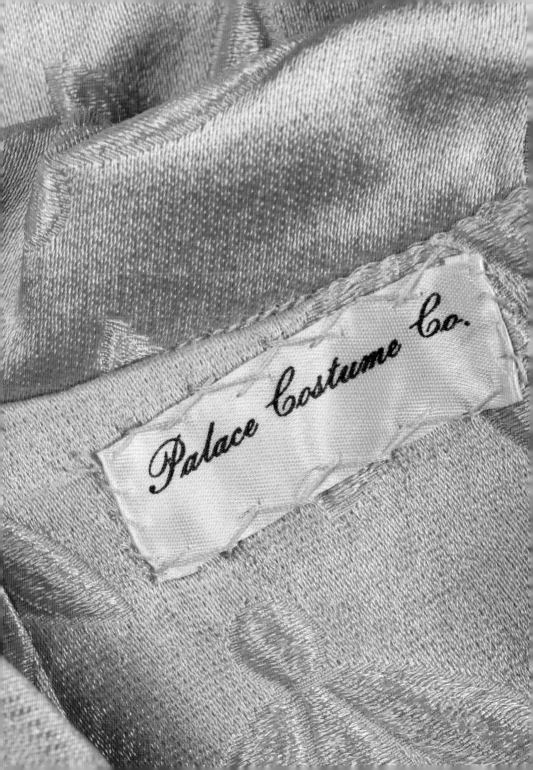

Philippe Albert

ALLEY CAT → BY BETSEY JOHNSON 9/10

pauline trigere

Elva and Andy's
MANSION HOUSE
Private Stock

BOB MACKIE

EMILIO PUCCI
FLORENCE - ITALY
10

STEPHEN SPROUSE

DESIGNED BY
Michael Travis

Kay Erlin
CALIFORNIA

JACK BRYAN
DESIGNED BY DUPUIS
DRY CLEAN ONLY

V
valentino
BOUTIQUE
6

LANVIN
by Hathaway

G. Gucci s.p.a.
MADE IN ITALY

MSS 206
Palace Costume Co.
BALENCIAGA
STYLE IN PARIS

Emilio Pucci
FLORENCE - ITALY
MADE IN ITALY
Saks Fifth Avenue
EMILIO PUCCI BOUTIQUE
TO BE COMMERCIAL DRY CLEANED
WITH COLD PERCHLOROETHYLENE
PRESS WITH COOL IRON
10